W9-DHM-683

The
DRAWING
of
AMERICA

MARSHALL B. DAVIDSON

The DRAWING

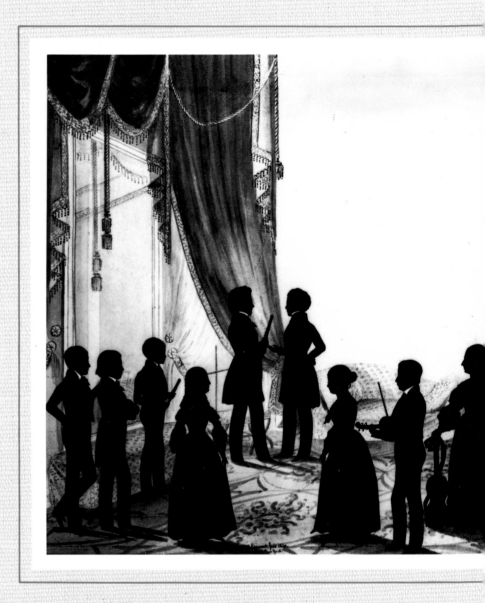

Eyewitnesses

of AMERICA

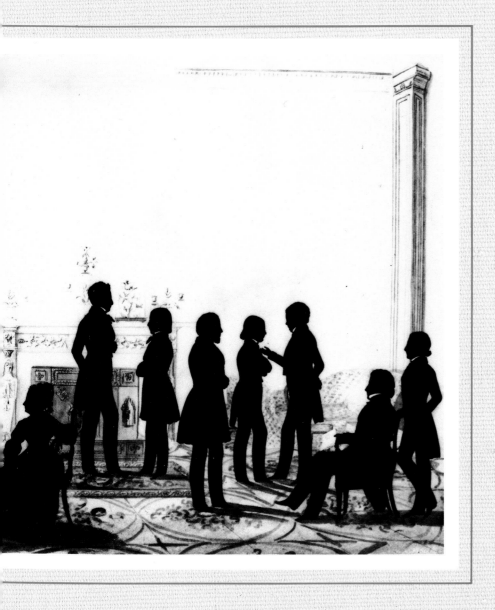

to History

HARRY N. ABRAMS, INC., PUBLISHERS, NEW YORK

For "E. M."

Project Manager: Lois Brown

Editor: Sheila Franklin

Designer: Dirk Luykx

Photographic Research: Lois Brown, Cynthia Deubel, and Ann Levy

Title page: Augustin Edouart. Reception at the House of Dr.
John C. Cheesman (plate 141).

Library of Congress Cataloging in Publication Data
Davidson, Marshall B.
The drawing of America.
Bibliography: p. 248
Includes index.
1. Drawing, American. 2. Water-color painting,
American. 3. United States in art. 4. United States—
History—Pictorial works. I. Title.
NC105.D38 1983 741.973 82-16465
ISBN 0-8109-0807-7

Contents

Acknowledgments

The idea for such a book as this was initially proposed by Lois Brown. During the course of planning and completing the project, her suggestions have been timely and helpful. Hers was also the exacting task of procuring the photographs that are here reproduced. This she did with a high degree of professional competence, with hard-tried patience, and with unflagging cheerfulness.

In editing my manuscript, Sheila Franklin made many valuable criticisms. These not only improved the text but also saved me from making a number of errors. If any remain in the book, it is entirely my fault. The sensitive job of designing the book was entrusted to Dirk Luykx. In his skilled hands, the very considerable variety of illustrations has been smoothly blended with the accompanying text.

With their sure knowledge of the drawings of the American scene, Janet Byrne, Paul Cummings, and Sinclair Hitchings gave me advice that eased me over troublesome spots. I am grateful to each of them for their friendly assistance.

Many thanks should also go to Donna Whiteman who gave me constant encouragement as my writing progressed, as she has on other occasions over past years. Her long experience with my handwriting enabled her to once again magically transmute illegible scrawls into neatly and correctly typed copy fit to be read.

I owe a special debt to Paul Gottlieb who made it possible for me to undertake this project. I hope he is pleased with the outcome.

M. B. D.

Introduction

IN THE SUMMER OF 1493, an extraordinary book was published at Nuremberg, Germany. A concluding passage of the text explained that the historical accounts compiled in the volume included all "the events most worthy of notice from the beginning of the world to the calamity of our time." A few blank pages were left at the end of the printed text for recording whatever little of importance might occur before doomsday forever closed the story of mortal man. Christian Europe was obviously in a sorry state of mind. Divided by discordant forces within and threatened by Mongol hordes at its borders, to some it seemed that Europe had little future to look forward to.

However, at almost precisely the same time, another publication, holding entirely different portents, was issued at Barcelona. This was a small pamphlet which contained a printed version of a letter by Christopher Columbus, in which he reported the epochal discoveries made on his first voyage across the Atlantic. The import of his message could not, of course, immediately be imagined, no less fully understood. (Columbus himself died without knowing that he had discovered a new world. He believed instead that he had found a westward passage to the Orient.) But, as one explorer after another, following Columbus's lead, crossed the western ocean and returned to publish their findings, the magnitude of the discovery became apparent.

World maps had to be revised to accommodate the newly discovered continents and heavenly bodies had to be recharted to account for the newly observed constellations. Most important, man's vision had to be adjusted for a new view of the future; what was hoped would be a better future. What was to unfold in the land now known as the United States, in the roughly five hundred years that have passed since Columbus's first announcement, is illustrated in the drawings reproduced on the following pages.

This book is not about drawings as such except in their capacity, whatever their aesthetic merit, to speak for themselves in elucidating the story of this country—its people and its places—in a direct and immediate way. Their special importance here is that they are one-of-a-kind, on-the-spot, eyewitness documents. Such pictorial reporting can often evoke aspects of experience that can be recalled in no other way; for the arts can sometimes speak to us when written histories remain dumb. Many of the drawings reproduced here are sophisticated works by highly professional artists. Others are crude efforts by untrained observers eager to record a significant

event or sight which no skilled artist was likely to have witnessed and which somehow seemed worthy of being drawn, with whatever pen and paper was at hand. In any case, they offer unique insight into the nature of American experience over the years.

The term "drawing" comprehends works in pen or pencil, charcoal or crayon, pastel or gouache, and watercolor—the last of which the eminent English art critic John Ruskin once alluded to as a more advanced kind of drawing. This means, in effect, all works done on paper except prints and photographs. Some of the examples here illustrated served as models for well-known, mass-produced prints of one sort or another, such as the popular lithographs of Currier & Ives. But these printed copies commonly lost the immediacy and often some of the accuracy of the originals in the hands of lithographers and engravers. Others served as preliminary "takes" that were subsequently worked up into finished oil paintings in the studio. Here too similar transformations took place, for a more formal presentation of the artist's primary impressions was often desired. The drawings themselves, then, remain as close to the visualized truth of man's experience as human sensitivity can register.

The First Americans

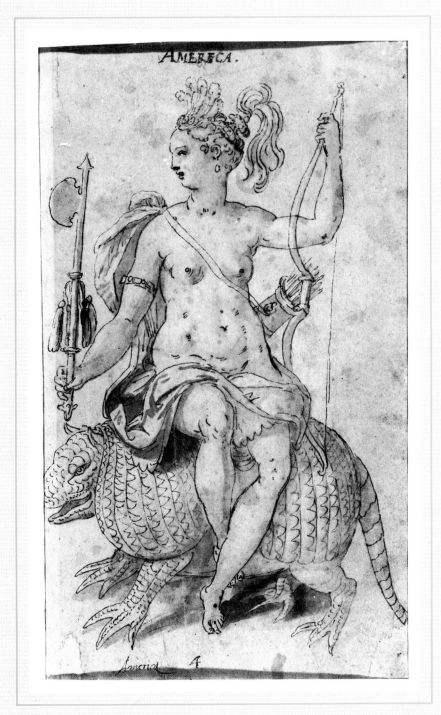

1. Maarten de Vos. America. 1594. Pen and ink and wash. Stedelijk
Prentenkabinet, Antwerp

Earliest Views of the New World

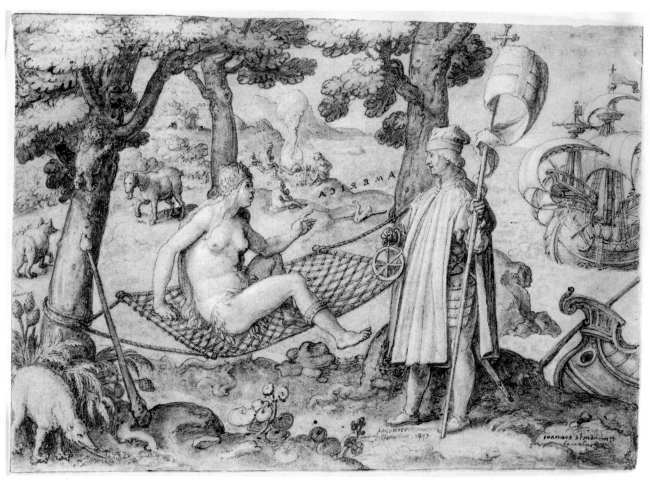

2. *Johannes Stradanus. Discovery of America: Vespucci Landing in the New World. c. 1580–85. Pen and brown ink, 7½ × 10⅝".*
The Metropolitan Museum of Art, New York. Gift of the Estate of James Hazen Hyde, 1959

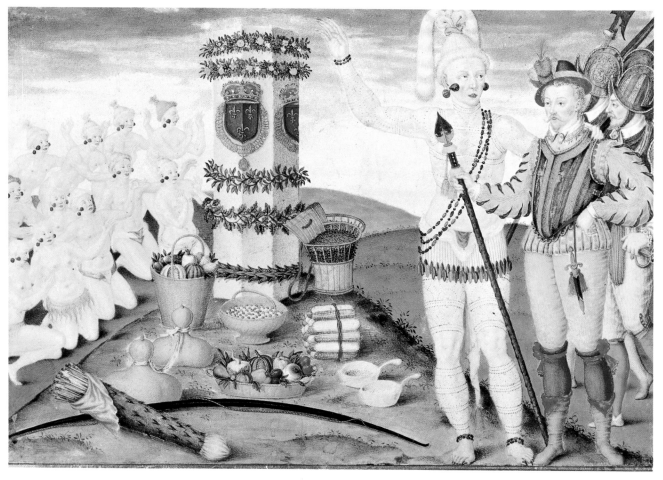

3. *Jacques Le Moyne de Morgues. René de Laudonnière and Chief Athore at Ribaut's Column. 1564. Gouache, 7 × 10¼".*
New York Public Library, Print Collection

ALL AMERICAN HISTORY is in a sense the story of westward expansion. The pioneers in this great drift of peoples were the intrepid early navigators who crossed the Atlantic to discover, scout, and then colonize the shores of the New World. A second wave of expansion gathered force in the late eighteenth century when other, no less intrepid, frontiersmen led the way from the coastal settlements into the wilderness and ultimately across what is now the continental United States, to be followed by untold millions of westering people in the century to come. This was the closing phase of the movement that had originated centuries earlier, and that, as its momentum increased, became the greatest folk migration in history. Its numbers far exceeded those of the wandering Germanic hordes who swept over Europe in the early Middle Ages. And it gave America a unique heritage of adventure and accomplishment that still colors our thoughts and attitudes.

Although the early voyages of Christopher Columbus antedated those of Amerigo Vespucci by several years, Vespucci's name early became fixed on maps showing the New World because of his imaginative, sometimes mendacious, but always persuasive reports. We have a graphic reminder of this self-promoting accreditation in an allegorical drawing made some seventy years after his death (plate 2): the "discoverer," elaborately dressed, is holding in one hand a banner displaying the constellation Southern Cross and in the other a mariner's astrolabe. (The likeness of Vespucci may have been taken from a portrait made of him during his lifetime.) He confronts America, symbolized by an opulent nude figure seated in an Indian hammock. She is identified by the word "America," lettered in reverse since the drawing was intended to serve as the model for an engraving.

In the background, cannibalistic natives are seated around a fire, enjoying a meal of human flesh. The scene includes what may be the earliest surviving drawing of American flora and fauna. Apparently the artist, Johannes Stradanus, worked from genuine material brought back from America by returning voyagers. The anteater, the horselike tapir, the sloth climbing a tree, and the pineapple at the tree's base each has its name inscribed beside it.

Such allegorical representations of the known continents, each with its separate attributes, were popular exercises in the late sixteenth century. In another drawing from this period (plate 1), America is shown as a woman equipped with Indian bow and arrows, somewhat implausibly riding side-saddle on an outsize armadillo. Like the anteater and the sloth, the armadillo was a creature peculiar to the American wilderness. Up until this time, virtually all known pictures of the New World were based on hearsay, with imaginative flourishes by the artist providing further details when they were missing from verbal accounts.

Wherever they touched shore in America, the early explorers were greeted, in one fashion or another, by native Indians, tribesmen of widely differing appearance, dress (or undress), and cultural heritage. Many more, of course—probably a million or more—of still different backgrounds and customs, were scattered throughout the vast inland wilderness of the continent and would come to the white man's attention only in later years. In 1493 Columbus returned to Spain with a handful of Indian captives, and more were brought back by subsequent voyages. Such strange beings were prime curiosities when they appeared on the streets of Europe. Even to this day, the American Indian remains something of an enigma to many Europeans. Sight unseen, he has been variously conceived as the uncanny, savage

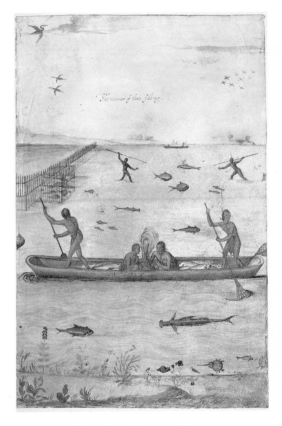

4. *John White. The Manner of Their Fishing. 1585–87. Watercolor. British Museum, London*

hunter of James Fenimore Cooper's early novels, the incredibly chaste and virtuous Atala of Chateaubriand's popular romance, or the bloodthirsty scalp hunter of second- and third-rate movie thrillers. Long after the white man had usurped most of the Indian's domains, otherwise well-informed Europeans continued to believe that all Americans were "redskins." In the 1830s a group of credulous Frenchmen came to the inn where James Fenimore Cooper was staying on one of his trips abroad, hoping to catch a glimpse of this "red man" from the wilds of America.

A watercolor of 1564 by the French artist Jacques Le Moyne de Morgues is the earliest known surviving picture of an American Indian on his native ground (plate 3). In it, Le Moyne shows members of a French expedition being greeted by a group of Timucua tribesmen, at a site in northeastern Florida where a Huguenot settlement had been wiped out by Spaniards a few years earlier. Athore, the chief of the Timucuas, who were a tall, muscular people, is shown proudly explaining to the visiting Europeans how a column erected by their ill-fated countrymen as a symbol of French possession of the area has become, for the Indians, an object of veneration, to which they make offerings of food, arms, and garlands of flowers.

Most of Le Moyne's many original drawings of the American scene have been lost. Painted and engraved copies have survived, but, interesting as these may be, the "improvements" made in such transcriptions lose the fresh evidence of the artist's direct observations.

The most illuminating surviving records of sixteenth-century America were provided by John White, governor of Sir Walter Raleigh's ill-fated Lost Colony on Roanoke Island, off the coast of North Carolina. White's capable watercolors (plates 4, 5) show Indian life as he observed it in the years 1585–87. If in his drawings he chose to avoid the less appealing, more barbaric aspects of the customs and practices of his aboriginal subjects, it should be remembered that, as a British colonizing agent, it was in White's interest to create a favorable view of the New World. The truth of the matter, however, was grim. When White returned to America in 1591, after a voyage to England to secure relief for the colonists, he could find no trace of them. Their actual fate remains a mystery, but that they were massacred or taken captive, by such Indians as those he faithfully recorded following their peaceful pursuits, seems altogether plausible.

As was the case with Le Moyne's drawings, White's, too, were reproduced in engraved copies by the Flemish publisher Théodore de Bry and were widely distributed in Europe. In fact, so well known were these published versions that the White drawings in the British Museum were for years catalogued under the publisher's name. Then, in the last century, in the course of extinguishing a fire that had broken out in the museum, White's originals were rediscovered. (As a curious by-product, the dampness caused by hosing down the conflagration resulted in pale duplicates being offset on sheets of paper that had been interleaved to protect the originals.)

For good reasons, the early European visitors were intensely interested in the natives whose lands they would ultimately usurp. In the decades following White's efforts, dozens of reporters with varying degrees of competence recorded the likenesses of the Indians they encountered. In 1654 Peter Martensson Lindström, a well-bred and educated young Swede, visited New Sweden on the Delaware and studied the local natives—the Delaware, or Lenni-Lenape, Indians (plate 6). Though his stay in the area was brief (the little colony was overthrown the year after he arrived by the Dutch under their wooden-legged leader, Peter Stuyvesant), Lindström

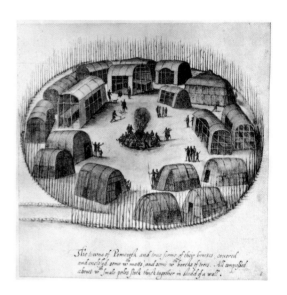

5. *John White.* The Town of Pomeiock. *1585–87. Watercolor. British Museum, London*

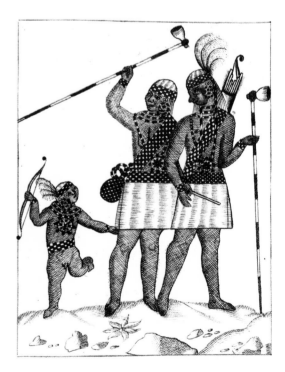

6. *Peter Martensson Lindström.* Two Delaware Indian Men and a Boy. *1654. Pen and ink. Riksarchivet, Stockholm*

nevertheless managed to write an account of these strange beings whom he described as naked except for cloths around their waists and wampum strings around their necks. "It is a brave people," he continued, "daring, revengeful . . . eager for war, fearless, heroic. . . ." Among their less worthy attributes, he found them "very mischievous, haughty . . . eager for praise, wanton bestial, mistrustful, untruthful and thievish, dishonorable, coarse in their affections, shameless and unchaste." Lindström concluded that their behavior was "more inclined toward bad than toward good."

Among the curiosities of the New World that excited the imagination of Europeans was the Indian practice of burning the dried leaves of the tobacco plant (plate 7) and "drinking smoke." The habit of smoking caught on quickly in Europe, to the delight of some and the despair of others. James I described it as "a custome lothsome to the eye, hatefull to the Nose, harmefull to the braine, dangerous to the Lungs, and in the blacke stinking fume thereof, neerest resembling the horrible Stigian smoke of the pit that is bottomelesse." However, that royal warning went largely unheeded. So quickly and firmly did the practice become fixed that, for better or for worse, the farming of tobacco as a staple for export became a vital factor in the economy of some of the southern colonies. In Virginia the cultivation of tobacco proved to be a mixed blessing. Although the profits from tobacco saved the struggling colony from extinction, the single-minded concentration on raising this cash crop at the expense of subsistence farming almost destroyed it.

The first European adventurers in the region of present-day New York State were confronted by members of the Iroquois Confederation—consisting of the Mohawk, Oneida, Onondaga, Cayuga, and Seneca Indians—whose material culture was the most advanced of the Eastern Woodlands area. Because of their superb political organization and military prowess, the Iroquois were feared by other Indians (plate 9) and respected by white invaders. In the end, the Iroquois played a crucial role in the drawn-out contest between the English and the French for empire in the New World. It is possible that the French could have won that contest had they not engaged the Iroquois in battle on the shores of Lake Champlain in 1609. Although the French were victorious, theirs was a Pyrrhic victory at best for this battle earned them the enmity rather than the friendship of these awesome warriors. As a result, the Iroquois formed alliances with the Dutch and the English, successfully thwarting France's hitherto unrivaled domination of the lucrative fur trade and thereby lessening their control in the area.

The French also faced Indian enmity in the lower Mississippi River valley, where the Natchez were the largest and most powerful tribe. In 1729 these warriors sacked a French trading post that had been established in Indian territory some years earlier, killing scores of white inhabitants. In revenge, the French recruited other Indians, some from as far north as Illinois, and drove the Natchez from their homeland. A drawing from this period by Alexandre de Batz (plate 8) shows the widow, son, and successor of a chief who has been killed by the Natchez; the successor, a belligerent warrior, is flaunting three enemy scalps attached to a pole he is holding.

Lured by tales of abundant wealth, Spain's conquistadores invaded Mexico and the lands to the south, subjugating the natives they encountered in their path. To the north of Mexico, according to old legends, lay the Seven Cities of Cibola, where as yet undiscovered hoardings might be found, riches surpassing the treasures of the great Montezuma. Instead, in what is

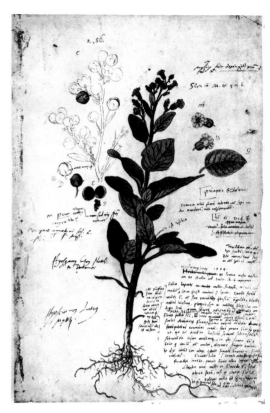

7. *Artist unknown. Tobacco Plant. c. 1554–55. Pen and ink and watercolor. From Konrad von Gesner's* Historia Plantarum. *Universitätsbibliothek Erlangen-Nürnberg, Germany*

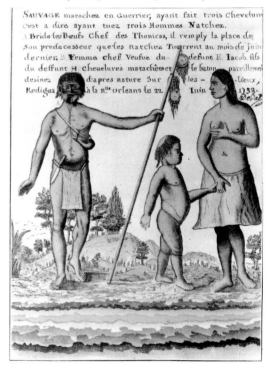

8. *Alexandre de Batz.* Savage Adorned as a Warrior. *1732. Pen and colored inks, 13 × 9½". Peabody Museum, Harvard University, Cambridge, Mass.*

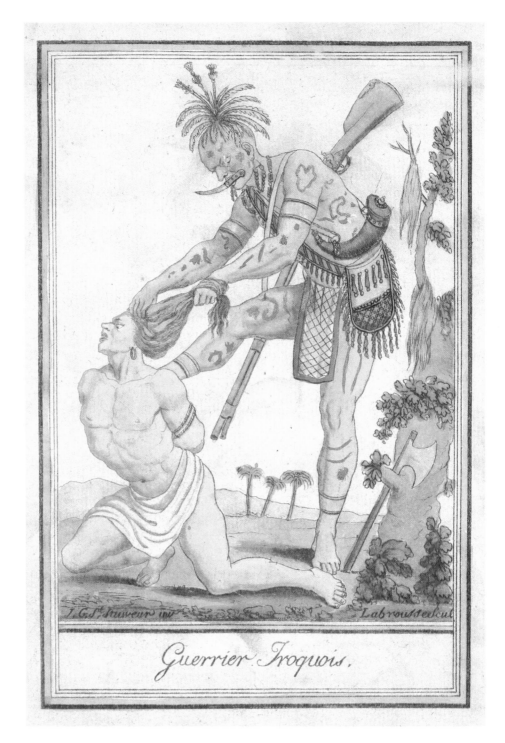

9. *J. Grasset de Saint-Sauveur.* Iroquois Warrior Scalping an Indian. 1787. *Hand-colored engraving, 6¾ × 4½″. Library of Congress, Washington, D.C.*

now the southwestern United States, the Spanish pioneers found a variety of humble settlements whose wealth consisted of the bare necessities of life wrung from the semiarid and generally inhospitable environment.

Among the tribes living in that sizable area were the Pueblo Indians, whose stone or adobe communities housed the oldest civilization north of Mexico—a culture that reached its peak almost a thousand years ago. Such intricately planned and constructed architectural conglomerations may have given rise to the magic legend of Cibola. The last of these pueblos was built in 1699 at Laguna, near Albuquerque, New Mexico. When this site was sketched by Richard Kern in 1849 (plate 11), the Pueblos, despite centuries of Spanish rule, still followed many of their ancient ways as they continue to do today.

The Pima Indians, who occupied a part of what is now Arizona, were a generally peaceful tribe who welcomed Spaniards from Mexico and, later, other whites from the eastern United States. They lived in dome-shaped huts made of poles covered with brush and mud (plate 10) and tilled the land much as their forefathers had done for centuries. Their communities

10. Seth Eastman (after John Russell Bartlett). Village of the Pima Indians, River Gila. *1850s. Watercolor. John Carter Brown Library, Brown University, Providence*

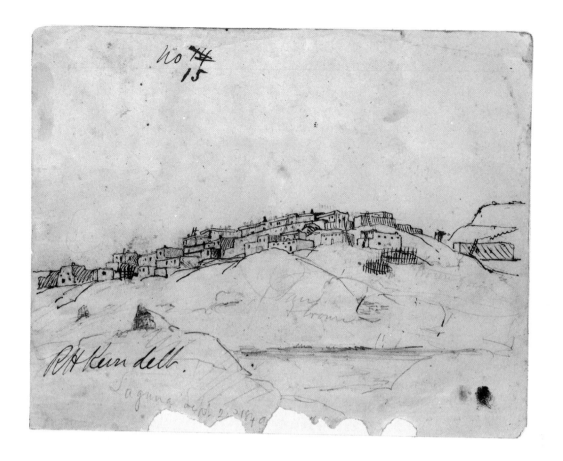

11. Richard H. Kern.
Laguna. 1849. Pen and
ink, 5¾ × 7¼". Peabody
Museum, Harvard
University, Cambridge,
Mass.

12. B. Möllhausen.
Navaho Indians. 1859.
Watercolor. Museum für
Völkerkunde, Staatliche
Museen Preussischer
Kulturbesitz, West Berlin

13. *José Cordero.* A Spanish Soldier Attacking California Indians. *1791. Drawing. Museo Naval, Madrid*

provided a convenient stopping place for pioneers who took the southern route to California in the 1850s.

The Navahos came to this same general area more than five hundred years ago (plate 12)—in time to meet, and to threaten, the earliest white intruders. They were the relations of the fierce Apaches, and their hostile demonstrations against whites and Indians alike were stopped only in the 1860s, when Kit Carson, with his indomitable companions and some Indian allies, invaded their homeland and laid it waste. Today the Navahos are the largest Indian tribe in the United States, renowned for their traditional and very skillful weaving and silverwork.

In sharp contrast to the Navahos and the Apaches, the coastal Indians encountered by early white visitors to California were, for the most part, a friendly and peace-loving people. Innocent and unskilled in the practice of war, they proved to be no match for the mounted Spanish soldiers who, while accompanying missionaries northward from Mexico, systematically assaulted and subdued them (plate 13). Forced submission to the white man and his strangely different life-style seemed to diminish these strong, handsome people both physically and spiritually. In 1816 a European artist visiting the San Francisco mission characterized the Indians he saw there as "lazy, stupid, jealous, gluttonous, timorous . . . they have the air of taking no interest in anything." The same impression is conveyed in the accompanying illustration (plate 14), in which the natives are rendered as puny and ill-favored specimens.

14. *Alexandre-Jean Noël.* California Indians. *1769. Pen and ink and watercolor. The Louvre, Paris*

Verbal and visual reports such as these seemed to lend credibility to a preposterous theory put forth by the eminent French naturalist Buffon (whom Catherine the Great considered "the first mind of the century in his field") that all life in America was a degenerate form of that which existed on the European continent. All living things—flora and fauna—were included in his contention and man, Buffon concluded, was the most conspicuous example of this degeneration. Witness the poor Indian, he went on, who was physically, morally, and intellectually inferior to the European man: lacking in vigor and endurance, sexually frigid and perverted, cowardly and short-lived. After the age of seventeen, he continued, the Indian lapsed into brutal stupidity, and so on.

Such monstrous and ridiculous assertions brought forth a carefully reasoned and documented rebuttal from Thomas Jefferson. He argued the case for the physical prowess and sensibility of most Indians with conclusive authority. He also pointed out that American bears were almost three times the size of their European counterparts; that the bison, which had no European equivalent, weighed as much as eighteen hundred pounds; and that in virtually every other category of fauna, from elk to dormouse, the American versions were, by Jefferson's calculations, the larger and more vigorous. In 1787 Jefferson had the skin, skeleton, and horns of a huge moose sent to Buffon for his further edification. Were more proof needed, the Frenchman could not have failed to notice that the tall American towered above him when they dined together at the Jardin du Roi (later named the Jardin des Plantes) in Paris.

The coastal tribes constituted only a fraction of the Indian population of California; other tribes were more advanced and less submissive. However, when white men surged into California from the east, their policy toward each of these tribes was uniform and brutal. Following the pattern of the frontier, they carried out a systematic campaign of extermination and isolation. In 1850, by the time the United States had taken over the territory along the West Coast, most of the natives had been reduced to a sorry state. As one sympathetic reporter wrote, "None here but see and lament their sad condition."

Footholds in the Wilderness

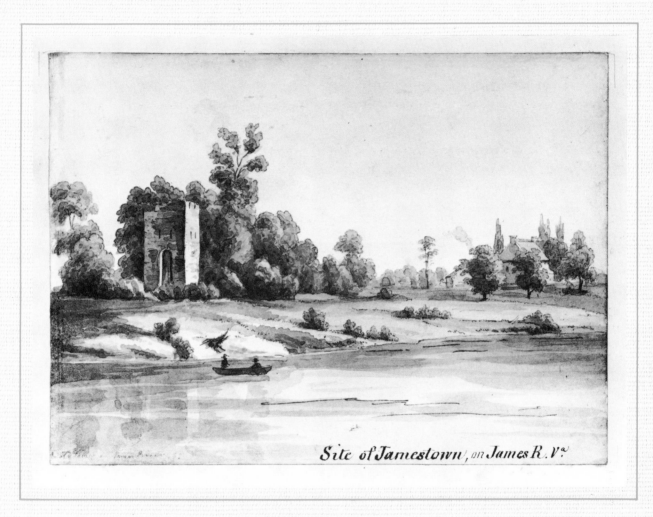

15. *August Köllner. Site of Jamestown, on James River, Virginia. c. 1845. Sepia, 7⅞ × 14⅞″. New York Public Library, I. N. Phelps Stokes Collection*

The First European Settlements

NGLAND was relatively slow in taking a serious step toward colonizing the New World. Her first colorful ventures were limited to voyages undertaken in the martial spirit of her gentlemen adventurers, those Elizabethan sea dogs who cleared the ocean lanes before the colonists' advance. But by the dawn of the seventeenth century, when the exploitation of America had become a matter of commercial speculation, her colonizing efforts began in earnest, leading to the planting of permanent settlements.

Each of these settlements had a unique history and situation and by the early eighteenth century each had, for the most part, assumed the separate character that it would long retain, even as a state of the independent nation in much later years. Rarely did the realities of New World experience coincide with the preconceived notions of life in America that most colonists brought with them. The colonies were spread out over a wide area, and the climate, the topography, the soil, and the attitudes of local Indian tribes all posed novel problems that varied from one latitude to another. To adapt old habits and fond hopes to the unexpected was necessary to survival and development.

Forgetting Raleigh's unsuccessful attempt at Roanoke, the beginning of England's western movement came with the founding of a settlement at Jamestown, Virginia, in 1607. For the small group of colonists who first

16. *Benjamin Henry Latrobe.* View of Green Spring House. *1796. Pencil, pen and ink, and watercolor, 6⅞ × 10⅞". Maryland Historical Society, Baltimore*

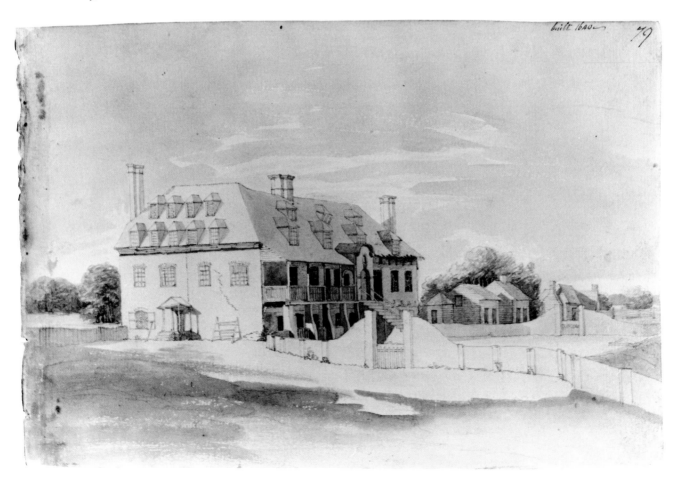

settled this area, life was full of very real hardships and ordeals. Most were wiped out by disease, starvation, and neighboring Indians (described in one sample of promotional literature as "generally very loving and gentle, and doe entertaine and relieve our people with great kindnesse. . ."). Fortunately for them, Captain John Smith was among their ranks. However tall may be some of the tales he wrote about his adventures—such as his rescue from almost certain death by the dusky Indian princess Pocahontas—it is fair to conclude that without his practical efforts the infant colony might well have perished.

However, the colony survived its early misadventures, as well as a brief civil war and a conflagration, and remained the capital of Virginia until Williamsburg was made the new seat of government at the end of the seventeenth century. After that the old village fell into decay. Only the tower of a brick church that had been raised about 1639 remained standing (plate 15), a picturesque, ivy-covered reminder that near this site twenty years earlier English colonists had established the first legislative assembly in the land. Little did they know at the time that this form of representative self-government and democratic process would become a fundamental principle of the British colonies in America.

About the middle of the seventeenth century, Sir William Berkeley, sometime royal governor of the Virginia Colony, had built for himself a magnificent countryseat near Jamestown. Known as Green Spring, it was the largest building of the period and the showplace of the early colony. His widow referred to it as "the finest seat in America & the only tollerable place for a Governour." Even in dilapidated condition it was still an impressive pile when the architect-engineer Benjamin Henry Latrobe sketched it in 1796, a few years before it was demolished (plate 16).

The Jamestown exploits recounted by Smith have become so legendary that they tend to overshadow his vital role as a founder of New England, which he explored, mapped, named, and described. One of his excellent maps shows "Plimouth," a site he so called eight years before the Pilgrims landed in that area in 1620.

The very word "Pilgrims," referring to these early forefathers, was first used by William Bradford in his *History of Plimouth Plantation*. These "scriblled writings," as he termed his manuscript, lay all but forgotten for two centuries. When resurrected and, in 1856, finally published, this account marked the true beginnings of Pilgrim history as we have come to know it. Bradford wrote with particular insight for he was a principal actor in the events he recounted and, as sometime governor of the colony, a chief of the inner councils at Plymouth when matters of moment were intimately discussed. Because he did not plan to publish his manuscript, his descriptions of the daily life of his fellow settlers have a candor that completely destroys our stereotypical conceptions of these men and women—conceptions that have long served as, and still remain, a prominent part of their legend. He showed them as he knew them; not as plaster saints, but as human beings with their all too many frailties and vanities existing alongside their rugged strengths and austere convictions.

In Plymouth, as in virtually all early New England villages, the meetinghouse stood at the very center of community life. In 1683 the Pilgrims replaced a "strong & comely" but nondescript structure (that also served as a fort, court of justice, and jail) with a new building that better accommodated their religious needs. Built with funds from the sale of land confiscated from the Indians after the bloody King Philip's War, it measured some

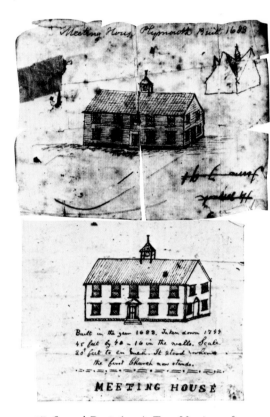

17. Samuel Davis (attr.). Two Versions of an Early Plymouth Meetinghouse, Built in 1683 and Taken Down in 1744. *Pen and ink, 3½ × 5″ (above); 3¼ × 4⅜″ (below). Pilgrim Society, Boston*

18. Artist unknown. View of Boston. *c. 1790. Oil on panel, 17½ × 50″. Worcester Historical Society, Worcester, Mass.*

forty-five by forty feet in plan, with glass windows and a cupola rising from a pyramidal roof. It remained standing for sixty-one years. Primitive as it may seem in the crude drawing of it that has survived (plate 17), it held the seed of those lovely spired churches that would grace the New England countryside in years to come—enduring witnesses to both the stability and order of the surrounding society, and to the spirit of reverence and self-control with which the people within the shadows lived and governed themselves.

Plymouth was annexed to the Massachusetts Bay Colony in 1691. Boston, already a part of that colony, was born on a small, rocky peninsula in 1630, and had long since overshadowed its older little neighbor in size and importance. Relatively quickly it became "the principal mart of trade in North America" and the hub of New England activity and culture. As early as 1663 it was reported that Bostonians were building their houses "close together on each side of the streets as in London." It was to become, for a while, the largest town in the British colonies.

Like all the early American settlements, Boston was born of the sea and the ocean, and its coastal lanes were its lifelines. In 1790 an unsung artist rendered a view of the budding little city as it appeared about 1730

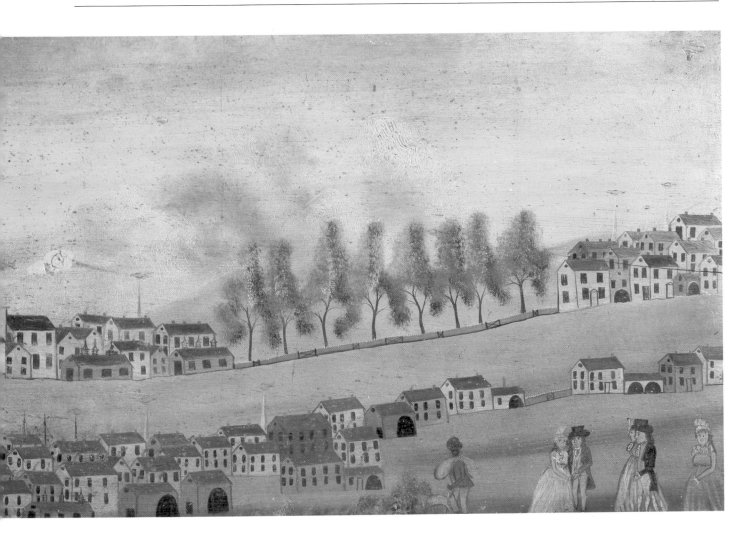

(plate 18). In it, ships are prominently featured and appear almost as numerous as the clustered buildings onshore. Many years earlier, in 1716, Boston had built the first colonial lighthouse, "a high stone building in the form of a sugar loaf, upon the top of which every night they burn oil to direct and guide the vessels at sea into the harbour." This towering white landmark, which still stands, was one of the first sights to catch the eye of the Swiss artist Karl Bodmer when he sailed into Boston Harbor on the morning of the Fourth of July, 1832 (plate 19).

The English were not the first to arrive at the site of present-day New York City. In the 1620s the Dutch—under the leadership of Peter Stuyvesant—had already asserted a modest claim there by establishing a trading post on the southern end of Manhattan Island. In time this patch of land, for which they gave the local Indians some trading goods (valued by later historians at about twenty-four dollars), would become one of the wealthiest areas on earth. New Amsterdam, as the settlement was named, rose to little importance under Dutch rule. Nevertheless, hemmed in on its island tip by a protective wall—site of the future Wall Street—the town did soon become a miniature replica of a typical Dutch city, a character it retained until well after the English took possession of the colony in 1664. Fifteen years after

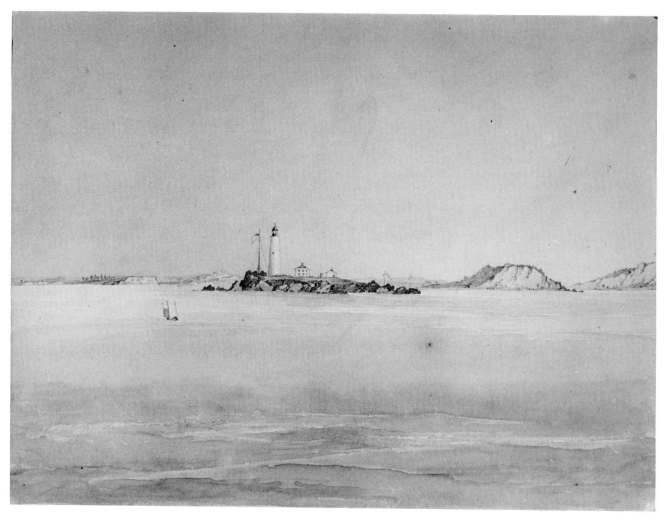

19. *Karl Bodmer*. Boston Lighthouse. *1832. Watercolor, 6¼ × 8½". The InterNorth Art Foundation, Joslyn Art Museum, Omaha*

that takeover a Dutch missionary visited the town in the course of his search of a suitable place for members of his sect to settle. He found it "a pretty sight," and in his drawing of it he obviously made an honest effort to record exactly what he saw from Brooklyn Heights across the East River (plate 20).

From its beginnings New Amsterdam, which the English renamed New York, was a sailors' town with a polyglot, free-spending, cosmopolitan population. To visitors from other colonies, it seemed an exotic place. In the 1700s its nestling houses of parti-colored brick and tile, and stepped gable ends facing the street, were picturesque reminders of a persisting Dutch legacy. The occasional survival of these structures continued to excite interest for more than a century. About 1770 the Swiss-born artist and naturalist Pierre-Eugène du Simitière spotted and drew one such building with wrought-iron beam anchors (plate 21), providing as its date the year 1689. He felt certain there were many more and even earlier examples still standing. Almost sixty years later, when James Fenimore Cooper was passing through New York, he remarked that there were still a few Dutch buildings to be seen in the rapidly growing city. They are, of course, long since gone.

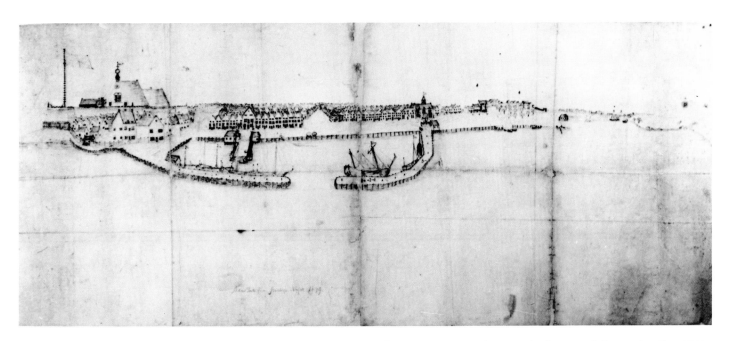

20. *Jasper Danckaerts.* New York from Brooklyn Heights. *1679. Watercolor, 12⅞ × 32⅜". The Long Island Historical Society, Brooklyn, N.Y.*

21. *Pierre-Eugène du Simitière.* New York Housefront Dated 1689. *c. 1770. Pencil, 7½ × 9¼". The Library Company of Philadelphia*

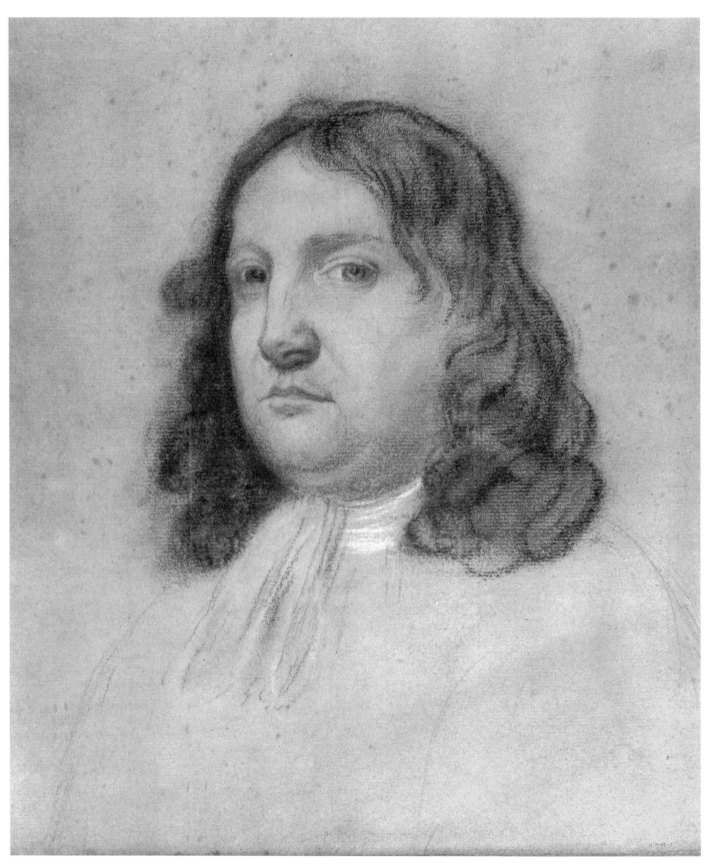

22. Francis Place. William Penn. n.d. Colored chalks, 11⅞ × 8⅛″. Historical Society of Pennsylvania, Philadelphia

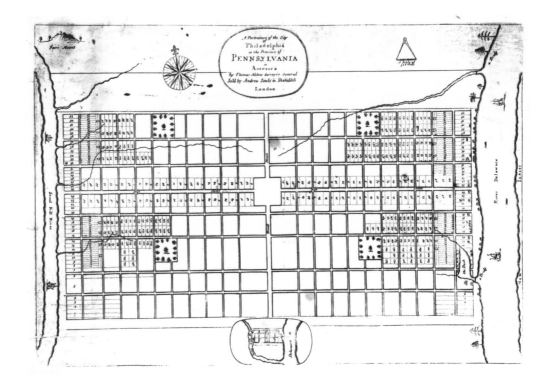

23. Thomas Holme. Plan
of Philadelphia. *1683.*
Engraving, 11⅜ × 17½″.
*American Philosophical
Society Library,
Philadelphia*

Almost every material trace of New Amsterdam has vanished in the name
of change and progress. As one historian has observed, there is less left
standing of Peter Stuyvesant's town than there is of the Athens of Pericles.

One of the most enterprising and enlightened colonizers of the New
World was William Penn (plate 22). An inspired Quaker, he alluded to
Pennsylvania, the colony he founded in 1681, as the "Holy Experiment."
Here he offered haven not only to those "schismetical factious people" the
Quakers, but to all others who would welcome an opportunity to live to-
gether in a spirit of brotherly love. He had widely and energetically adver-
tised his proposed colony on the Continent as well as in England, and, in
short order, Philadelphia became a port of entry for swarms of hopeful
immigrants from various European lands.

There was nothing quite like this phenomenal development in colonial
experience. Penn's several treaties with the Indians were fair and generous,
sealed with an intention that the natives and the whites "must live in Love,
as long as the Sun gave light." The French philosopher Voltaire observed
that these were the only agreements between the aborigines and the Chris-
tians which were never sworn to and never broken; proof, he concluded,
that men of different beliefs and races could lead the good life side by side
without strife.

Philadelphia (a name compounding the Greek words for love and friend)
was from the start a carefully planned city (plate 23). It was to be "a green
countrie towne" that would never burn (as so many colonial cities did), and
would provide a wholesome ambiance. This it did, with its straight, wide
streets unlike the crooked lanes of early Boston and New York, symmetrical
brick houses each with a garden, and intervening spaces reserved for fields
and orchards. Small wonder that, within a few score years, it became one
of the largest and most important cities under British rule.

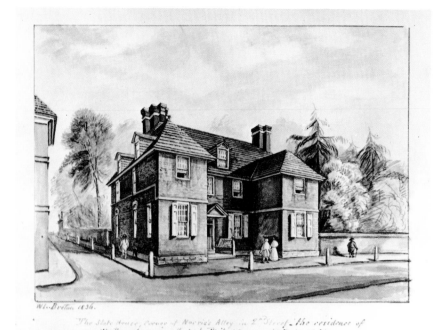

24. William I. Breton. The Slate House.
1836. Pen and ink wash, 5⅛ × 7¼″.
The Library Company of Philadelphia

William Penn paid two visits to his thriving colony. In January 1700, during his second stay in Philadelphia, he took up residence in the so-called Slate House, one of the finest buildings in the city. This relatively large brick structure with a slate roof had been built shortly before by one Samuel Carpenter on part of a lot he had purchased at the founding of Philadelphia. It remained standing, with some alterations, until 1867 (plate 24).

Shortly before Penn undertook his "Holy Experiment," the colony of Carolina was founded along the coast far to the south. According to the original plans of its absentee English proprietors, this was to have been a feudal colony. Its constitution, drawn up with the help of the eminent philosopher John Locke, was designed to regulate the degrees of nobility and dependency that would obtain on the distant shores of America. Large landholders were to be dignified by such romantic titles as baron, cacique, landgrave, and the like. That bizarre blueprint for life in the New World was, of course, never worked out. A resident aristocracy quite as impressive as any envisioned by Locke did soon develop in Carolina, but it grew out of the enterprise of those colonists who seized the opportunities provided by the richness of the land and by the traffic in its produce.

The port city of Charles Town (now Charleston) was founded in 1680 and burgeoned so rapidly into a major entrepôt of the Atlantic seaboard that to refer to it as a foothold in the wilderness seems hardly appropriate. Within a generation it had gained "ye reputation of a wealthy place" to which had been attracted people of many different faiths and backgrounds: Barbadians, dissenters from England, Scottish Covenanters, French Calvinists, New England Baptists, Dutchmen from Holland and New York, Quakers, Irish Catholics, Jews from various places, and still others. Cosmopolitan though they were, even New York and Philadelphia did not include a more remarkable mixture of varying elements in their populations. In the benign, subtropical climate of Carolina, these many strains fused into a unique civilization—urbane, aristocratic, and leisurely.

The most important early view of Charleston shows the young city as it appeared about 1739, stretching out along the bank of the Cooper River (plate 25). With its long array of handsome buildings and its colorful flotilla of trading and pleasure vessels crowding the river, it creates a fair and

intimate impression of one of colonial America's most unusual and charming urban centers. A few years earlier, before Blackbeard and others of his piratical trade had been eliminated from the scene, richly laden vessels such as these had offered them attractive prizes.

It was in this milieu that the first resident professional artist in America, Henrietta Johnston, practiced her craft during the first quarter of the eighteenth century. Apparently Irish-born, she arrived in the city about 1706 or 1707 with her husband, Gideon, an Anglican clergyman, and almost immediately started producing pastel portraits of the local gentry to eke out the family finances. "Were it not for the Assistance my wife gave me by drawing Pictures . . . ," Gideon recalled, "I should not have been able to live. . . ." At least once, Henrietta journeyed as far as New York in a successful quest of commissions. Although Mrs. Johnston's talents were modest, her agreeable and direct likenesses were an exceptional accomplishment for a woman in America at the time (plate 26).

To the north, south, and west of the settled British colonies, confined as they were by ocean and mountain to the eastern coastal zone, France and Spain were staking strong counterclaims to the rest of the North American continent. While colonists from many different lands were sinking the first roots of Carolina, Robert Cavelier, Sieur de La Salle—the intrepid explorer and empire builder of New France—was embarking upon a prodigious journey. Working his way south and west from Quebec, he descended the Mississippi River to the Gulf of Mexico. There, on April 9, 1682, he pronounced France's claim to the great American West. On that day, wrote Francis Parkman, "The realm of France received on parchment a stupendous accession. The fertile plains of Texas; the vast basin of the Mississippi from its frozen northern springs to the sultry borders of the Gulf; from the woody ridges of the Alleghenies to the bare peaks of the Rocky Mountains—a region of savannahs and forests, sun-cracked deserts and grassy prairies, watered by a thousand rivers, ranged by a thousand war-like tribes, passed beneath the sceptre of the Sultan of Versailles; and all by virtue of a feeble voice, inaudible at half a mile."

La Salle named the regions he claimed Louisiana, after that "Sultan," Louis XIV. It was an enormous area, and though vaguely defined, it counted many times the size of France. In another expedition a few years later, La Salle tried to rediscover by sea the site where he had made his original claim. In the course of that unsuccessful venture he was murdered by one of his disgruntled crew—an ignominious end for an inspired pioneer. However, the French were determined to secure the foothold La Salle had tentatively established near the Mississippi Delta, to hold it as an outpost to discourage encroachments by the Spaniards from the west and the British from the east, and to make use of it as a depot through which the incalculable riches of the Mississippi Basin could be funneled for export to the waiting markets of Europe.

One of the earliest tangible developments toward the last of these ends was the founding of a trial colony at New Biloxi (present-day Biloxi), Mississippi. This was undertaken in 1719 by a great monopolistic trading company conceived and promoted by John Law—a Scottish speculator who had by his aggressive tactics become comptroller general of France, and who advertised his scheme in the most extravagant manner. Europe responded to his blandishments with a frenzy of reckless optimism. The first residents of the prospective city lived in tents; there was also a large wooden ware-

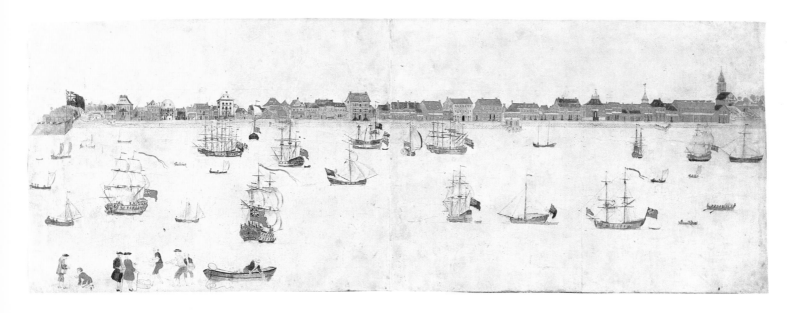

25. Bishop Roberts. View of Charleston. Before 1739. Watercolor, 15 × 43⅜". Colonial Williamsburg, Va.

house, a palm-thatched infirmary, and a surgeon's office, as shown in the eyewitness drawing by Jean-Baptiste-Michel Le Bouteux, one of Law's associates (plate 27). "At the start all was well," reported one of the colonists.

It did not remain so for long, however. In December 1720, what became known as Law's "Mississippi Bubble," inflated to improbable proportions, suddenly burst, leaving a scattering of worthless paper stock and impoverished investors throughout Europe. By then, many of the colonists had in fact died and the rest sat at the water's edge waiting for relief ships that it seemed would never come.

The episode was still fresh in the mind of the Abbé Prévost, when he wrote the novel *Manon Lescaut,* published in 1731. In it, he has his tragic heroine flee to the remote and primitive settlement to escape from the consequences of her amorous career in Paris. In this New World, whither her lover follows her, the troubled courtesan finds ultimate relief by dying, her character transformed by true love and suffering.

Although Law himself was ruined, one of his early schemes survived unscathed. He had planned the Crescent City of New Orleans and this nascent community took root. Although in 1720 it consisted of only a small cluster of houses (plate 28), it proved to be a firm foothold and was soon made the capital of Louisiana Colony. Carefully designed for future growth by skilled military engineers, it gradually took on the appearance of an orderly, progressive trading center.

The French thrust into the interior of North America had been brilliant strategy in its attempt to duel with European competitors for control of the continent. As one element in this master plan, a stockaded fort and trading post called Ville d'Etroit ("city of the strait") had been founded in 1701, near the western tip of Lake Erie (plate 29). The British captured this vital outpost in 1760, renaming it Fort Detroit. For more than thirty years they retained the site against fierce Indian onslaughts, until, in 1796, they were forced to relinquish its ownership, and it passed instead into the hands of the United States. From such rude and often bloody beginnings, the frontier bastion would develop into one of the nation's major industrial cities.

In the second half of the eighteenth century, while the trans-Appalachian region remained for a time a "dark and bloody" obstacle to the westward migration of British colonists, a new frontier was being established

26. Henrietta Johnston. Frances Moore. c. 1720. Pastel, 11½ × 8½". Collection Mr. and Mrs. David A. Schwartz, Blairstown, N.J.

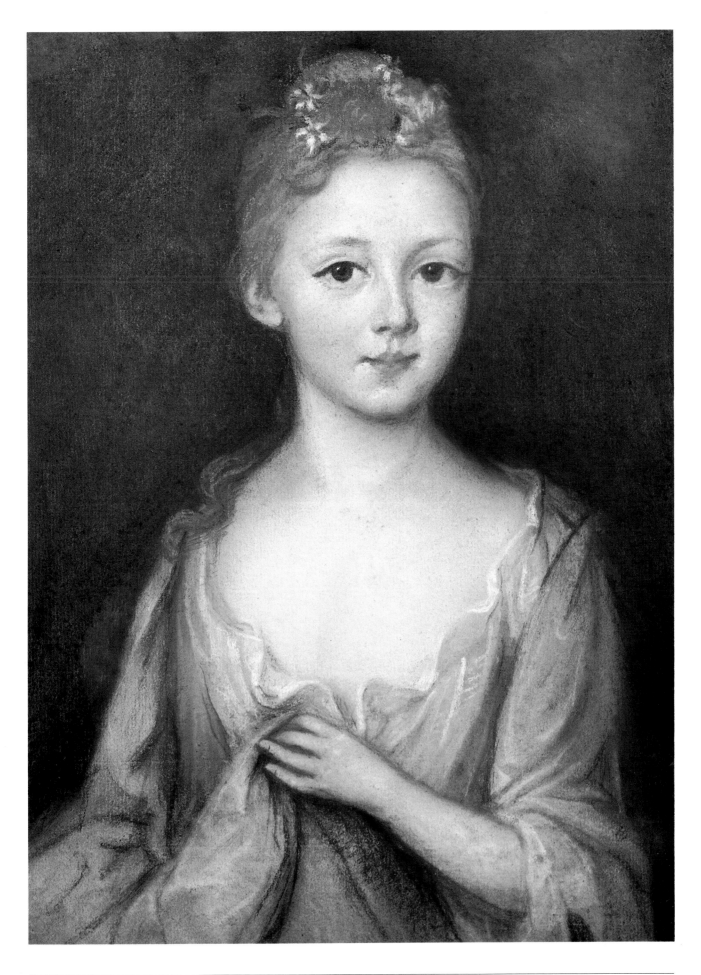

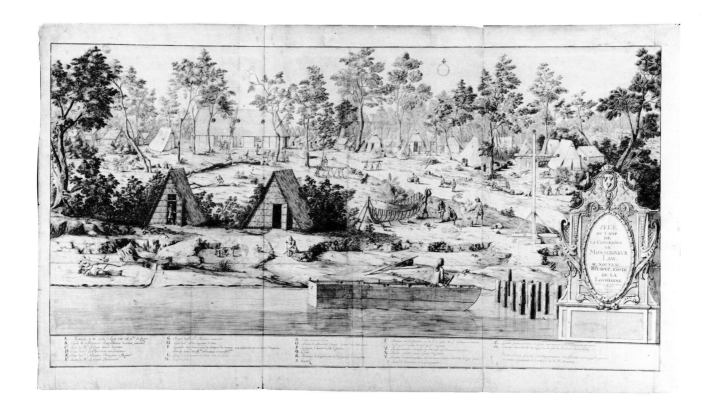

more than two thousand miles distant along the shores of the Pacific. Although the Spaniards had visited the fringes of the fabled land of California long before and had laid extensive claims to it, settlements comparable to those in the East did not finally take root until almost one hundred years later. Now, in the later years of the eighteenth century, these claims were being threatened by the intrusive maritime explorations of other nations. Russian, French, English, Dutch, and American ships were appearing with increasing frequency along the far-western coast. Most of these were on reconnaissance expeditions aimed at sizing up the area for possible colonization, and they included among their crews competent artists who could help their sponsors visualize the prospects. Still others were in search of the elusive Northwest Passage (a navigable waterway linking the Atlantic and Pacific oceans) that for centuries had troubled the dreams of the most hopeful adventurers.

Short of money and of military and naval resources, Spain wielded her most effective instrument of defense, her Sword of the Spirit. By order of the Spanish emperor Charles III, Franciscan priests were sent northward from Mexico to found a chain of red-tiled adobe missions in Alta California. These were to extend from San Diego to Monterey at intervals of a day's march, with four modest presidios, or garrisons, to protect them. At the very least their presence would be a visible reminder of Spain's claim to the land. On June 3, 1770, the royal standard was planted with impressive ceremony on the shores of Monterey Bay. The Franciscan mission of San Carlos was founded there by Father Junípero Serra, a heroic priest who had led the sandaled monks on the long march northward. A year later the mission was moved near to what is now Carmel, California, where it was visited in 1792 by the English explorer George Vancouver. A watercolor of the modest settlement, based on an on-the-spot drawing by a member of Vancouver's crew, shows the mission as it then appeared (plate 30), picturesque and tranquil on the surface, but, in actuality, a virtual camp of enforced labor for the enslaved Indians who worked within its bounds.

On August 5, 1775, Juan de Ayala of the Spanish Royal Navy became the first white man, as far as is known, to sail through the Golden Gate.

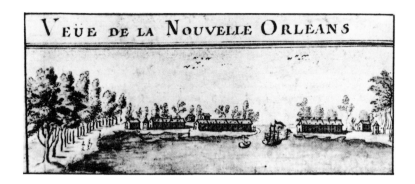

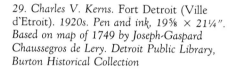

28. *de Beuvilliers.* View of New Orleans. *1720. Cartouche sketch from map "Nouvelle de la Partie de Ouest de la Province de la Louisiane, sur les Observations et Découvertes du Sieur Bernard de la Harpe." Howard-Tilton Memorial Library, Special Collections Division, Tulane University, New Orleans*

29. *Charles V. Kerns.* Fort Detroit (Ville d'Etroit). *1920s. Pen and ink, 19⅝ × 21¼". Based on map of 1749 by Joseph-Gaspard Chaussegros de Lery. Detroit Public Library, Burton Historical Collection*

The presidio and mission of San Francisco were founded in the summer of the following year, a month after rebellious British colonists in the East had issued the Declaration of Independence.

Farther north along the northwest coast, international rivalry continued to mount. In 1778 Captain James Cook sailed into Nootka Sound, off the coast of Vancouver Island, and claimed the land for England. Soon this area was at the center of a growing dispute over territorial claims and trading rights. That natural harbor provided ideal anchorage for the cruisers and trading vessels plying those far western waters under different flags. In the summer of 1789 two Spanish warships sailed into the harbor, seized the vessels of a British trader, and took them to Mexico. War between the two nations threatened, and was averted only after lengthy diplomatic exchanges between London and Madrid. For the moment Spain was in a poor condition to challenge the naval might of Britain and her allies. Realizing this, she backed down, but Spanish ships continued to visit the area. In 1790 a convention signed at Madrid peacefully resolved the controversy, with England securing a lasting foothold on the northwest coast. The magnitude of this diplomatic triumph was considerable. For the first time since 1494, Spain conceded that other nations had rights in the Pacific zone.

The following year Captain Vancouver, who had earlier sailed with Captain Cook, was dispatched from England to take over the Nootka territory. At one point, as he worked his way up the coast north of San Francisco, he hailed a strange vessel heading south. It was the American ship *Columbia,* out of Boston, Captain Robert Gray at the helm. Gray was on his second trading voyage to those parts, returning from an adventurous

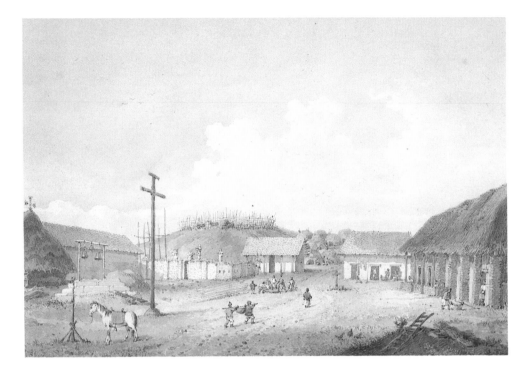

visit to Juan de Fuca Strait, between the present-day state of Washington and Vancouver Island (plate 31). He was assured that nothing of importance would be observed farther south along the coast. Disregarding that bit of intelligence, Gray continued on his way. A few days later, on May 11, 1792, he discovered the Columbia River (as he named it), which Vancouver had missed in passing.

Even though it was not the fabled Northwest Passage, Gray had indeed discovered one of the great rivers of the West. More important, by planting the flag of empire on this site, he had opened a worldwide dominion for American trade.

The Colonial Scene

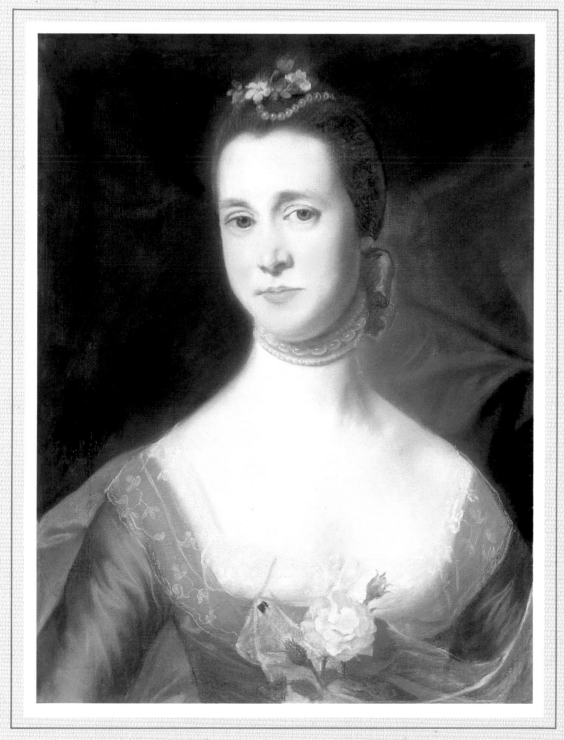

32. John Singleton Copley. Mrs. Edward Green. 1765. Pastel, 23 × 17½". The Metropolitan Museum of Art, New York. Curtis Fund

Life in Peace and in War

IN TIME all those different and widely scattered footholds, secured in the American wilderness by several nations over the centuries, were incorporated into the United States. First among them, of course, were those situated in the thirteen original British colonies: New Hampshire, Massachusetts, Rhode Island, Connecticut, New York, New Jersey, Pennsylvania, Delaware, Maryland, Virginia, North and South Carolina (formally separated in 1712), and Georgia. Strung out along the eastern seaboard, these became the base for the enterprises that subsequently brought the rest of the continental span into the national domain.

By the second quarter of the eighteenth century, the colonists had already occupied most of the Atlantic coastal area, from the "Arctic braced" forests of northern New England to the wide deltas of South Carolina. In 1733 Georgia became the thirteenth and southernmost colony. This settlement, it was hoped, would serve as a buffer against Spanish intrusions as well as a link with friendly Indians; it performed both of these functions well.

As Benjamin Franklin conservatively predicted it would, the population of colonial America almost doubled every twenty years. By 1760 the figure had passed a million and a half, a fourfold increase in less than half a century. From the beginning the settlers were a decidedly mixed breed. As Thomas Paine pointed out at the time of the Revolution, Europe, not England, was America's parent country. No two witnesses reporting the colonial scene saw it in the same way. "Fire and Water are not more heterogeneous than the different colonies in North America," reported one widely traveled observer. However, about mid-century, another sophisticated witness, after a 1,624-mile journey up and down the coast, concluded that in spite of the colorful variety of life in America, "as to politeness and humanity [the colonists] are much alike except in the great towns where the inhabitants are more civilized, especially in Boston." He thought the ladies of that city were "free and affable as well as pretty." They appeared conspicuously in public, he reported, dressed elegantly, and, he added, "I saw not one prude while I was there."

The living likenesses of such well-favored ladies, and of their spouses and progeny, were the subjects of some superb drawings by the Boston-born artist John Singleton Copley (plate 32). Perhaps the most accomplished of colonial artists, Copley's largely self-developed talents were phenomenal. In his work, native art came to a fair flower even in, to borrow the artist's own words, "so remote a corner of the Globe as New England." His self-portrait (plate 33) is typical of the brilliantly realistic likenesses that came from his brush and that recall John Adams's observation: "You can scarcely help discussing with them, asking questions and receiving answers." They were indeed drawn to the life and were better pictures than any Copley had seen as he learned his art.

In 1774, as war clouds gathered over the colonies, Copley quit his native land and, after traveling in Italy, went to London to improve his already considerable skills and to establish a reputation in a wider world. He complained that, for all his successes at home, his countrymen generally regarded art as "no more than any other useful trade . . . like that of a Carpenter, tailor or shew maker." In this he was quite right. In the minds of most colonial Americans, art was a useful social accomplishment; it had a shared purpose. Every responsible and competent workman was considered an artist, be he a navigator, a surveyor, a silversmith or be she an industrious and adept housekeeper or cook. In such a society, the artist was

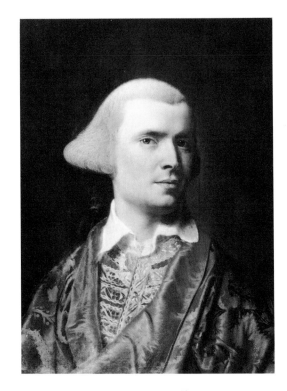

33. John Singleton Copley. Self-Portrait. c. 1770–71. Pastel, 23⅛ × 17½". The Henry Francis du Pont Winterthur Museum, Winterthur, Del.

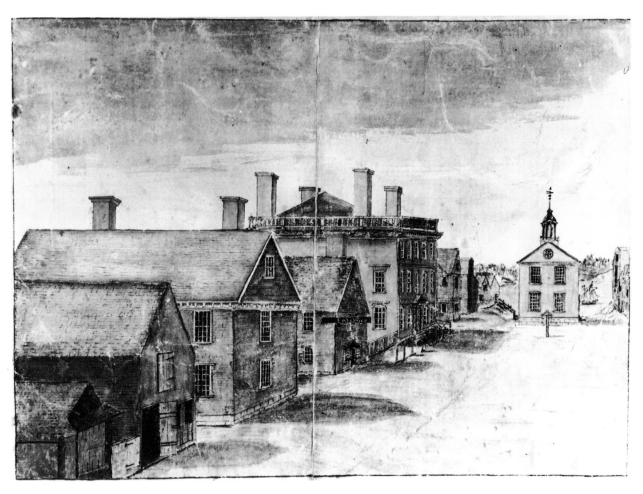

34. *Dr. Joseph Orne. School Street, Salem. c. 1765–70. Watercolor, 13¼ × 16⅞". Essex Institute, Salem, Mass.*

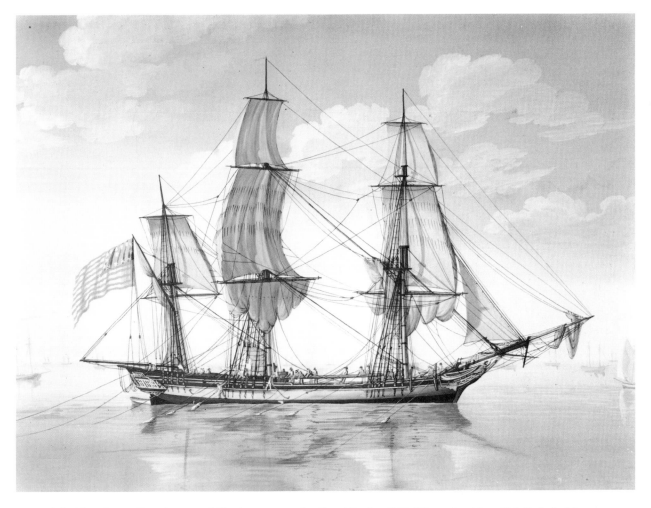

35. *Michele-Felice Corné. Ship America of Charleston upon the Grand Banks. 1789. Watercolor, 13 × 18". Peabody Museum of Salem, Mass.*

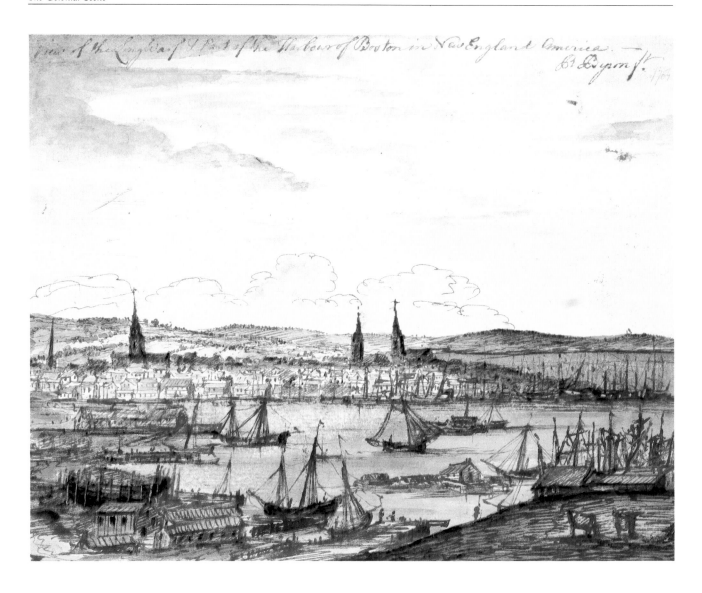

not considered a special sort of person (as we tend to think), so much as every person was a special sort of artist.

It was in this general spirit that a contemporary of Copley's advertised in the Philadelphia press, urging his readers to study drawing since "its utility being so extensive . . . there are few arts or professions in which it is not serviceable. . . . Engineers, architects, and a multitude of professions, have frequent occasions to practice it." Drawing was, he added, "a kind of universal language, or living history understood by all mankind."

With or without such encouragement, with or without other professional needs to serve, colonists of every stripe occasionally turned to their pens, pencils, and watercolors to record some aspect of living history which they observed or in which they participated. A lieutenant by the name of Richard Byron, for example, rendered a unique watercolor prospect of Boston as it appeared in 1764 (plate 36). As in all other early views, the city faces a harbor crowded with sailing vessels of all descriptions. At mid-century a convivial New York merchant described Boston much as we see it here. The city, he wrote, was the "Largest Town upon the Continent, Having about Three Thousand Houses in it, about two Thirds of them

36. Lieutenant Richard Byron. View of the Long Wharf and Part of the Harbor of Boston. 1764. Watercolor, 7¼ × 12″. The Bostonian Society, Boston

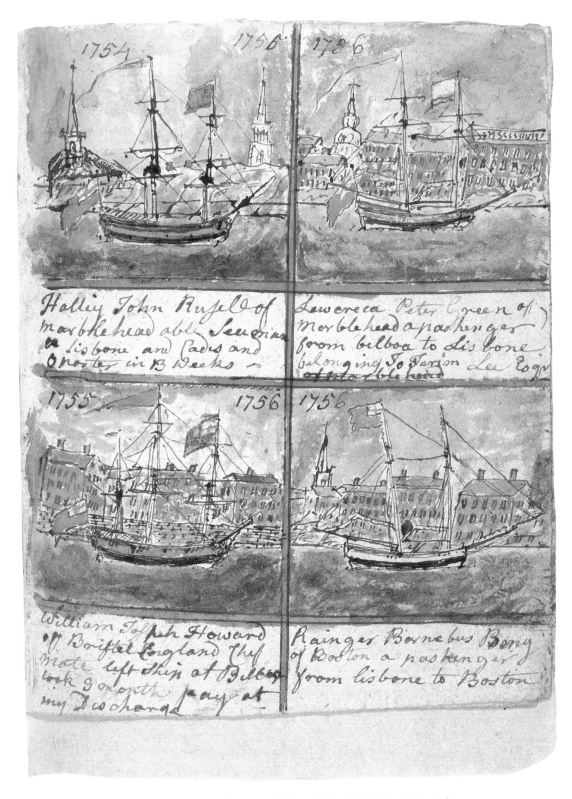

37. *Captain Ashley Bowen. Page from Diary. (Upper left) 1754–55 the* Halley, *John Russell of Marblehead; (lower left) 1755–56 the* William, *Joseph Howard of Bristol, England; (upper right) 1756 the* Lucretia, *Peter Green of Marblehead; (lower right) 1756 the* Ranger, *Barnabus Binney of Boston. Watercolor, 7½ × 6″. Marblehead Historical Society, Marblehead, Mass.*

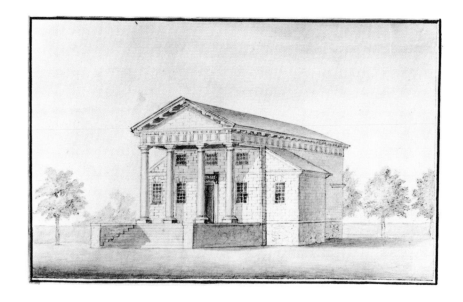

Wooden Framed Clap Boarded & some of the Very Spacious Buildings which together with their Gardens about them Cover a Great deal of Ground. . . ."

Actually, for various reasons, including epidemics and high taxes, Boston's population declined slightly in the decades preceding the Revolution. But such outlying smaller seaports as Salem, Marblehead, Newburyport, and others grew in size and importance.

Nothing remains of the Salem shown in Joseph Orne's drawing, which probably dates from 1765 to 1770 (plate 34). At that time the little port was rising in importance as a shipping center and would soon rival Boston in the lucrative trade with the Orient. The large square house in the middle of the drawing was at one point the home of Elias Hasket Derby, the merchant prince who left an estate of a million and a half dollars when he died in 1799. How closely Salem clung to saltwater can be judged by the sailing vessel shown to the right of the schoolhouse at the end of the street. (The whipping post in front of the school provides a quaint reminder of colonial mores.)

The shipowners of Salem were duly proud of their vessels and they commissioned the best artists of the day to paint pictures of them. About the end of the eighteenth century, the Neapolitan artist Michele-Felice Corné came to Salem in one of "King" Derby's ships and spent the rest of his long life drawing, among other things, likenesses of the ships that came to and went from New England seaports (plate 35).

Marblehead, another of the smaller ports, once had the reputation of being "the greatest Towne for fishing in New England." It was that and something more. One of its more colorful seafarers, Captain Ashley Bowen, uninhibited by his obvious lack of artistic talent, left behind him a unique, carefully documented graphic record of some of the many ships he saw during his adventures on deep water (plate 37). From the time he shipped as a cabin boy in 1739 until he retired as a captain in 1763, Bowen sailed the Mediterranean and the Caribbean seas, hunted whales where they were to be found, and fished off the Grand Banks; he fought on a privateer and was thrice captured by the French; and in his proudest moment, he served under Captain James Cook in the siege of Quebec (1758–59) during the French and Indian War. (This was the same Captain Cook who won fame as an explorer in the Pacific.)

Some years earlier Peter Harrison, a young English sea captain who had settled in Newport, Rhode Island (then a major colonial maritime cen-

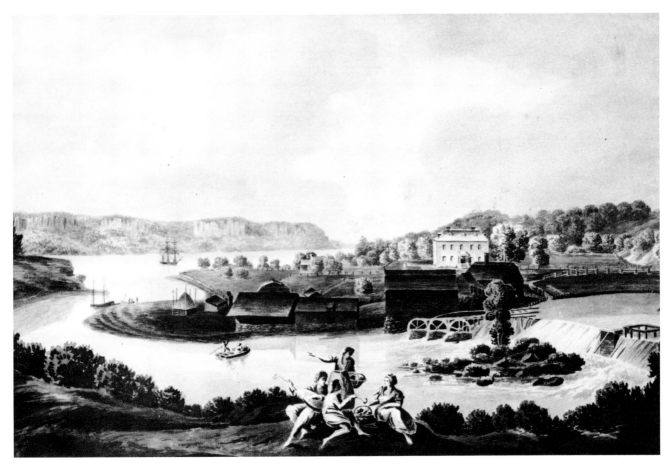

39. D. R. Philipse Manor. 1784. *Sepia wash, 19¼ × 26¼″. Sleepy Hollow Restorations, Tarrytown, N.Y.*

ter), had been captured by a French privateer and imprisoned at Louisburg—the "Canadian Gibraltar"—on Cape Breton Island. Upon his release he drew an accurate plan of that fortified post that so impressed William Shirley, the governor of Massachusetts, that he was commissioned by Shirley to design an elegant new mansion in Roxbury. From then on, Harrison undertook one commission after another, becoming involved in everything from the planning of forts and lighthouses to the building of public markets and private dwellings. The Redwood Library, which he designed in 1747 and which still stands in Newport (plate 38), was one of the most advanced examples of architecture in America at the time, and, as a result of this and other designs, Harrison has been called the most "masterly architect in the colonies." He was a Tory and upon his death, tragically, misguided patriots burned his personal library, including his collection of drawings.

Throughout the eighteenth century and beyond, the monopolization of large tracts of land by a relatively few families had an important effect on the development of the New York Colony. These great holdings were a legacy of the patroon system of the early Dutch government and of the extravagant handouts of England's royal governors. The Schuylers, Livingstons, Van Rensselaers, Philipses, and others held tenaciously to these huge estates. Such landlordism, together with the presence of the Iroquois in the Mohawk Valley and the mountain barriers of the Catskills and the Adirondacks, discouraged the abundant immigration that was feeding the hinterland of other colonies.

For one, Philipse Manor at Yonkers (plate 39) comprised a huge triangular area: its base ran along the Harlem River from the Hudson to the Bronx rivers, and its apex was formed at the junction of the Croton and

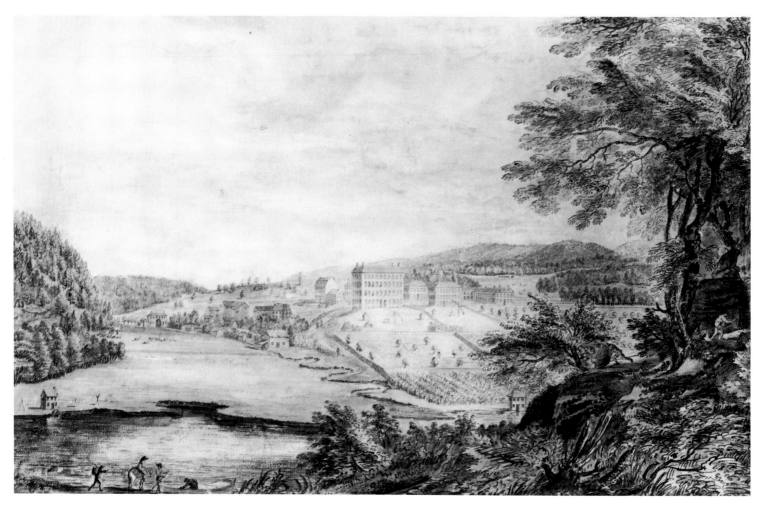

40. Artist unknown. Bethlehem, Pennsylvania. 1742. Watercolor, 12¼ × 19⅝". Private collection

Hudson rivers. Over these ninety thousand acres, assembled as early as 1702, successive Philipses ruled like feudal lords. Such an anachronistic survival of ancient privilege had no plausible place in the American democracy that was to develop as the years passed. In the nineteenth century the traditional manorial system was completely disavowed by popular will. As a remembrance of earlier times, the old stone Philipse manor house has been carefully restored and the frame gristmill adjoining the house faithfully reconstructed.

In Pennsylvania, unlike New York, the backcountry was wide open to settlement and rapidly filled up with industrious and independent farmers and "mechanicks," who flourished in their new surroundings. Prominent among them were the Moravians, sectarian refugees from the Rhineland, who in 1741 founded the town of Bethlehem (plate 40). Practicing a sort of agrarian communism, these earnest folk enriched the land they occupied and maintained a vigorous religious and cultural life in which, as in other Pennsylvania German communities, music played an important role (plate 41). Bethlehem soon became one of the showplaces of America, visited by a host of interested travelers. "I was at their Church," wrote Benjamin Franklin of his visit there in 1756, "where I was entertain'd with good Musick, the Organ being accompanied with Violins, Hautboys [oboes], Flutes, Clarinets,

41. *Lewis Miller. The Musical Life of York. c. 1830. Watercolor, 9¾ × 7⅝". York County Historical Society, York, Pa.*

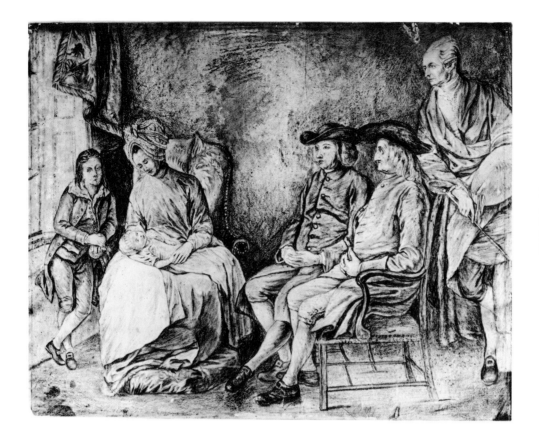

42. Benjamin West. The Artist's Family. c. 1758. Charcoal, 20⅛ × 26⅜". The Art Museum, Princeton University, Princeton, N.J.

etc." In 1785, while they were still relatively new compositions, Franz Josef Haydn's "Russian" Quartets were performed at Bethlehem and, some years thereafter, his *Creation*.

By the middle of the eighteenth century, Philadelphia had become one of the more brilliant ornaments in the British colonial empire. Except for its distance from the capitals of the Old World, there was little that was provincial about the city. Although the enormous, worldwide reputation of Benjamin Franklin tended to overshadow the attainments of his fellow citizens, Philadelphia abounded in men of brilliant minds, some of them as highly regarded in Europe as they were in America. No colonial city enjoyed a more consistently active social and cultural life. Shortly before the Revolution, two young Philadelphia poets, attending college in Princeton, New Jersey, hailed their home city as the "mistress of our world, the seat of the arts, of science, and of fame." Here Benjamin West had taught himself the art of drawing and painting before he left for London. By the time he was twenty-four, West had reached the top of his profession. Not long thereafter, he became president of the Royal Academy and possibly the most widely known American painter in history. His talents were far from fully developed when he went abroad, never to return to his native land, but his youthful sketches promised great things (plate 42). Among other subjects, he sketched his friend Francis Hopkinson (plate 43), Philadelphia's first dilettante—a composer, balladeer, essayist, poet, satirist, painter, and among still other accomplishments, a signer of the Declaration of Independence.

The region south of Pennsylvania boasted few towns of any consequence. In this area, a plantation economy had developed based principally on the production of cash crops. Manors, or plantations operated by slave labor, were the principal community centers. Taylor's Mount (plate 44),

43. *Benjamin West. Francis Hopkinson
Conversing with a Lady. c. 1758. Pencil, 6¼
× 3⅞". Historical Society of Pennsylvania,
Philadelphia*

44. *Edward Day. The Northeast Prospect of
Mr. Edward Day's Dwelling Houses and
Buildings at Taylor's Mount. 1779. Pen and
brown ink and wash, 12 × 19". Maryland
Historical Society, Baltimore*

situated at the head of Gunpowder River in Baltimore County, Maryland,
was a typical home of a moderately well-to-do planter, with "every necessity
and convenient building for the reception and accommodation of a genteel
family." Characteristically, it resembled a small, largely self-subsisting vil-
lage, with the dwelling house in the center of a cluster of detached buildings
that included kitchens, smokehouses, servants' and slave quarters, stables,
and the like.

Founded in 1649 by Puritan exiles from Virginia, Annapolis long re-
mained the only town of any size in Maryland. Here, as in virtually every
leading colonial town, convivial societies of fashionable men were formed
("knots of men rightly sorted," as one contemporary explained) whose mem-
bers gathered periodically for divers serious or frivolous reasons. Their agenda

included political and literary discussions, musical diversions, the pleasures of wining and dining, and various kinds of high jinks that at times reached a riotous climax (plate 45).

As the century advanced, Baltimore overshadowed Annapolis in size and commercial importance if not in social distinction. Although the town was not founded until 1729, its location beside a spacious harbor with an adequate supply of waterpower made it a natural market for the Susquehanna watershed. From this strategic site, it could tap the rich agricultural production of the backcountry Pennsylvania farms, mill the harvests of grain, and export the flour for sale in the West Indies and elsewhere. At midcentury Baltimore consisted of only twenty-five houses and about two hundred people. But only a few years later, according to the colonial governor, it had "the Appearance of the most Increasing Town in the Province" (plate 46).

Rice and indigo cultivated in the raw, primeval swamps and the hot lowlands of South Carolina were the staple crops to which the colony owed a substantial measure of its prosperity (plate 47). Black slaves were imported to prepare and cultivate these malarial fields where white freemen would not work and, as the eighteenth century progressed, South Carolina became one of the largest slave-holding colonies in North America.

Seasonally, to avoid the intolerable heat of summer, the landed aristocracy retreated from their plantation homes to their town houses in Charleston, there to join a round of urban diversions. The unstinting hospitality and the sophisticated sociability that prevailed in the city during this season seemed to visitors of more moderate habits a matter of caution. In 1749 Governor James Glen warned that in such an extravagant manner of living the South Carolinians were going the way of the ancient Romans.

The accompanying sketch drawn about ten years later pictures a con-

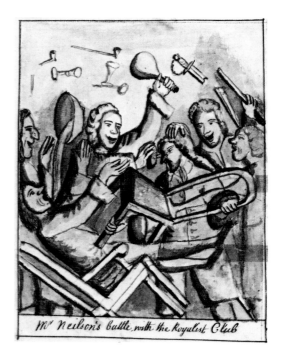

45. *Dr. Alexander Hamilton. Mr. Neilson's Battle with the Royalist Club. c. 1745. Wash, 7⅞ × 5⅝". Maryland Historical Society, Baltimore*

46. *John Moale, Jr. View of Baltimore. 1752. Watercolor and pen and ink, 9½ × 19½". Maryland Historical Society, Baltimore. Gift of Samuel Moale*

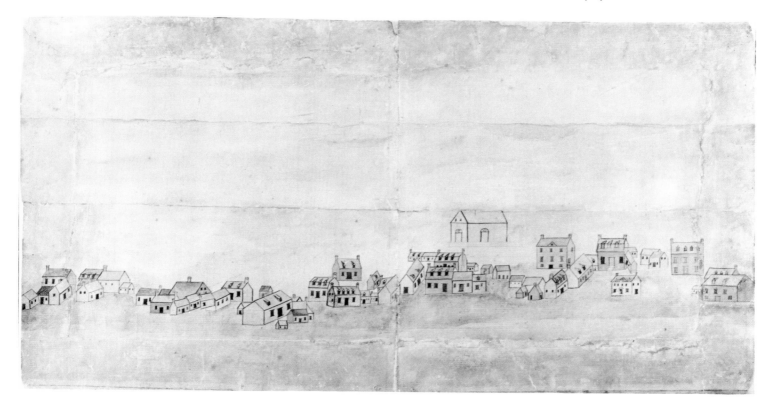

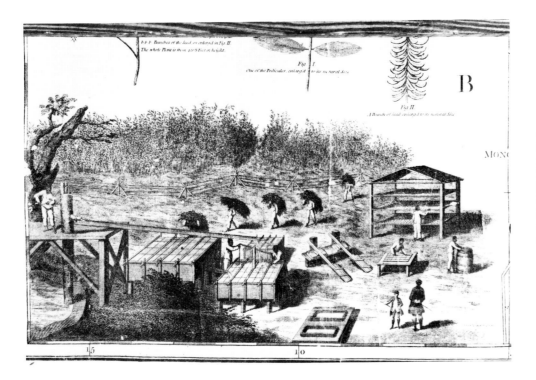

47. *John Lodge.* Indigo
Culture in South Carolina.
*1773. Pencil, 6 × 11½".
Inset from map showing
Parish of St. Stephan, Craven
County; based on survey map
by Henry Mouzon, Jr. The
Charleston Library Society,
Charleston, S.C.*

vivial stag party at the home of Peter Manigault, a graduate of London's
Inner Temple and one of the most accomplished and best equipped of
Charleston hosts (plate 48). It is shocking to recall how close such a sparkling
milieu was to other, raw realities of the colonial scene. Of the guests at
Manigault's table, three were subsequently killed by Indians in nearby fron-

48. *George Roupell. Mr.
Peter Manigault and His
Friends. c. 1760. Black
ink and wash, 10⅛ ×
12⅛". The Henry Francis
du Pont Winterthur
Museum, Winterthur,
Del.*

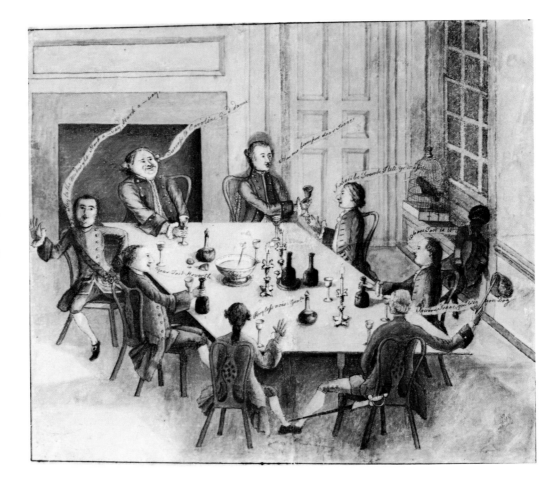

tier wars, a fate hardly to be envisioned on the occasion of their carefree bibulous gathering.

Although the British colonies were thriving, the threat of French competition for empire in the New World increasingly menaced the whole length of colonial America. England was determined to rid itself of this threat; France, with the aid of eager Indian allies, was equally determined to keep the British colonists within their narrow coastal limits. Several skirmishes ensued, with such borderland conflicts reaching a decisive phase during the French and Indian War, roughly between the years 1753 and 1763.

Even though the British forces heavily outnumbered the French, the former faced repeated defeats during the early stages of the war. George II, realizing that action had to be taken in order to stave off continuing losses, appointed William Pitt as head of the British forces in 1757. With this appointment, the tide began to turn. The British launched attacks by land as well as by sea. In midsummer 1759 Major General Jeffrey Amherst, who had already met with success at Fort Ticonderoga, forced the French to quit and blow up their fort at Crown Point on the west shore of Lake Champlain in northern New York. There, before proceeding north toward Canada, he built a new fortress near the occupation camp he had established for his victorious troops. (Both Fort Ticonderoga and the fort at Crown Point were to play important roles in the American Revolution.) A few months after Amherst's triumph, Brigadier General James Wolfe sailed up the St. Lawrence River in order to lay siege to Quebec—the very heart of the French-American empire. In a battle on the Plains of Abraham, the French were defeated. Quebec soon capitulated, and in 1760 Montreal also fell.

After these defeats, French claims to North America were vastly reduced. With the mopping up that followed, the British colonies for the first time in generations felt free of an awful menace and could look with greater confidence to a future of their own with lessened need of protection by the mother country. One eminent English historian wrote that the success of Wolfe's campaign determined the destiny of mankind for ages to come. With that triumph, he concluded, "began the history of the United States"; the colonies were spurred on their way to independence.

For decades preceding the Revolution, the separate colonies were in some ways closer to the mother country than they were to one another. A growing number of colonists were going "home" to Britain. (Nathaniel Hawthorne chose the title *Our Old Home* for his satiric commentary on England.) Like Manigault, they went to read law at the Inns of Court, to study medicine and art, to take orders in the Anglican Church, or simply to savor the amenities of life as they were observed overseas. "It is the fashion to Send home all their Children for education," noted one observer of the South Carolinians, "and if it was not owing to the nature of their Estates in this Province, which they keep all in their own hands, and require the immediate overlooking of the Proprietor, I am of the opinion the most opulent planters would prefer a home life [in Britain]." In outlook, those who enjoyed the benefits of education overseas were closer to their English cousins who attended Oxford or Cambridge than they were to the Americans who attended the provincial colleges of the New World. The southern plantation owners felt a closer kinship with England's landed gentry than they did with the New England merchants who drove hard bargains at their tidewater wharves in Maryland, Virginia, and the Carolinas.

There was enough room in North America to prevent any serious

friction between the differing groups of colonists, enough profitable work to be done so that few would honestly feel dispossessed, and enough adaptability in those who made a go of colonial life to enable people to get along together. In the long run, the very rivalries and competition between one colony and another were the result of frequent intercourse, the jealousies aroused were born of interrelated concerns that eventually led to recognition of a common destiny—what was to be a free and independent destiny.

As Edmund Burke pointed out to Parliament, America's ultimate separation from England was, after all, deep in the nature of things; and what the "Laws of Nature and of Nature's God" would put asunder, neither men of patience and goodwill nor all the king's horses and all the king's men would be able to put back together again—though they tried in their different ways. It took a long and wasteful war, that nobody wanted, to prove that America was, and of right ought to be, free and independent.

With the Boston Tea Party (which occurred on December 16, 1773), the people of that provincial Massachusetts town threw down the gauntlet to the mighty British empire (plate 49). In spite of the stirring events and mounting feelings that would lead so inexorably to bloodshed at Lexington and Concord, there was surprisingly little violence during immediately pre-Revolutionary days. Contrasted with the French and Russian revolutions, and with the rise of Nazism, the restraint and reasonableness on both sides of the growing controversy were extraordinary. Even the Tea Party was conducted with "great order and decency," and not without a sense of high comedy as the actors played their roles very thinly disguised as Mohawk braves, with war whoops and tommyhawks to lend color to their resolute performance. Plans for dumping the tea had been worked out at the Green Dragon Tavern (plate 50) and in other local taverns. "Not the least insult was offer'd to any person," save to one man who tried to sneak some tea to shore.

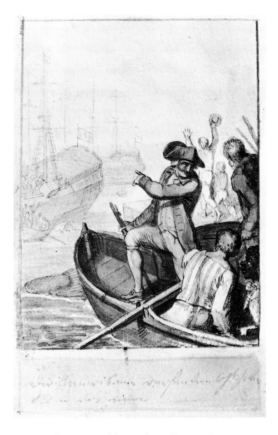

49. *Johann Heinrich Ramberg.* Boston Tea Party. *Wash. From* Allegemeines Historisches Taschenbuch, 1784. *The Metropolitan Museum of Art, New York. Bequest of Charles Allen Munn, 1924*

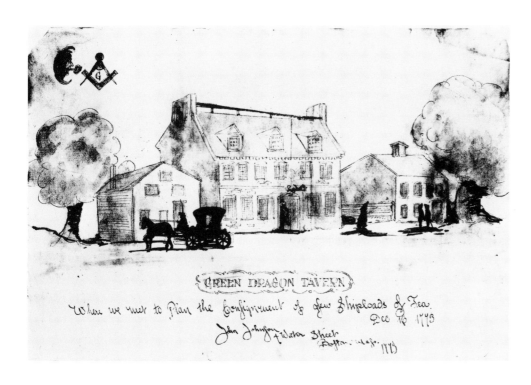

50. *John Johnson.* Green Dragon Tavern. *1773. Wash, 8½ × 12½". American Antiquarian Society, Worcester, Mass.*

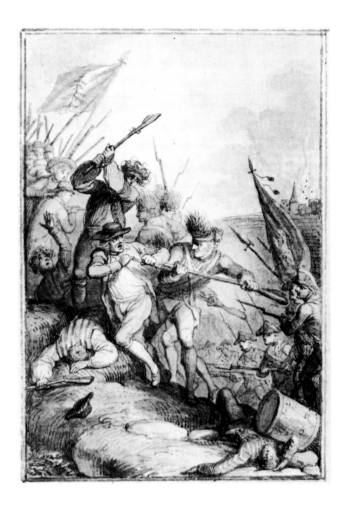

51. Johann Heinrich Ramberg. Battle of Bunker Hill. *Wash. From* Allegemeines Historisches Taschenbuch, *1784. The Metropolitan Museum of Art, New York. Bequest of Charles Allen Munn, 1924*

England responded to the Tea Party by imposing a series of harsh political, judicial, and economic sanctions that became known in America as the "Intolerable Acts." By aiming these sanctions specifically at Massachusetts, and by excluding the other twelve colonies from "punishment," Parliament hoped and expected that they would remain docile. The reverse was true. As a direct result of the severity of these actions, the colonies felt impelled to stand together, and in September of 1774 the First Continental Congress met in Philadelphia. (Only Georgia did not send delegates.) From this point on, the colonies acted in concert against England.

If there were any doubts that this growing friction was to mean war, they were settled on June 17, 1775, with the Battle of Bunker Hill, or, more correctly, Breed's Hill. Here, on Charlestown peninsula overlooking Boston, the British lost almost one half of their engaging force—more than one thousand men—before the colonists, their ammunition exhausted (they were reduced to using their guns as clubs and to hurling rocks), were forced to quit their redoubt (plate 51). No army in British history had ever known such slaughter. General Sir William Howe, commander of the British troops, wept for the pity of it. A report was sent to England that the "rebels are not the despicable rabble too many have supposed them to be" (plate 52).

In spite of the rout at Bunker Hill, the "rebels," under George Washington's command, kept the British forces bottled up in Boston. The British proclaimed martial law and imposed a curfew on the inhabitants. Food was scarce in the city, and Abigail Adams wrote her husband, John, that not even a single pin could be had "for love or money." On January 14, 1776, the besieged occupation forces made a foray to Dorchester Neck and in a

defiant gesture put houses and barns to the torch (plate 53). But that was a gesture of frustration. As one popular song of the time asked, what had General Thomas Gage—the British commander of the occupying force—now but "a town without dinner, to sit down and dine in."

Howe, who superseded Gage, was in a stranglehold and on St. Patrick's Day, 1776, he quit Boston for good, sailing to Halifax, Nova Scotia, to await reinforcements. The Continental army broke camp to face the enemy again at New York, but, unfortunately, it had left most of its good luck behind. The fortification of New York had begun before Washington's arrival. A nine-gun battery was set up at Horn's Hook, near what is now the mayor's mansion on the East River. On July 2, shortly after Washington's arrival with his little army, Howe landed in New York Harbor. (Coincidentally, the Continental Congress voted for independence on the very same day and, two days later, the Declaration of Independence was signed.) Within a month the largest expeditionary force ever assembled by Great Britain had cast anchor at New York (plate 54). Aboard those vessels were more than thirty thousand trained professional soldiers. Howe quickly demonstrated the ineffectiveness of American shore batteries by blithely sending two of his ships thirty miles up the Hudson. They passed Fort Washington without trouble and returned safely, although American fire ships attempted to destroy them. On November 16 the British won the battle for Manhattan by taking Fort Washington and, after scaling the Palisades, taking Fort Lee, which overlooked the Hudson opposite Yonkers. In the wake of Washington's withdrawal, a large part of Manhattan was destroyed by fire. Along

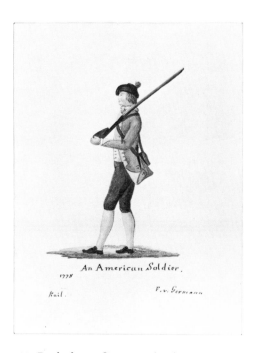

52. Friedrich von Germann. An American Soldier. 1778. Watercolor, 5⅛ × 4⅜". From Max von Eelking's Memoirs and Letters and Journals of Major General Riedesel, During His Residence in America, *1868. New York Public Library, Print Collection*

53. Archibald Robertson. Burning of the Houses on Dorchester Neck. 1776. Wash, 11½ × 18⅞". New York Public Library, Spencer Collection

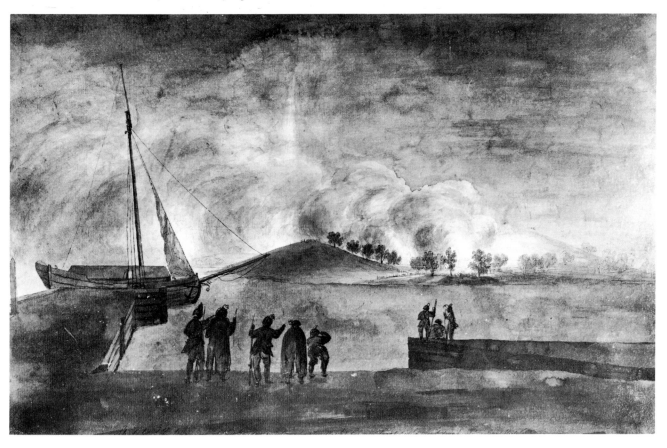

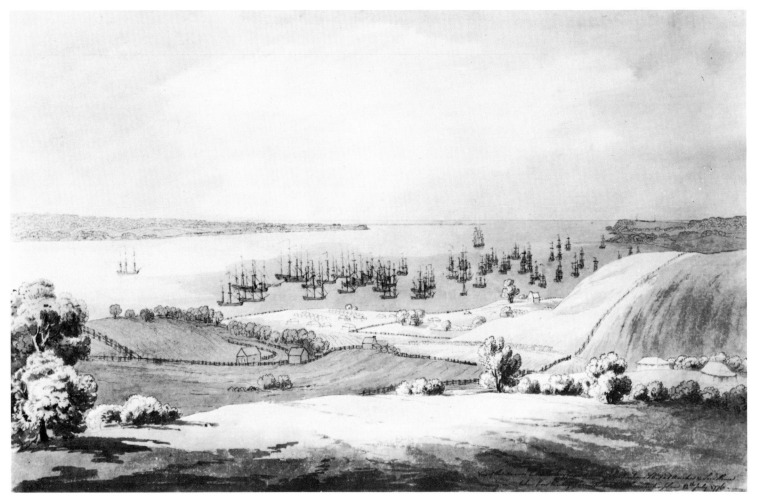

54. *Archibald Robertson. British Fleet and Camp on Staten Island. 1776. Wash, 11½ × 18⅞". New York Public Library, Spencer Collection*

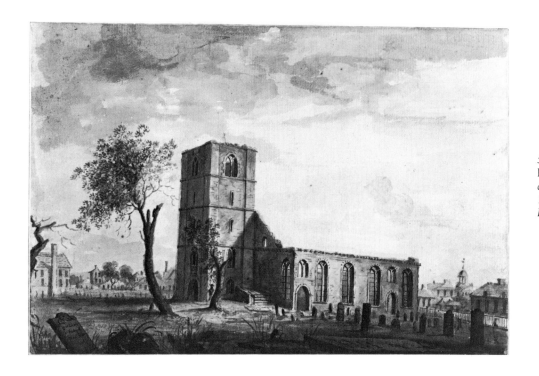

55. *Lord Rawdon (attr.). The Ruins of Trinity Church. c. 1780. Watercolor, 6⅞ × 10½". New York Public Library, Emmet Collection*

with almost five hundred other structures, Trinity Church was reduced to ashes (plate 55).

Washington was forced to retreat southward through New Jersey to a dubious haven behind the Delaware across from Trenton. From there he wrote Congress on December 20, 1776, that in ten more days his dwindling army might cease to exist. However, the man was indomitable. Five days later, on Christmas night, with timing and daring that won the praise of the British general Charles Cornwallis and of Frederick the Great, the king of Prussia, Washington crossed the Delaware and captured a host of Hessian mercenaries—hirelings of the British. Afterwards a contingent of his volunteers, their terms of service up, hiked home to the waiting chores on their farms.

In mid-December 1777 Washington and his tatterdemalion conscripts went into winter quarters at Valley Forge, facing what was probably their cruelest test of the war. However, when it is dark enough you can see the stars. Just before he established that grim camp, Washington had received word that, on October 17, the British general John Burgoyne had surrendered his entire army of over five thousand crack troops at Saratoga. He had been stalled there in his campaign to march down from Canada and seal off New England from the other colonies by closing the vital Hudson River passageway. It was the news of this American victory, forged under the command of Major General Horatio Gates (plate 56), that brought France—long a rival of England and now confident of a favorable result—into the struggle against Great Britain (plate 57).

56. *John Trumbull*. Major General Horatio Gates. 1790. *Pencil, 4⅝ × 2¾″. The Metropolitan Museum of Art, New York. Gift of Mr. Robert W. de Forest, 1906*

57. *Pierre Ozanne*. French Fleet Leaving the Mediterranean. 1778. *Watercolor, 9¾ × 16½″. Library of Congress, Washington, D.C.*

58. *Pierre-Charles L'Enfant. The American Encampment at West Point. 1778. Watercolor. Library of Congress, Washington, D.C.*

59. *Major John André.
Self-Portrait. 1780. Pen
and brown ink, 4 × 5⅛".
Yale University Art
Gallery, New Haven,
Conn.*

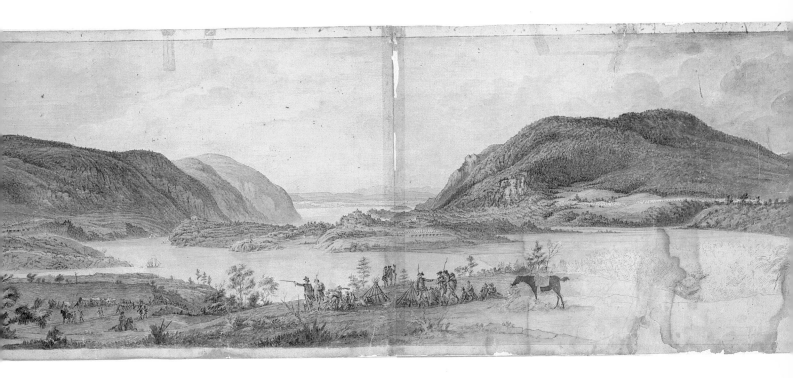

To prevent the British from moving upstream through the Hudson River valley, the Continental army had fortified the site of West Point, a high rocky mass on the west bank of the river (plate 58). In 1780, with the British still occupying Manhattan, Benedict Arnold was at his own request given command of this critical post. Embittered by what he considered a lack of recognition of his heroic exploits at Saratoga and elsewhere, he decided to sell out to the British for a cash reward. However, his plans went askew when a young British spy, Major John André, was captured with incriminating documents on his person. (Arnold escaped to the British.) The day before he was hanged at Washington's headquarters at Tappan, New York, André sketched a self-portrait that suggests the calm dignity with which he faced his last hours on earth (plate 59).

The Revolution was in its seventh year when a fleet of French warships under Admiral de Grasse arrived at the mouth of Chesapeake Bay during the commencement of the siege of Yorktown. It is said that when he heard of its arrival, Washington, long aware that only with such substantial naval support could his cause prevail, "acted like a child whose every wish had been gratified." With masterly timing and strategy, de Grasse bottled up the bay, cutting off Cornwallis's troops onshore from the succor by sea which they had to have in order to maintain combat. Cornwallis had no

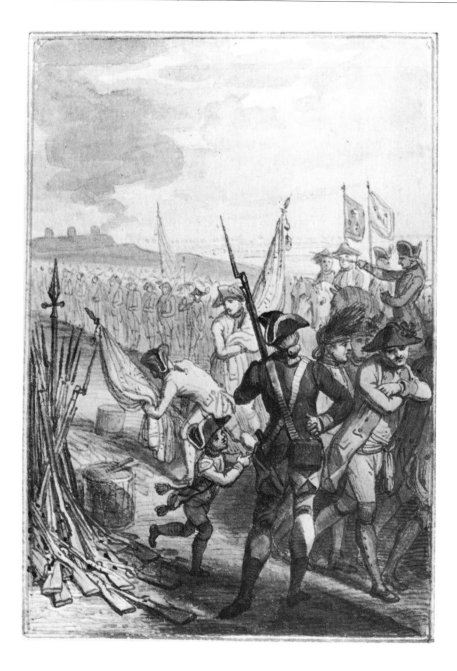

60. Johann Heinrich Ramberg. The Surrender of Cornwallis. Wash. From Allegemeines Historisches Taschenbuch, 1784. The Metropolitan Museum of Art, New York. Bequest of Charles Allen Munn, 1924

choice but to surrender his entire army to the American and French forces that had assembled to confront it (plate 60). On October 19, 1781, as the British laid down their arms, their band very appropriately played "The World Turned Upside Down." The long war was not over, but it was ending.

A New Nation

61. James Sharples. George Washington. c. 1795. Pastel,
9½ × 7½". Colonial Williamsburg, Va.

The Burgeoning Young Republic

SINCE WORLD WAR II many new nations have been conceived and born in various parts of the world. When the federal government of the United States was established in the 1780s, the birth of a nation was an uncommon, even a sensational, event. There were some who doubted that the infant American republic could survive; others hoped and believed that it might become a model for mankind to emulate; and still others, many in fact, were completely unaware of or indifferent to what had taken place in the New World. When John Quincy Adams, son of the second president, arrived in Prussia in 1797 to serve as American minister to Berlin, he was introduced to one "worldly" officer of the guard who unblushingly admitted that he had never heard of the United States of America.

Whatever the outcome might be, at the start it was a new adventure in statecraft. As H. G. Wells, that profound social thinker and novelist, has written, this trial in government was undertaken in a manner, on a scale, and under circumstances that made it seem "like something coming out of an egg." The first bright sign that this unprecedented experiment in self-government might succeed came with the adoption of the Constitution and the inauguration of Washington as president. For the electorate to have chosen any other leader would have been unthinkable. His likeness was known abroad as well as at home through all manner of paintings, prints, and drawings (plate 61).

New York City was chosen as the nation's first capital. It was not then as large as Philadelphia, but, with its magnificent harbor and mounting commercial enterprise, it already promised to become the nation's principal window to the world at large. Washington would have recognized it from the drawing reproduced here (plate 63). In the dead center of the scene stands the Government House, originally intended as the residence of the president but never occupied as such. In anticipation of the city's being chosen as the capital, the ancient City Hall on Wall Street at the foot of Broad, built about 1700, had been skillfully modernized to accommodate the national government (plate 62).

The designer-architect of that impressive transformation was Pierre-

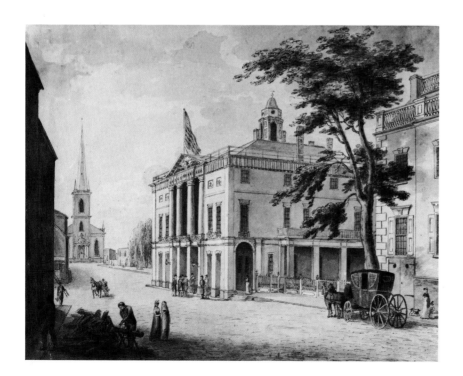

62. *Archibald Robertson.* Federal Hall and Wall Street. *1798. Watercolor, 8⅜ × 11". The New-York Historical Society*

63. *Archibald Robertson (attr.).* View of New York from the Jupiter. *1794. Watercolor, 24 × 30½″. Museum of the City of New York*

64. *John Joseph Holland. View of Broad Street, Wall Street, and Federal Hall. 1797. Watercolor, 11¾ × 17″. New York Public Library, I. N. Phelps Stokes Collection*

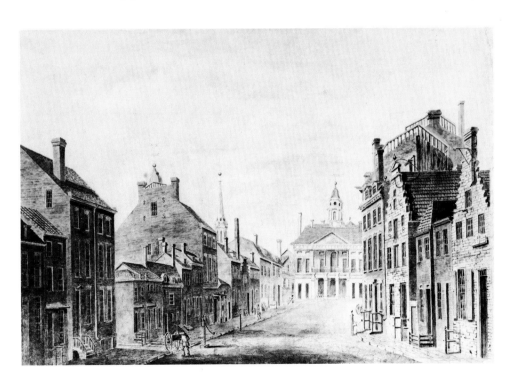

Charles L'Enfant, a French veteran of the American Revolution, who had most generously volunteered his services. (When the grateful citizens of New York offered him ten acres of Manhattan real estate as a gift, he declined, observing that he had no need to stoop to "petty gains.") The modern character of L'Enfant's renovation, called Federal Hall, contrasted sharply with the styles of the earlier Georgian and still older Dutch structures that lined the adjacent streets (plate 64), and with the recently reconstructed Trinity Church on Broadway (see plate 62).

On April 30, 1789, Washington's inauguration was held on the balcony of Federal Hall. People from all over crowded the streets, the windows, and the rooftops to catch a glimpse of the proceedings. Inside, a lofty, marble-lined chamber some seventy by fifty feet in plan (plate 65) had been designated, and was already being used, as the temporary home of the House of Representatives.

In spite of such elaborate preparations, New York remained the capital only briefly. Fourteen months after the inauguration, largely in order to satisfy the southern states, Congress resolved to move the seat of government to a more central location. With Washington's approval, a district was set aside on the east side of the Potomac River where a permanent capital city was to be planned and built. While those prospects materialized, the government would sit for ten years in Philadelphia.

The building of the permanent capital was entrusted to L'Enfant. Following his plans, trees were cleared in the wilderness, and brick kilns, which would process building materials, were constructed. A cornerstone was laid in 1791, but further developments were long in taking solid shape. The first requisites for the Federal City were a Capitol to house Congress and an executive mansion to house the president. In 1800, the date designated for the occupancy of these structures, both were woefully incomplete. Only

65. Pierre-Charles L'Enfant. Chamber of the House of Representatives, Federal Hall. *1789. Drawing. Library of Congress, Washington, D.C.*

one wing of the Capitol was standing (plate 66), but workmen were busily cutting stone for another.

In November, John Adams (plate 67) became the first of many to occupy the President's House. It was still far from furnished, and his wife, Abigail, had to use the "great unfinished drawing room" as a drying-room for the laundry. She referred to the building as "the great castle." Within a few years, however, what would become known as the White House (plate 68) had taken on a familiar appearance in the hands of Benjamin Henry Latrobe—an English architect who had come to this country in 1796 and whose obvious talents were quickly noticed in his adopted country. Abigail observed that her new home was "capable of every improvement, and the more I view it, the more I am delighted with it."

For the rest, the budding little city—"a little village in the woods," "a

left: 66. William Birch. North Wing of the Capitol. *1800. Watercolor, 8½ × 11⅜". Library of Congress, Washington, D.C.*

above: 67. John Singleton Copley. Study for Portrait of John Adams. *n.d. Pencil and chalk, 18¾ × 14¼". The Metropolitan Museum of Art, New York. Harris Brisbane Dick Fund, 1960*

left: 68. Benjamin Henry Latrobe. View of the East Front of the President's House with the Addition of the North and South Porticos. *1807. Watercolor, 15½ × 20". Library of Congress, Washington, D.C.*

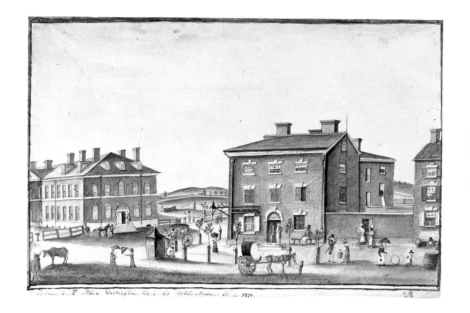

capital without a city," as it was variously termed—long remained a community of unpretentious private homes, boardinghouses, and shops that sharply contrasted with the stately structures rising in their midst (plate 69). Pennsylvania Avenue, Washington's main thoroughfare, presented a stretch of yellow, sticky mud or deep, fine dust depending on the weather and the season. In his sketch of the avenue, drawn early in the nineteenth century, Latrobe carefully omitted the tree stumps and swamp grass that disfigured the scene at the time (plate 70).

The official life of the city was occasionally enlivened by the presence of Indian visitors who came to Washington to pay their respects to the Great White Father and to dicker with the government. In 1804 a delegation of Osages appeared preparatory to ceding the greater part of their western homelands to the United States, lands which today constitute much of Missouri, Arkansas, and Oklahoma. While in Washington, a number of these formidable warriors sat for the French-born artist Charles-Balthazar-Julien-Févret de Saint-Mémin, who drew their profile portraits with the aid of a physiognotrace, a mechanical device that enabled artists to make repeated accurate likenesses of a subject (plate 71).

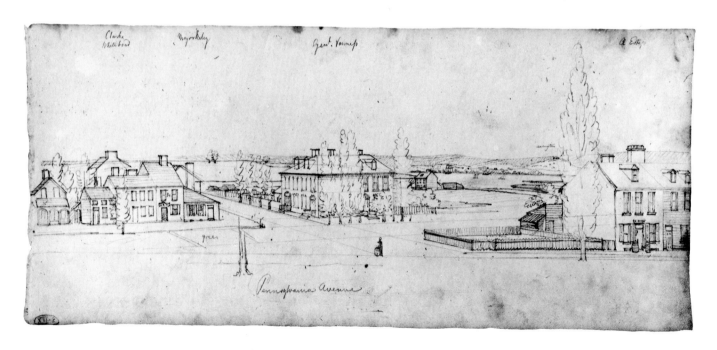

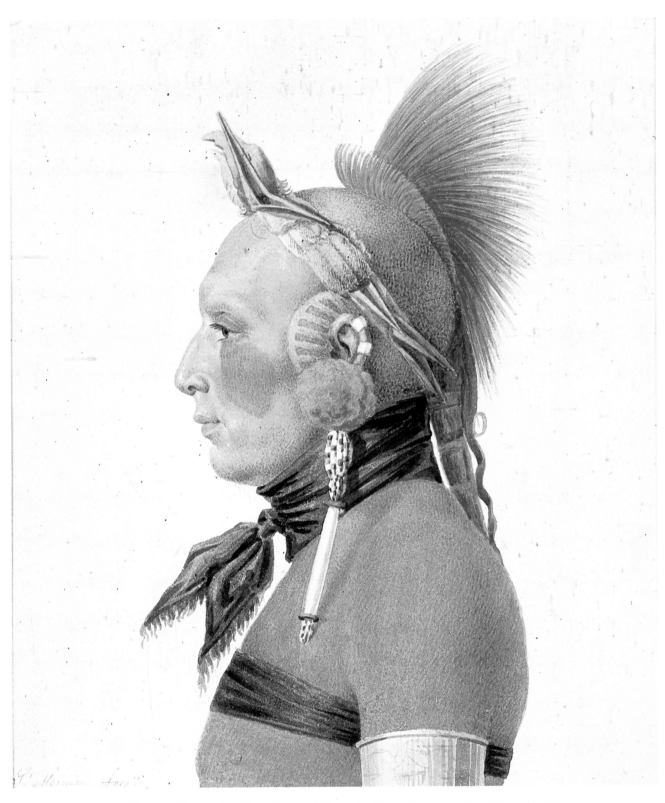

71. *Charles-Balthazar-Julien-Févret de Saint-Mémin. An Osage Warrior. c. 1804. Watercolor, 7½ × 6¾". The Henry Francis du Pont Winterthur Museum, Winterthur, Del.*

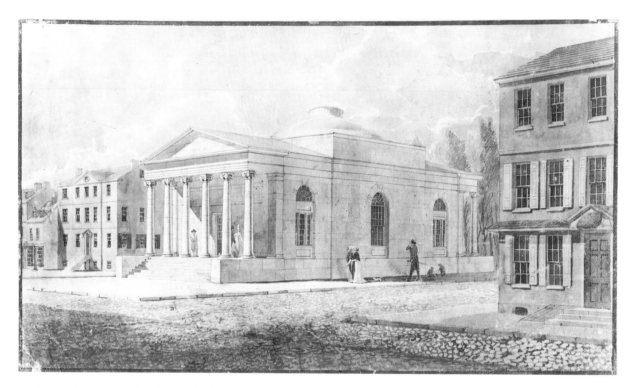

72. *Benjamin Henry Latrobe.* Bank of Pennsylvania. *1798. Pencil, pen and ink, and watercolor, 10½ × 18″. Maryland Historical Society, Baltimore*

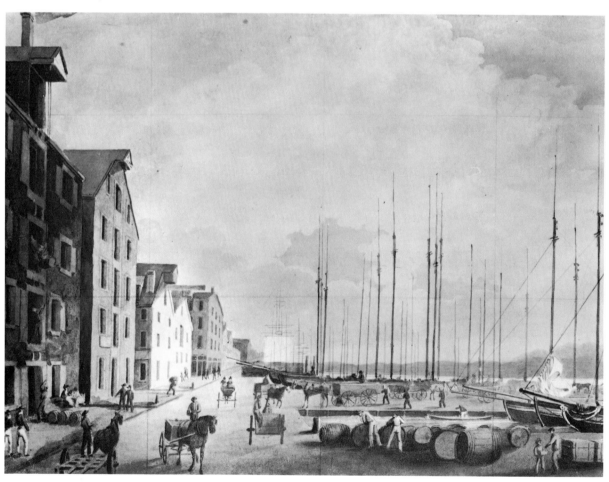

73. *Thomas Birch.* Delaware River Front, Philadelphia. *n.d. Watercolor, 10⅛ × 13⅞″. Museum of Fine Arts, Boston. M. and M. Karolik Collection*

From 1790 to 1800, the decade that Philadelphia had remained the provisional capital, and for some years after, Penn's "green countrie towne" was the most important financial center of the nation. It was a mecca for foreign visitors, some of whom called it "the London of America." Its banks, such as the Bank of Pennsylvania (plate 72), built by Latrobe, and its merchant exchange were among the finest American buildings of their time. When James Fenimore Cooper visited the city early in the nineteenth century, he observed that such splendid architecture was "a tribute to gold . . . to be expected here."

Although its activities were somewhat restricted by the relatively narrow Delaware River, the port of Philadelphia was a busy place (plate 73). It was not surpassed by New York until 1797. Products from all quarters of the world could be found on its wharves: rum, coffee, muscovado sugar, and salt from the West Indies; wines, fruits, drugs, and dry goods from Europe; and silks, porcelains, teas, and spices from the Orient. Manufactured goods and agricultural produce from Pennsylvania were piled high, waiting for export in all directions.

Within the city itself, the lasting influence of Penn's sober Quaker precepts could still be discerned, imparting to the town a particular character. In 1812 a Russian diplomat and voyager, the sometime artist Pavel Petrovich Svinin, remarked that on Sundays "one meets in the streets . . . only gloomy faces, the faces of people sunk in meditation, and one does not meet a single smile" (plate 74). He also noted, almost plaintively, that the

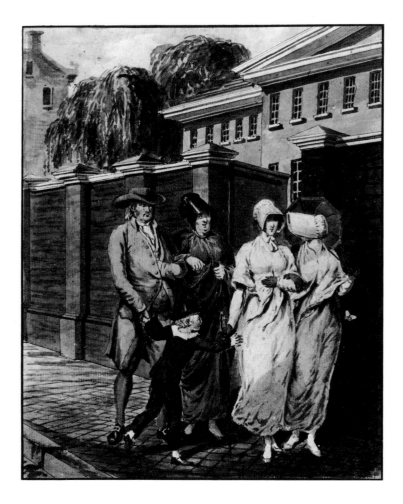

74. *Pavel Petrovich Svinin.* Sunday Morning in Front of the Arch Street Meetinghouse. *1811–12. Watercolor, 9 × 7¼″. The Metropolitan Museum of Art, New York. Rogers Fund, 1942*

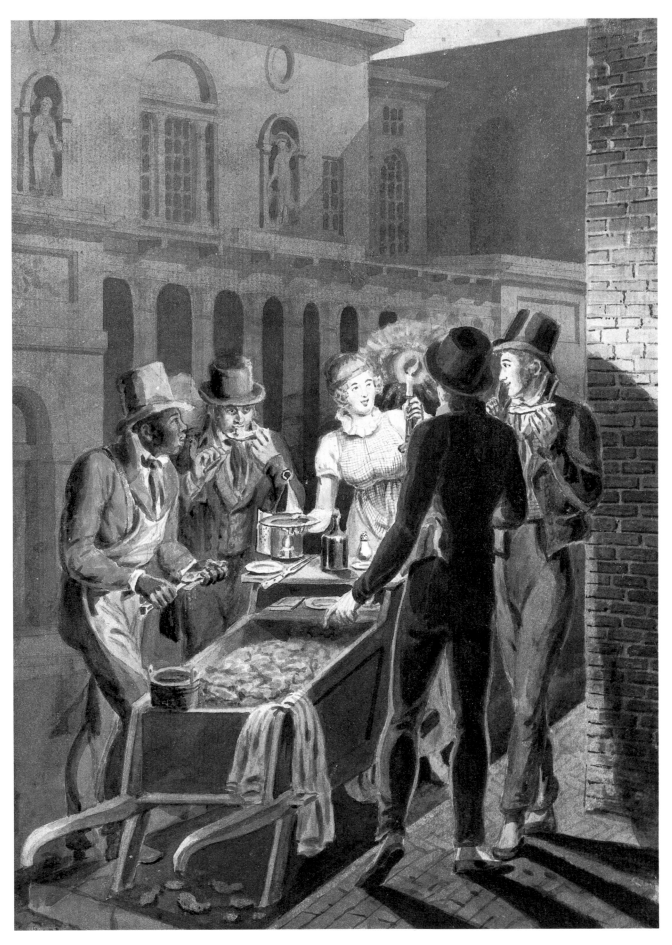

75. *Pavel Petrovich Svinin. Nightlife in Philadelphia: An Oyster Barrow in Front of the Chestnut Street Theater. 1811–12. Watercolor, 9⅜ × 6⅛″. The Metropolitan Museum of Art, New York. Rogers Fund, 1942*

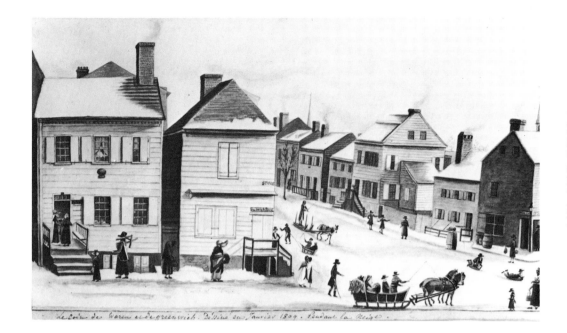

76. Baroness Anne-Marguerite-Henrietta Hyde de Neuville. The Corner of Warren and Greenwich Streets . . . During the Snow. 1809. Watercolor, 15½ × 21". Museum of the City of New York

Quakeresses had "fine figures and small feet" and that "their bonnets lent their snowy languid faces . . . a kind of melancholy which heightens the seductive charm of their blue eyes and fair tresses."

There was another side to Philadelphia, however. One French observer, visiting the city when it still served as our capital, commented on the aristocratic Philadelphians' fondness for worldly diversions and recalled going to a ball which in no way suffered in comparison with elegant European entertainments. At one formal dinner he attended, two young ladies appeared with "very naked" bosoms in the most advanced French Empire fashion. Overcoming stern resistance from her more conservative citizens, Philadelphia built the Chestnut Street Theater. Renovated at the turn of the century by the ubiquitous Latrobe, it soon became the most elaborate playhouse in the nation, and a focal point for the city's fashionables (plate 75).

When the capital was moved from New York in 1790, one gloomy prophet had predicted that the city would be deserted and would "become a wilderness, peopled with wolves, its old inhabitants." In actuality, New York was then beginning its meteoric development from a relatively modest port to "the great commercial emporium of America." By 1795 the shipping tonnage of its harbor had doubled; and by 1810, it had trebled. In the next four years, the number of houses increased by almost twofold and, in the years that followed, this increase accelerated. The baroness Anne-Marguerite-Henrietta Hyde de Neuville, a refugee from Napoleon's troubled France, visited the city during the winter of 1809 and pictured a typical middle-class neighborhood (plate 76). A seasonal snowfall had smoothed the way for sleighs, whose tinkling bells were a welcome relief from the clatter made by carriage and cart wheels as they passed over cobbled streets.

In 1803 New York undertook the construction of its third (and present) City Hall. When it was completed in 1812, Federal Hall (which had resumed its old role as municipal headquarters since 1790) was finally torn down after more than a century of service. A few years later the Swedish artist Baron Axel Klinckowström drew a view of the city, featuring the new

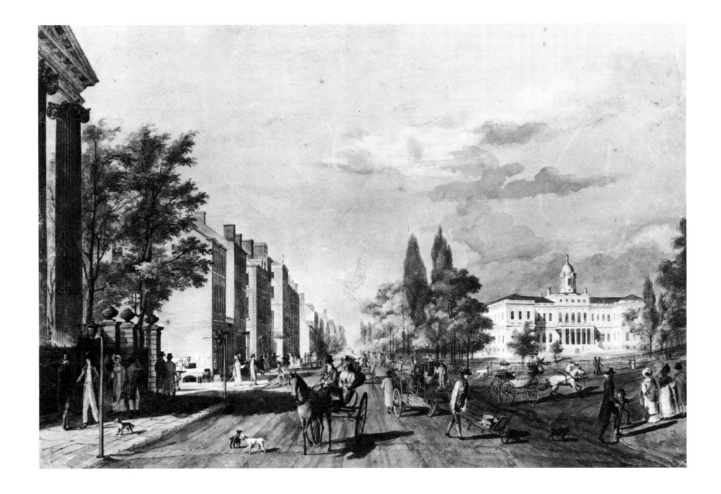

building which, he wrote, was "built in a light and pretty style" (plate 77). From his sketch, he added, one could get "a good idea of this part of New York, which really is attractive." Perhaps intentionally, he had neglected to record the scavenger pigs rooting along the "great and handsome" Broad-way, creatures upon whose casual progress the city still largely depended for disposal of its refuse.

Despite the growth of these and other cities, overland travel for some years remained painfully slow and even hazardous. In 1791, when Wash-ington made a necessary southern tour, Jefferson wrote him, "I shall be happy to hear that no accident has happened to you in the bad roads." Five years later it took one stagecoach four days to get from Philadelphia to Baltimore. Until adequate bridges were built, ferrying across rivers—large or small—could prove to be a perilous adventure (plate 78). On one occasion the redoubtable Horatio Gates, hero of Saratoga, was discouraged from crossing the Hudson River from New Jersey to New York, when he saw how badly shaken up the incoming passengers were after having braved that wintry passage.

During those early years of the nineteenth century, one of the most dramatic achievements of the age was staged on the Hudson River at New York. In 1806 the artist-inventor Robert Fulton had returned to the city after spending twenty years painting and tinkering in Europe. The next year he launched the *North River Steamboat of Clermont*, which, propelled by the engine that Fulton had developed (plate 79), made a successful run from Manhattan to Albany (a distance of about one hundred fifty miles) in thirty-two hours. Earlier steamboats had "sailed" farther and faster but none of them had proved commercially feasible. The *Clermont*, on the other hand, paid dividends and was an entirely practical success. From that point on,

77. Baron Axel Leonhard Klinckowström. Broadway and the City Hall in New York. 1819. Watercolor, 21 × 27½". Museum of the City of New York

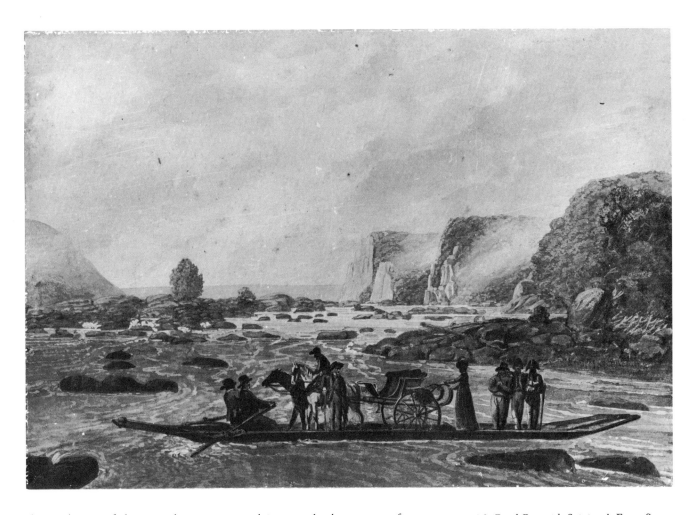

the evolution of the steamboat progressed in an unbroken curve of accomplishment. Soon Fulton and his wealthy patron, Robert R. Livingston of Clermont, New York, had several of the novel craft operating around New York.

　　The third of their fleet to be built, the *Paragon,* lived up to its name. In the dining salon, with its bronze, mahogany, and mirrored fittings, one hundred fifty persons could be accommodated; the best wines and ices were served in all seasons; the cooking was done by steam; and the service was impeccable. To Svinin, who saw and drew the vessel (plate 80), it was a spectacle of wonder, "a whole floating town." Fulton himself observed to a friend that the *Paragon* "beats everything on the globe, for made as you and I are we cannot tell what is in the moon."

78. Pavel Petrovich Svinin. A Ferry Scene on the Susquehanna at Wright's Ferry, near Havre de Grace. 1811–12. Watercolor, 8¾ × 13″. The Metropolitan Museum of Art, New York. Rogers Fund, 1942

79. Robert Fulton. Design for Steamboat Engine. 1808. Ink and colored washes, 15¼ × 25″. The New Jersey Historical Society, Newark. Solomon Alofsen Collection

OVERLEAF:
80. Pavel Petrovich Svinin. Deck Life on the Paragon. 1811–12. Watercolor, 9⅞ × 14¼″. The Metropolitan Museum of Art, New York. Rogers Fund, 1942

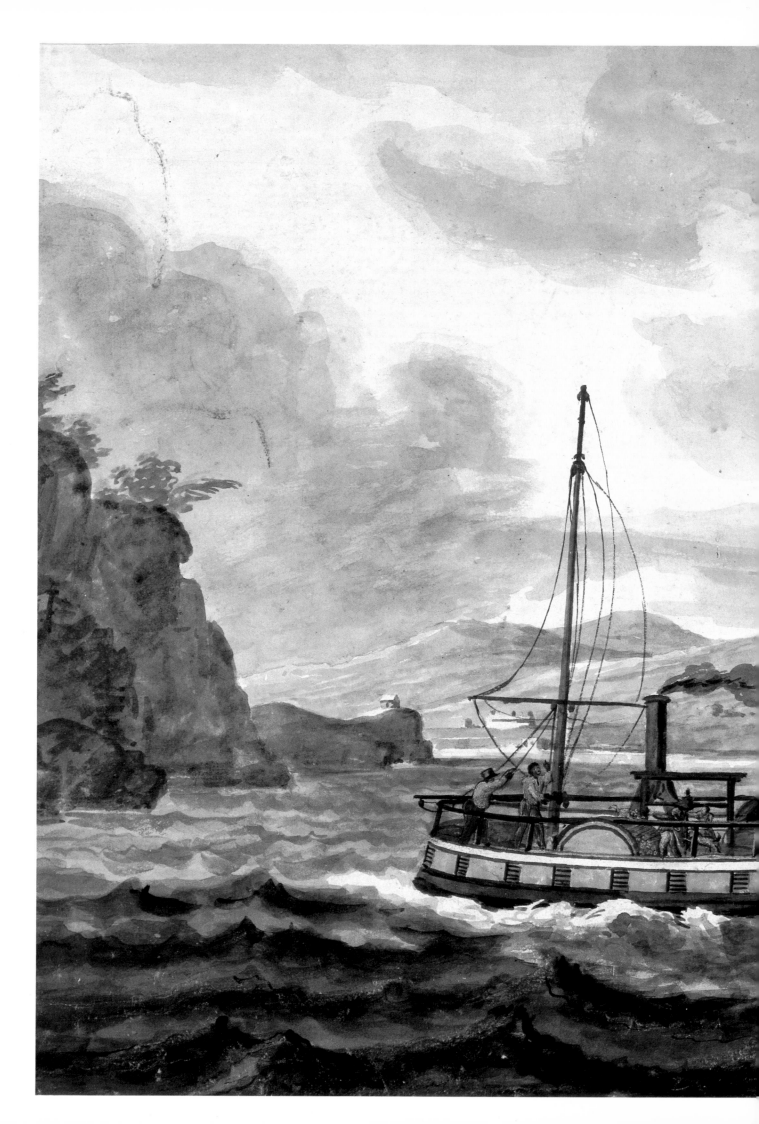

Elevation and plan of the principal Story of the New State House in Boston.

Edw. Bulfinch.

81. Charles Bulfinch. Elevation and Plan of the Principal Story of the New State House in Boston. 1787. Pen and ink wash, 11½ × 8⅞". New York Public Library, I. N. Phelps Stokes Collection

82. Samuel Griffin. A Westerly Perspective of Part of the Town of Cambridge. c. 1783–84. Watercolor and pen and ink, 5¾ × 12½". The Harvard University Archives, Cambridge, Mass.

By Samuel Griffin, class of 1784.

Everywhere in the new republic, there was a need for more buildings to serve the state as well as the national government. To that end, before the close of the eighteenth century, young Charles Bulfinch, a native of Boston, designed the Massachusetts State House (plate 81). Completed on the rise of Beacon Hill, it was the most ambitious building ever undertaken in New England. (In later years Bulfinch was charged with the completion of the Capitol in Washington.)

Bulfinch had taken a Master of Arts degree at Harvard College in 1784, the same year that Samuel Griffin, who made the accompanying sketch of the college buildings (plate 82), was graduated from that venerable institution. It was there that Bulfinch first became acquainted with some of the important books that would shape his career as the first native-born professional architect in America—a career he eminently succeeded in, even though he was self-taught. It was largely thanks to his efforts that, during his generation, Boston became an elegant New England capital, a city with more harmonious architecture than any other in the land at the time.

The dome of Bulfinch's State House was sheathed with six thousand sheets of copper that had been rolled at Paul Revere's recently established foundry in nearby Canton. (It was gilded, as it now appears, only sixty years later.) Revere also supplied copper for the roof of New York's City Hall and for the hull of the *Constitution* ("Old Ironsides"). In 1800, when he had his likeness drawn by Saint-Mémin (plate 83), he was a somewhat portly gentleman of sixty-five years. He was not then as famous as he would later become, after Henry Wadsworth Longfellow poeticized his memorable ride, but he was prosperous, inventive, and industrious well into his old age.

In Virginia the change from colony to statehood had brought disaster to the old capital of Williamsburg. In 1781 Cornwallis had occupied and plundered the town, stripping the place of food and leaving an epidemic of smallpox. The capital had already been moved to Richmond, in 1779, and Williamsburg, so long the social and cultural center of the Virginia Tidewater, gradually fell into neglect and decay. When Latrobe visited the place in 1796, he sketched an interior of the former capitol building, picturing "the beautiful statue of Lord Botetourt [an early governor] deprived of its head and mutilated in many other respects" (plate 84).

83. Charles-Balthazar-Julien-Févret de Saint-Mémin. Paul Revere. c. 1800. Chalk, 20¼ × 14¼″. Museum of Fine Arts, Boston. Gift of Mrs. Walter Knight

84. Benjamin Henry Latrobe. View of Lord Botetourt's Mutilated Statue, Williamsburg. 1796. Pencil, pen and ink, and watercolor, 6⅞ × 10⅞″. Maryland Historical Society, Baltimore

85. *Benjamin Henry Latrobe.* View of
Richmond from Bushrod Washington's
Island. 1796. *Pencil, pen and ink, and
watercolor, 6¼ × 10¼". Maryland
Historical Society, Baltimore*

86. *Thomas Jefferson.* Front Elevation of
the Virginia Capitol. *c. 1785. Pencil, 12¼
× 8⅜". Massachusetts Historical Society,
Boston*

Scale ¼qnette = 1' Virginia Capitol: End elevation - Study

87. Benjamin Henry Latrobe. Proposed
Ballroom for Theater in Richmond. *1797–98.
Watercolor and pen and ink, 16⅛ × 21⅞".
Library of Congress, Washington, D.C.*

Richmond, on the other hand, developed into a city of some size and
consequence after the Revolution. In Latrobe's drawing of it (plate 85), the
skyline is dominated by the state capitol building, which was designed by
Thomas Jefferson in the radically "new" classical temple style. In planning
this structure, Jefferson had been inspired by the Maison Carrée, a Roman
temple in Nîmes, France, which he considered "the most perfect and pre-
cious remain of antiquity in existence. . . . I determined, therefore," he wrote,
"to adopt this model and to have all its proportions justly drewed" (plate
86).

At the time of Latrobe's visit to Richmond, he fell in with a group of
English actors and was inspired by their congenial company to design a new
cultural center for the city. Had it materialized, this handsome edifice, with
its assembly rooms, hotel, and theater (plate 87), would have been one of
the most distinguished architectural complexes of the time.

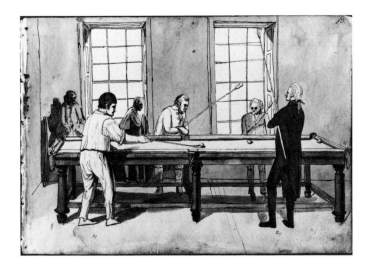

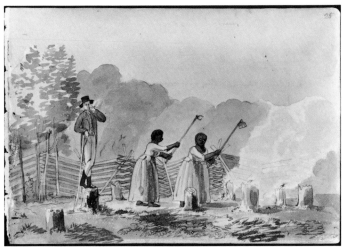

above left: 88. Benjamin Henry
Latrobe. Billiards in Hanover
Town, Virginia. 1797. Pencil,
pen and ink, and wash, 7 ×
10¼". Maryland Historical
Society, Baltimore

above right: 89. Benjamin Henry
Latrobe. An Overseer Doing
His Duty, Sketched from Life
near Fredericksburg. 1798.
Pencil, pen and ink, and
watercolor, 7 × 10¼".
Maryland Historical Society,
Baltimore

90. Benjamin Henry Latrobe
(attr.). Thomas Jefferson.
c. 1799. Pencil. Maryland
Historical Society, Baltimore

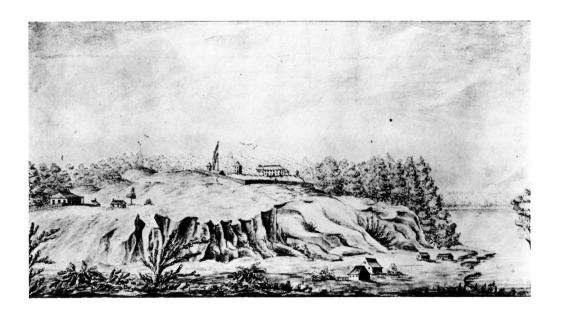

91. Victor Collot. The Spanish Fort
Above Natchez. 1796. Pen and ink and
watercolor. Bibliothèque Nationale, Paris

Latrobe was primarily an architect-engineer (the first in America to combine these two professions), but he was also a prolific artist who made graphic records of all that attracted his imagination. His interests ranged from insects to mountains, from sporting customers playing billiards in a country tavern (plate 88)—proficiency in which game John Adams considered the sign of an ill-spent youth—to plantation overseers supervising slaves at their grubby chores in the field (plate 89). Upon his arrival in America, Latrobe quickly won the attention and respect of Jefferson, who, in 1803, appointed him surveyor of public buildings for the United States. The friendly association of the two men provided Latrobe with ample opportunity to observe Jefferson and to draw his likeness, and the accompanying illustration is generally considered to be the fruit of Latrobe's labor (plate 90).

Jefferson was a man of many parts, at the same time a devotee of the arts, a humanitarian of idealistic bent, a political activist, and a farseeing public servant. He shared with every chancellery in Europe the foreknowledge that the flag of the United States would have to follow the headlong westward progress of its citizens. If the way were not prepared by peaceful negotiations with other nations claiming those lands, a costly border war was all too likely. Without a better understanding of the nature of those lands, any plans for the inevitable expansion of the nation would not be wisely drawn. It was with these concerns in mind that he both consummated the purchase of the Louisiana Territory from France and initiated the Lewis and Clark expedition to the West Coast.

In spite of its setbacks on the Plains of Abraham, Detroit, and elsewhere, France had never abandoned La Salle's dream of a vast colonial empire in the heartland of the North American continent. With that in mind, Victor Collot, a French military spy, with a compatriot—both of them veterans of the American Revolution and skilled mapmakers—scouted the Ohio and Mississippi river valleys in 1796, carefully recording the terrain, the shorelines, and other matters of interest (plate 91). Clearly, France's intention was to contain the United States to the east of those rivers and to resume control of the Louisiana Territory, which had been in Spain's possession since 1762.

Although the latter objective was negotiated in a secret treaty with Spain in 1800, the former intention was never carried out. In fact, in 1803, when, with consummate diplomacy, Jefferson's envoys purchased that ter-

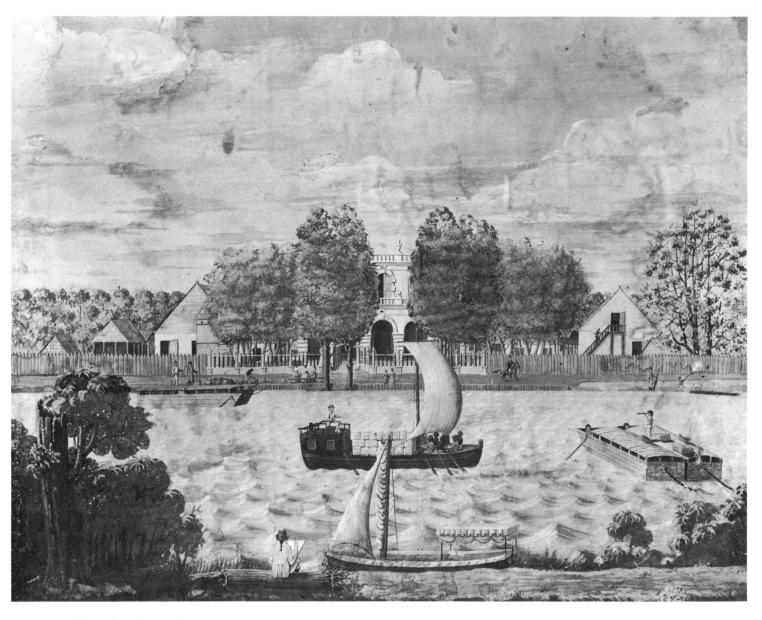

92. *Christophe Colomb.* Whitehall Plantation. *1790. Gouache, 19 × 22″. Private collection*

ritory for fifteen million dollars (over three million dollars of this total were actually French debts assumed by the United States Government), the French dream was finally abandoned. Remarkable as it seems in retrospect, Napoleon had what he considered compelling reasons for the sale. Over-extended in his European campaign, he needed cash to support his army and could ill afford to embark upon a military expedition in Louisiana. What-ever the reasons, this purchase has fairly been called "the greatest bargain in American history." With it came the fertile plantations of Louisiana and the historic Crescent City of New Orleans.

Not many of the eighteenth-century plantation houses that lined the banks of the Louisiana bayous have survived. One of the most impressive

and unusual of them, Whitehall on the Bayou Teche, appears in a view drawn in 1790 by the owner's son-in-law, who is pictured in the foreground, working on his drawing (plate 92). The main structure of this complex was designed in the Italian style and painted to simulate marble. The artist arbitrarily reduced the width of the river, focusing instead on the variety of vessels—some laden with cotton—which served the rural economy. A pleasure barge beside the artist suggests the affluence of the estate. Such planter aristocrats, reported one early nineteenth-century visitor, "are easy and amiable in their intercourse with one another, and excessively attached to balls and parties. . . . The past and future are seasons, with which they seem little concerned."

At the time of the Louisiana Purchase, New Orleans was almost a century old and had belonged to France, then Spain, then very briefly, France again. Even though much of the old French city had burned in the 1780s and had been rebuilt over the ashes during the Spanish administration,

93. Benjamin Henry Latrobe. Market Folks. 1819. Pencil and watercolor, 9 × 11⅜". Maryland Historical Society, Baltimore

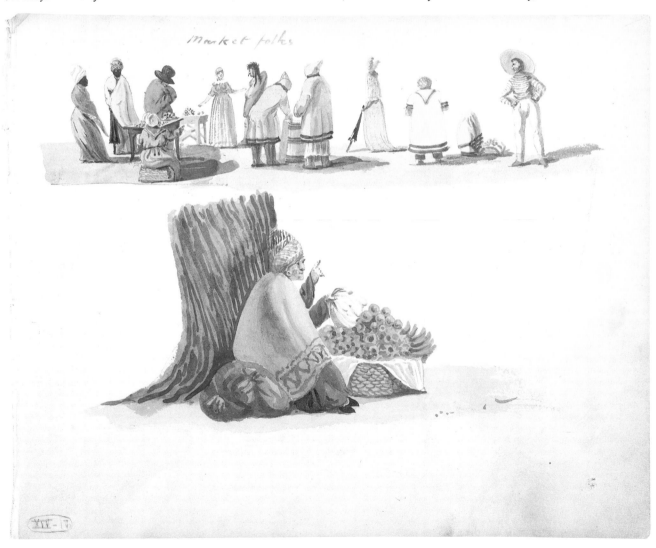

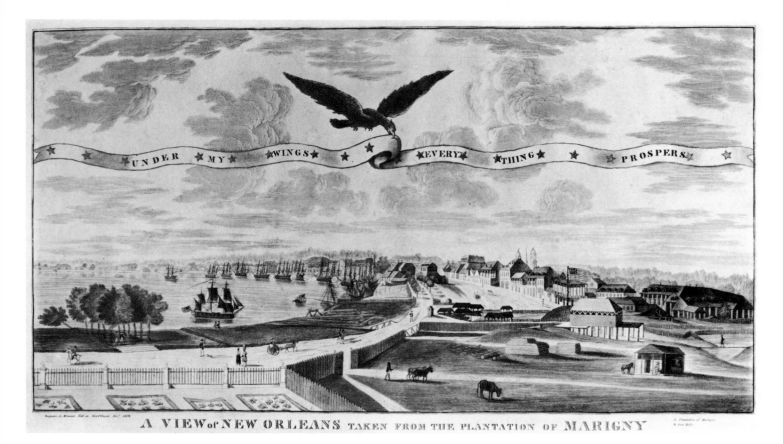

94. J. L. Boqueta de Woieseri. A View of New Orleans Taken from the Plantation of Marigny. *1803. Hand-tinted engraving,*
11⅝ × 21⅝". The Historic New Orleans Collection

Mrs. Frances M. Trollope, a harsh critic of American life, and the author
of the rather unkind book *Domestic Manners of the Americans,* thought it
still resembled "a French Ville de Provence" when she visited the city in
1828. With its mixed heritage, New Orleans still offers the most colorful
variant of urban life in America.

About the time that the artist J. L. Boqueta de Woieseri rendered the
accompanying illustration of New Orleans (plate 94), the city had approxi-
mately "one thousand houses, and eight thousand inhabitants, including
blacks and people of color. Nearly all the old houses are of wood, one story
high, and make an ordinary appearance," wrote one observer. She went on
to say that several of the new houses were two or three stories high and
that one of those had "cost eighty thousand dollars." Several years later
Latrobe came to New Orleans with, as always, his sketchbooks at the ready.
His quick eye caught the colorful variety of street scenes, which he accu-
rately recorded in a number of watercolor drawings (plate 93).

Looking at these carefree scenes, it is hard to believe that only four
years earlier, just outside the city, the last battle of the War of 1812 had
been fought. This war has been called the second war for American inde-
pendence, posing as it did the first serious foreign threat to the newly
emerging nation. Increasing friction in many areas contributed to the actual
outbreak of hostilities: belief that the British were promoting Indian insur-
rections along the western frontier, desire for more land on the part of

American frontiersmen, and, perhaps most important, problems concerning the regulation of trade. Americans resented the restrictions that England placed on her trade, and the British in turn resented attempts by Americans to circumvent set policies. Negotiations were embarked upon, but they proved to be fruitless. It was indeed an ironic moment in our history when, just as the British Parliament had decided to relax its maritime policy, but before its decision could be put into practice, the United States declared war.

As that war dragged on, the superior British navy waged inglorious warfare along the coast against usually inadequate opposition from American land forces. On June 1, 1813, Rear Admiral Sir George Cockburn of His Majesty's Navy sailed up Chesapeake Bay and proceeded to burn and plunder the town of Havre de Grace (plate 95).

In the summer of 1814, to protect itself against any such seaborne assault, Fort Stevens and a blockhouse had been constructed in the harbor of New York City. Although the city was spared serious challenges, other cities along the coast, particularly Washington, fared less well.

95. *William Charles (attr.). Admiral Cockburn Burning and Plundering Havre de Grace. 1813. Hand-colored etching, 8⅞ × 12¾".* *Maryland Historical Society, Baltimore*

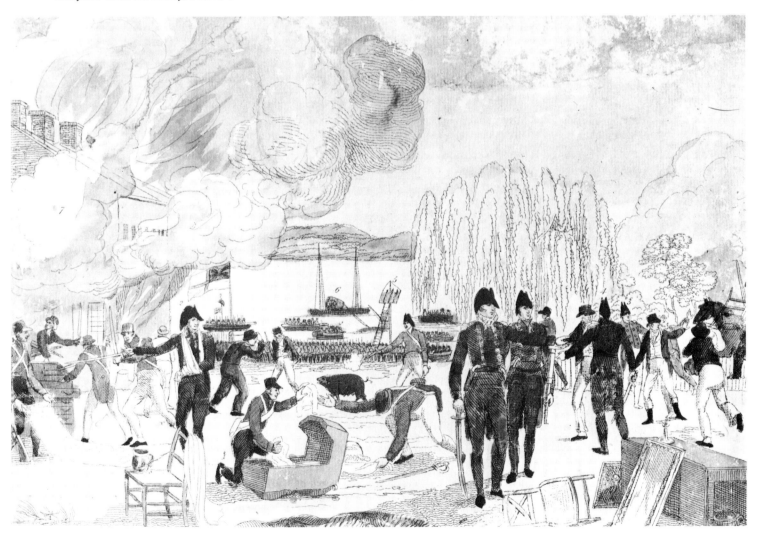

In what was one of the most humiliating episodes of the war, Cockburn arrived at Washington in August 1814 and promptly put the torch to the Capitol (plate 96) and the White House. (The White House had been completed by Latrobe with the aid of Dolley Madison. In 1811 Washington Irving described the finished drawing room there, with its handsome complement of furnishings, as a room of "blazing splendor," an unfortunately apt phrase since all those appointments went up in flames.) A British officer in charge of these demolitions performed his duty with some reluctance, remarking that "it was a pity to burn anything so beautiful" as the Capitol.

The last act of the War of 1812 was played out at New Orleans in January 1815 when Andrew Jackson's rough-and-ready troops slaughtered an army of British regulars. The battle had no military significance for, unbeknown to the combatants, a treaty of peace had already been signed overseas at Ghent. The victory provided a welcome boost to the national spirit, however, and remains a triumphant episode in the history of America. From that moment on, the United States felt free and able to consolidate its latent powers, to take stock of its vast resources, and to assume a confident place in the world scene.

96. George Heriot. The Capitol at Washington After the Fire. 1815. Watercolor, 4⅛ × 8″. The New-York Historical Society

The Nature of America

97. Frederic E. Church. Niagara Falls. 1856. Pencil and colored washes, 10¾ × 12⅜".
Cooper-Hewitt Museum, the Smithsonian Institution's National Museum of Design, New York

Wonders of a Virgin Wilderness

FOR MANY YEARS after the discovery of America was announced, accounts of the New World continued to include tissues of fancy and credulity, at best facts that were wondrously construed. In the minds of most men, geography and hearsay, natural history and romance were hopelessly jumbled. Those who traveled to the farther reaches carried with them preconceptions that often led them to see what they wanted to see; those who did not accepted the varied reports from unseen lands as equally plausible. America might be, as some said, an earthly paradise where nature bounteously provided for man's needs and wants without requiring his travail, and where the Fountain of Youth might be found along with the Tree of Life.

It was also believable that this was a land of an utterly strange, unpredictable, and sometimes horrifying nature. In the sixteenth century Hernando de Soto said he had discovered a river (not then known as the Mississippi) so vast that "a man standing on the shore could not be told, whether he were a man or something else, from the other side," and on whose prodigious current huge trees tossed and tumbled as they were swept along on their way out to sea. About the same time, some three hundred years before the giant California redwoods were first reliably described, the European chronicler Peter Martyr reported tales of "trees of such bigness that sixteen men joining hands together could scarcely embrace one of them."

Rumors concerning the immensity of the American landscape were fueled by early eyewitness accounts which often embellished the already staggering facts. The reports of the Recollect friar Louis Hennepin are typical in this regard. Hennepin had discovered Niagara Falls while accompanying La Salle's expedition down the Mississippi River and, in 1697, he published a book about his travels. It was enormously popular and ran to thirty-five editions in four languages, advertising the cataract to a huge European public. In it, he described this natural wonder as "a vast, prodigious Cadence of Water which falls down after a surprising and astonishing manner, insomuch that the Universe does not afford its Parallel." In the first edition he wrote that the falls were five hundred feet high, about three times the actual height. In the next edition he raised the figure to six hundred. In a small sketch made in 1856 (and later worked into a large painting), Frederic E. Church quickly and convincingly suggests the thundering reality of the subject—a reality awesome enough without exaggeration (plate 97).

After the American colonists had won their independence from the Old World, rumors continued to persist; but these centered on the untracked regions of the West—regions supposedly peopled by strange monsters, human and bestial. Landscapes in that area were said to be equally strange: veritable cathedrals fashioned by nature from the rocky bluffs that towered above the Missouri River; and a thousand miles up that great waterway, a huge glittering mountain of solid white salt was said to exist.

In the Age of Enlightenment men of reason were driven to find whatever substance of truth lay behind such tall and wild tales. This, they learned, could be as startling as any rumor. In time men of every stripe joined the quest: enthusiastic young men with little training, who learned as they went, illustrious Harvard professors, scholarly German princelings, American soldiers on army wages, and artists with pen and brush, who made visual records of what was seen and discovered.

Fired by "a passionate desire" to view the natural scene of America with his own eyes, the English naturalist Mark Catesby visited this country from 1712 to 1719, and then again from 1722 to 1725, spending most of his

time in Virginia, the Carolinas, Georgia, and Florida. His explorations were underwritten by a number of wealthy backers interested in the natural sciences, men whose patronage was the equivalent of today's foundation or government grant. Catesby brought with him to the New World the credulity that so often accompanies explorers in strange new lands, and he was occasionally willing to take hearsay for evidence. He believed that, as he had been repeatedly told, rattlesnakes lured their prey within reach of their jaws by an "attractive power" that hypnotized squirrels, birds, and other unfortunate victims. Nevertheless, when his findings illustrated with his own drawings were published in 1731, they were received with due respect by such worthies as Carolus Linnaeus, Thomas Jefferson, and Georg Steller, the first white man (a German naturalist) to set foot in Alaska. While in Alaska, Steller recognized a relative of the eastern blue jay that he had seen pictured in Catesby's publication, available in a St. Petersburg library. In this book, among many other subjects drawn from life Catesby pictured the ivory-billed woodpecker (plate 98), the largest and mightiest axman of this tribe, which filled the woodland with its clarinet-like call, so rarely, if ever, heard today.

One lasting memorial to Catesby's discoveries remains in the scientific name given to the bullfrog, *Rana catesbeiana,* the largest frog in North America. Almost every naturalist who was newly arrived in America was impressed by the deep bass *jug-o'-rum* of this creature, a roaring sound that, as the common name of the frog suggests, was likened to the bellowing of a bull. When he first heard that noise, the Swedish naturalist Peter Kalm, who followed Catesby to the New World in 1748–51, feared that "a bad goring bull" was indeed threatening him. Kalm spent two and a half years in North America, wandering as far north as Quebec and as far west as the Blue Ridge Mountains, and was interested in everything he saw and heard. "I found that I had now come into a new world," he wrote, "and was seized with a great uneasiness at the thought of learning so many new and unknown parts of natural history." He could barely tolerate the murderous assaults of New Jersey mosquitoes and his "uneasiness" was only increased by what he considered to be the relative "brevity" of colonial women's skirts.

While in America, Kalm conversed with many prominent colonists, among them Benjamin Franklin, and John Bartram of Philadelphia whom the renowned Linnaeus considered the greatest natural historian in the world. (George III appointed Bartram as his "official botanist" for the Floridas.) John's son William followed his father to more or less unexplored places, from the Catskills to Florida and the banks of the Mississippi.

In the autumn of 1765 they discovered "several very curious shrubs" near the Altamaha River (then spelled Alatamaha) in Georgia (plate 99). These proved to be a new genus, and John proposed to name it *Franklinia alatamaha* in honor of his good friend Benjamin Franklin. (The species, one of nature's rarities, has not been seen in the wild state since 1790, when the last remaining samples were removed for transplanting.)

William published an account of his travels in 1791. He was a gifted artist whose watercolors illuminated his written observations, which were both more accurate and more lyrical than anything of the sort yet put into print. At times, however, he gave way to poetic exaggeration, as when he described the "subtle greedy alligator" of the Florida swamps, "rushing forth from the flags and reeds." "Behold him . . ." William wrote. "His enormous body swells. His plaited tail, brandished high, floats upon the lake. The

waters like a cataract descend from his opening jaws. Clouds of smoke issue from his dilated nostrils. The earth trembles with his thunder. . . ."

Obviously, the younger Bartram's book was a story of adventure as well as a natural history and, in both capacities, it exerted a tremendous influence on the writers of the day. His volume (which within ten years had gone through nine editions in five European countries) opened the doors to an exotic world for such romancers and poets as Chateaubriand, Coleridge, Wordsworth, and Southey—all of whom borrowed impressions from its pages in their writings. Many of the passages that Coleridge wove into "The Rime of the Ancient Mariner," "Kubla Khan," and still other poems were inspired by Bartram's volume—sometimes with whole passages lifted verbatim.

In the picturesque countryside of Florida, described so vividly by Bartram, Chateaubriand discovered the embodiment of his feminine ideal in the dark-eyed Indian girls—maids with the primitive innocence of forest children. The Florida landscape, too, had a haunting and romantic beauty, with its vast swamps and moss-hung oaks and cypresses, and it caught the eye of, among other artists, Joseph Rusling Meeker, when he was serving as a paymaster in the United States Navy during the Civil War (plate 100).

Years later, in 1917, when John Singer Sargent was in Florida to paint a portrait of John D. Rockefeller, he took time out from his commissioned work to execute a series of watercolors depicting scenes in the neighboring swamps. In one of these, with his typical extraordinary virtuosity, he pictured a tangle of alligators in a somewhat less agitated state than that described by Bartram (plate 101).

above left: 98. Mark Catesby. Ivory-billed Woodpecker. c. 1724. Watercolor. Reproduced by gracious permission of Her Majesty Queen Elizabeth II, The Royal Library, Windsor Castle, Berkshire

above right: 99. William Bartram. Franklinia Alatamaha. 1788. Watercolor. British Museum (Natural History), London

100. *Joseph Rusling Meeker. Florida Swamp. c. 1861. Crayon on two sheets of paper, 17 × 30⅞″. Museum of Fine Arts, Boston. M. and M. Karolik Collection*

101. *John Singer Sargent. Muddy Alligators. 1917. Watercolor, 13½ × 20⅞″. Worcester Art Museum, Worcester, Mass.*

In the early decades of the nineteenth century, native American writers such as Washington Irving, James Fenimore Cooper, and William Cullen Bryant were celebrating a newly perceived beauty and grandeur in the natural American scene. Their visions were shared by artists who, in carefully drawn but lyrical portraits of the hills and lakes, the valleys and rivers of the still semiwild continent, created luminous vistas that enchanted their compatriots. Such men as Thomas Cole, Asher B. Durand (plate 102), Thomas Doughty, John F. Kensett, and others were then forming an unorganized fraternity of artists, later known as the Hudson River School. These artists roamed the river valleys and more distant areas sketching scenes and details (plate 103), which, when they returned to their studios, would often be incorporated into carefully finished landscape paintings. Cole, considered one of the founders of the school, spent weeks and months of every year sketching his way through the Catskills, the White Mountains, and wherever else he was lured by the wild scenery. He advised aspiring landscapists to practice such outdoor, on-the-spot drawing of nature as something fundamental to the development of their art.

Drawings, aside from their documentary interest, were also considered as ends in themselves, and connoisseurs of the day were filling their portfolios with examples by their favorite artists. In 1837 one visitor from overseas remarked that this country "seemed to swarm with painters" (plate 104).

Even before those artists established the Hudson River School, other artists had headed into the American West, where new and different wonders provided subjects for their pens, pencils, and brushes. The way of their travels had been presaged in 1804–6, by the epochal Lewis and Clark expedition, hailed by one eminent historian as "incomparably the most perfect achievement of its kind in the history of the world." Over a period of twenty-eight months these two men and a carefully selected company carried out their immensely complicated and perilous assignment—to explore and study the entire breadth of the continent—with a precision that was just short of miraculous. Jefferson chose young Meriwether Lewis (plate

104. *William Ricarby Miller.*
Self-Portrait at Weehawken.
1848. *Watercolor, 5¼ × 3¼″.*
The New-York Historical Society

105. Charles-Balthazar-
Julien-Févret de Saint-
Mémin. Meriwether
Lewis. 1807. Watercolor,
6¼ × 3¾". The New-
York Historical Society

106. *William Clark*. Flathead Indians. 1806. *Pen and ink, 7 × 5". Missouri Historical Society, St. Louis*

105) to lead the expedition—a man, Jefferson later recalled, whose remark-able qualifications for the job seemed to have been "selected and implanted by nature in one body for this express purpose." Jefferson's influence on almost every aspect of this enterprise was so profound that one learned student has suggested that it might well be remembered as the Jefferson expedition.

By the time these "Robinson Crusoes—dressed entirely in buckskins," as one St. Louis newspaper described the members of this corps of discovery, returned to civilization, most people had given up all hope of seeing them again. They had covered almost eight thousand miles of wild country—traveling from St. Louis, up the Missouri River, across the Rockies, down the Columbia River, to the shores of the Pacific, and back again—and had seen sights previously unknown to civilized man. What had been a vast territory of "rumor, guess, and fantasy" had, as a result of their efforts, been revealed as a land of observed reality. They had opened an overland route to the Pacific, and the maps they drew were not improved upon for many years. Unfortunately, no competent artist accompanied the expedition and although the diaries that every member of the corps was told to keep are spotted with primitive, impromptu sketches (plate 106), satisfactory renderings of much that they reported would have to wait for more proficient draftsmen to visit the lands they had traversed.

107. *Titian Ramsay Peale. The Mastodon. 1821. Wash, 14½ × 19″. American Philosophical Society Library, Philadelphia*

Jefferson had instructed Lewis to be on the lookout for mastodons and mammoths, which, it was rumored by some believers, might still be en-countered in the wilder West. He felt confident that, even if the animals themselves no longer existed, at least their skeletal remains could be found. (Years earlier Jefferson had cited the discovery of such remains in his ref-utation of Buffon's ridiculous contention that America had generated only smaller and weaker fauna than had Europe.) Charles Willson Peale, among others, had exhumed a mastodon's bones in New York State in 1801, and his son, Titian Ramsay Peale, sketched the skeleton in 1821 after the bones had been reassembled (plate 107).

Titian Peale had also served as a recording artist with the expedition of Major Stephen H. Long, which in 1819 and 1820 toured the Platte River, the foothills of the Rockies, and the Arkansas River. Upon his return Long reported that much of the land he had seen—the seemingly endless Great Plains—was little more than an uninhabitable "desert," rimmed by virtually impassable mountains. He was referring to a territory that today includes parts of Kansas, Colorado, New Mexico, Oklahoma, and Texas.

One of the most phenomenal natural wonders of the New World,

astonishing all who witnessed it, was the seasonal flight of passenger pigeons (plate 109). In earlier days these lovely birds would take to the sky in such astronomical numbers that they eclipsed the sun, turning day to dusk. In flight they sometimes continued to pass overhead for days, filling the air with the deafening thunder of their wings—a sound John James Audubon likened to "a hard gale at sea, passing through the rigging of a close-reefed vessel." When they stopped, Audubon observed, they broke the limbs of stout trees by the sheer weight of their numbers. The sole survivor of these untold millions of creatures, so long the prey of hunters, died in a Cincinnati zoo almost seventy years ago.

Audubon roamed the American wilderness with all the freedom of the wild creatures he sought to draw. He never did get as far west as he wished (he only got as far as Fort Union, at the mouth of the Yellowstone River), but from skins that were sent to him by correspondents, he was able to draw fair likenesses of such far-western birds as the giant California condor (plate 108)—the largest of all North American land birds, with a wingspan

108. *John James Audubon*. California Condor. 1838. Watercolor, 38½ × 25". *The New-York Historical Society*

109. John James Audubon. Passenger Pigeon. c. 1824. Pencil, watercolor, and pastel, 26¼ × 18⅜". The New-York Historical Society

110. *Karl Bodmer.* The White Castles on the Missouri River. *1833. Watercolor, 9 × 16⅜". The InterNorth Art Foundation, Joslyn Art Museum, Omaha*

approaching ten feet. (Lewis and Clark had seen this noble bird and referred to it in their diaries as "the butifull Buzzard of the Columbia.") In order to fit a lifesize image onto his paper, Audubon had to draw the figure into a cramped position.

Other later artists who visited the western lands witnessed scenes and wildlife that the Lewis and Clark troop had reported in their journals. In July 1833 the Swiss artist Karl Bodmer, in the entourage of the German explorer Prince Maximilian of Wied-Neuwied, accurately pictured the White Castles (plate 110), whose rocky formations on the upper reaches of the Missouri River they first mistook for architectural features. He also drew the Stone Walls (plate 111), even more extraordinary outcroppings which recalled the incredible structures that Jefferson, at the time of the Louisiana Purchase, had advised Congress might be discovered in that part of the continent. (When he viewed these formations, Meriwether Lewis had marveled at what he described as "scenes of visionary enchantment.")

Maximilian's scholarly direction and Bodmer's sure draftsmanship resulted in an unsurpassed gallery of the early West—a pictorial record upon which American studies of that western land and its inhabitants can still solidly depend. Bodmer's drawings of animals invite comparison with Audubon's paintings of the same subjects made some years later. He portrayed the prong-horned antelope (plate 112), a creature which is not actually an

antelope and which indeed has no close relative anywhere in the animal world. "His brains on the back of his head," William Clark had reported, "his nostrils large, his eyes like a Sheep he is more like the Antilope or Gazelle of Africa than any other species of Goat." Probably as many as one hundred million of them once filled the Plains, outnumbering even the buffalo, whose vast herds often blackened the landscape far beyond reach of the eye. Lewis had observed that the pronghorn could run more swiftly than "the finest blooded courser," and he likened its bounding progress to the rapid flight of birds. (In a spurt, pronghorns can indeed run at a speed of almost a mile a minute.)

Every early traveler who reached the prairies and plains of Nebraska cited Chimney Rock, near Platte River, as one of nature's wonders. In 1835 Samuel Parker, a roving missionary, climbed to the base of this extraordinary stone column and observed "some handsome stalagtites, at which my assistant shot," a singularly gratuitous gesture which furthered the process of natural erosion that through untold time has been eating away the formation. Two years later the Baltimore artist Alfred Jacob Miller, who traveled westward with an expedition headed by an eccentric Scot, Captain William Drummond Stewart, visited the site and drew a faithful likeness of the rock as it then appeared. Some years later, working from this sketch, he created a watercolor of the subject (plate 113).

Farther to the west stood the main ranges of the Rocky Mountains

111. Karl Bodmer. View of the Passage Through the Stone Walls, Not Far Below the Mouth of the Marias River. 1833. Watercolor, 9⅞ × 16⅞". The InterNorth Art Foundation, Joslyn Art Museum, Omaha

(plate 114). In 1807 John Colter, a veteran of the Lewis and Clark expedition, climbed high into these mountains and into the great plateau known to the Indians as "the summit of the world," now a part of Yellowstone National Park. There he reported seeing spouting geysers, smoking hillsides, bubbling pools, and other such sights as could not be believed by sane and sober men. Twenty years later another explorer visited the site and confirmed the reality of what Colter had seen—a reality that is more than captured in a watercolor by John Renshawe, done in 1883 (plate 115).

In 1540 Coronado's men under García López de Cárdenas had peered into the awesome depths of the Grand Canyon, hardly believing what they saw. For over three centuries, this unparalleled creation of timeless erosion remained a legend, unseen by other white men. Then, in 1858, a United States government expedition, headed by Lieutenant Joseph Ives of the U.S. Corps of Topographical Engineers, reached the floor of the gigantic gorge to plumb its mysteries. Ives observed that the area "resembled the portals of the infernal regions," a sight "unrivalled in grandeur." In 1880 the artist William Henry Holmes, traveling with another government expedition, ren-

112. Karl Bodmer. Head of Prong-horned Antelope. 1833. Watercolor, 9⅝ × 11⅛". The InterNorth Art Foundation, Joslyn Art Museum, Omaha

113. Alfred Jacob Miller. Chimney Rock. 1850s. Watercolor, 10¼ × 14¼". Walters Art Gallery, Baltimore

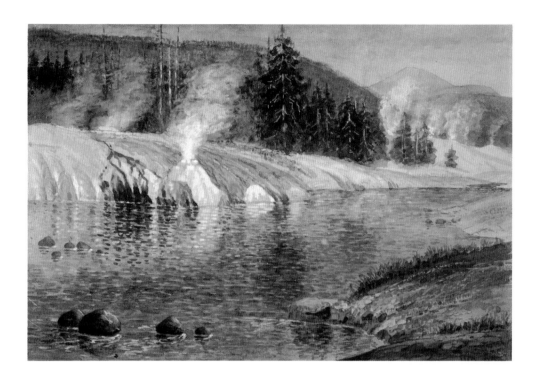

dered a heroic panorama of the canyon as a matter of record, suggesting to a wondering world the immensity of this spectacle (plate 116).

As earlier told, sixteenth-century reports mentioned trees of almost unbelievable size growing in the New World. Spanish explorers saw such trees when they arrived in California. These noble conifers—the giant coast redwoods (plate 117)—probably originated more than one hundred million

116. William Henry Holmes. Panorama from Point Sublime (detail). 1880. Chromolithograph, 20⅛ × 32¼". From Tertiary History of the Grand Canyon District, 1882. National Archives, Washington, D.C. Records of the U.S. Geological Survey

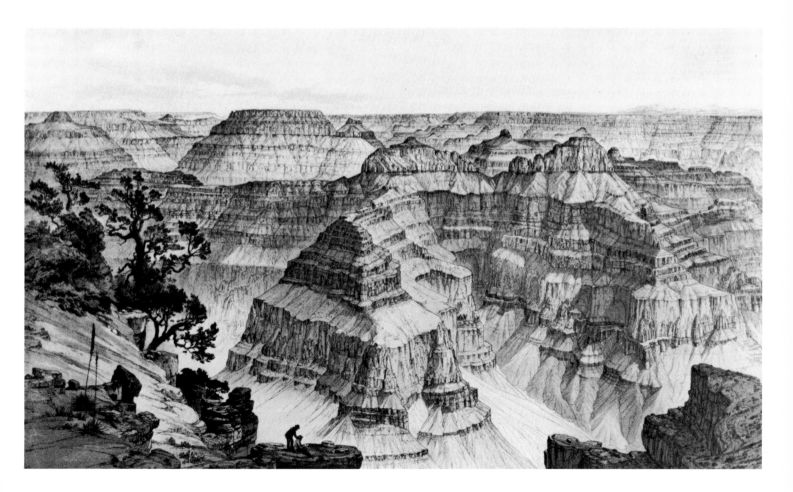

117. *Edward Vischer*. The Fremont
Tree—California Redwood. *1868. Pencil,*
6¾ × 5″. Bancroft Library, University of
California, Berkeley

years ago, but, over the millennia, with few exceptions they have been
exterminated everywhere except along the narrow strip of America's Pacific
coast. (As a footnote to the ancient history of the sequoia, fossil remains of
this same kind of tree were found and described in Europe several years
before the first specimens were shipped there from America.) The enormous
size and hoary age of the two species of coast redwoods—the big tree is
more than three hundred feet tall and as much as three to four thousand
years old (already twenty centuries old when Julius Caesar's legions were
landing in Britain)—have given rise to various legends. One agreeable story
tells of a lumberjack who, while attempting to cut down a redwood single-
handed, paused after a week's hard work, strolled around the tree to mea-
sure his progress and, to his surprise, found another lumberjack on the other
side who had also spent a week laboriously cutting away at his side of the
colossal trunk.

Seeds and specimens of the redwoods were sent to Europe, and giant
sequoias have been cultivated in England and on the Continent, where they
continue to grow to, as yet, modest size. In another thousand years or so
they may remain standing, grown to a towering height, as a monumental
reminder of Europe's interest in what had indeed been a New World of
natural wonders.

The Westward Way

118. John Trumbull. Brigadier General Anthony Wayne. c. 1791. Pencil on cardboard,
4¼ × 2¾". Fordham University Library, Bronx, N.Y. Charles Allen Munn Collection

Onward to the Wide Missouri

ALMOST FIFTY YEARS before the War of Independence, the Irish philosopher George Berkeley, dean of Derry, paid a brief visit to America. While there, he composed the memorable poem in which he wrote:

> Westward the course of empire takes its way;
>> The four first acts already past,
> A fifth shall close the drama with the day:
>> Time's noblest offspring is the last.

This prophetic allusion to the future of America was recalled years later as the people of this land surged inexorably and triumphantly across the continent.

Before the Revolution the British government had several times taken measures to restrain its American subjects from crossing the mountains that stood between their coastal settlements and the vast interior of the continent. Such prohibitions proved to be futile, however. As William Lord Dartmouth observed, no laws could bridle "that dangerous spirit of unlicensed emigration" that kept pioneers following the sun to distant horizons. If hell lay to the west, as one saying went, these people would cross paradise to reach it.

After the conclusion of the war, the growing problem of westward expansion became one for the new nation to settle as best it could and as quickly as possible. No one better understood the urgency of that problem than George Washington. "Open *all* the communications which nature has afforded between the Atlantic States and the Western territory, and encourage the use of them to the utmost . . . " he urged. "Sure I am there is no other tie by which they will long form a link in the chain of Federal Union."

Standing in the path of this advice were the grim realities encountered by those traveling west. Washington himself was well aware of what those realities were. Some twenty years before the beginning of the Revolution, he had accompanied the British general Edward Braddock on an ill-fated campaign against the French, near Fort Duquesne, on the site of what was to become the city of Pittsburgh. Washington was the only officer of Braddock's staff to survive intact the bitter retreat from the battlefield, where, as one French witness recalled, "the whoop of the Indians [allies of the French] struck terror into the hearts of the entire enemy."

From this humiliating episode in his early career, Washington learned to appreciate the ferocity with which the Indians would oppose intrusions into their western lands. With the eye of a good husbandman he could also appreciate the "exceedingly beautiful and agreeable" land that he had passed through on his way to battle and back, and to estimate the numerous advantages that it might afford settlers, could they succeed in pacifying the frontier. Both realizations would guide his policies as president in later years.

But at that time, and for some years to come, the borderlands beyond the Alleghenies remained a "Dark and Bloody Ground," as the Indian chief Dragging Canoe appropriately termed them. His sentiments were echoed in the first published history of Kentucky, which appeared in 1784. Daniel Boone, whose exploits were featured in that history (it was written as though Boone was in fact the narrator), reportedly referred to this area as a place where his own footsteps had "often been marked with blood." Countless others experienced the same. In 1780 the first government in

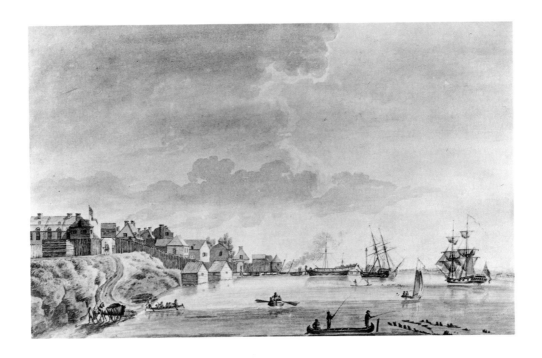

119. E. H. Detroit. 1794. Watercolor, 8⅛ × 14¾". Detroit Public Library, Burton Historical Collection

what was to become Tennessee was drawn up by 256 men. Ten years later hardly half a dozen of them were still living, and only one had died a natural death.

In spite of these gruesome episodes, the lure of commercial gain prompted speculators to buy up large tracts of land in the area beyond the mountains to the north and east of the Ohio and Mississippi rivers. Washington himself had acquired some thirty thousand acres along the Ohio before the Revolution. (In later years he offered that land for sale, concluding that "distant property in land is more pregnant of perplexities than profit.") While some profited handsomely from their holdings, others went broke. Whatever the particular outcome, one thing remained certain: as long as the Indian presence continued in the area, everyone's chances at success were radically diminished.

By the early 1790s border wars with the Indians had reached a critical phase, and American forces were suffering repeated defeats. Then, in 1794, a vital turning point was reached. Under Washington's instructions, General "Mad Anthony" Wayne (plate 118) roundly defeated the Indians at the Battle of Fallen Timbers, near present-day Toledo. (Wayne was anything but mad; his attack on the Indians was carefully and patiently planned.) The British, who were still occupying border forts along the frontier, had incited their Indian allies to drive the Americans out of this area, but, as a result of Wayne's victory, the Indians were forced to come to terms. In the Treaty of Greenville signed the following summer, they gave up most of their claims to the Northwest Territory—a vast area lying between the Ohio, the Mississippi, and the Great Lakes west of Lake Ontario and including the present-day states of Ohio, Indiana, Illinois, Michigan, Wisconsin, and part of Minnesota. The British in turn evacuated many of their forts, including the stockaded outpost at Detroit (plate 119). With that opposition removed, emigrants from the east streamed westward in ever-growing numbers.

From the long-settled communities of the eastern seaboard, the country to the west seemed like an interminable dark forest. It was said that a squirrel could leap from tree to tree for a thousand miles in the backcountry, scarcely seeing the sun or touching the ground. Earthbound travelers forging their way day after day through such thick gloom found the experience

120. George Harvey. Spring—Burning Up Fallen Trees. 1841. Watercolor, 13⅞ × 10¼″. The Brooklyn Museum, N.Y. Dick S. Ramsay Fund

121. Artist unknown. A Shelter in the Wilderness. 1808. Pen and ink, 9¼ × 7½″. From a diary by a British subject on a journey from New York City to Niagara Falls. New York Public Library, Manuscripts Collection

122. Joshua Shaw. Great Wielders of the Ax the World Has Known. c. 1810–20. Pencil. Museum of Science and Industry, Chicago

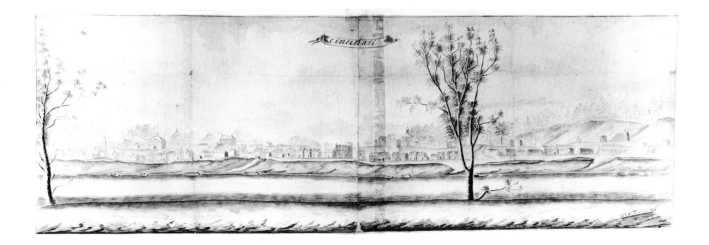

123. C. Williams. Cincinnati. 1807.
Watercolor, 9⅞ × 26⅜". Historical
Society of Pennsylvania, Philadelphia

oppressive beyond all expectations. One early observer reported that the American had an unconquerable aversion to the trees that hemmed him in at every turn. As if by reflexive action, he cut away all before him, and his skill with an ax was all but legendary. "Let one of these men upon a wood of timber trees," wrote one English visitor early in the nineteenth century, "and his slaughter will astonish you." The American axman, he concluded, did ten times as much in a day as any other man he had ever seen.

To ease and quicken the labor of clearing the land, to let the sun in and to make space for a house and a corn patch, trees were commonly girdled to kill them, then burned to strip them, and finally cut down to provide fence rails and firewood, leaving the charred stumps to be uprooted at a later time (plate 120). The log huts that were hurriedly put together and used for shelter in the meantime were, often enough, temporary contrivances that barely kept out wind or rain (plate 121). One pioneer noted in his journal that he started building such a cabin on a Wednesday and, three days later, having "kivered" it with bark, he was ready to move in and start housekeeping.

Crossing the mountains to the promised land on the other side was more taxing than many hopeful pilgrims had expected. "Come to a turable mountain tired us almost to death to git over it," wrote one of them in his diary. "Met a good many peopel turned back for fear of the Indians. . . ." The English-born artist Joshua Shaw apparently witnessed the trudging progress of travelers along such routes and he recorded their journey in a number of drawings (plate 122).

With good fortune and enough determination, such "infatuated emigrants" could find their way to the fabled lands of the West where it was tempting to believe that every man could be "a prince in his own kingdom." Even the first published history of Kentucky (which chronicled some gruesome realities) somewhat extravagantly foretold the day when the western territories would bloom with cities that "in all probability will rival the glory of the greatest on earth."

Although most of the western settlements did not quite measure up to these exalted expectations, several communities were indeed thriving. Cincinnati was one of them. Originally called Losantiville, it was founded in 1788 and named the capital of the Northwest Territory in the following year. Less than twenty years later, it had become a busy transshipping center (plate 123).

One of the main gateways to these farther reaches had been carved out by members of the Braddock expedition years earlier. By hacking their way through the wilderness from the Potomac to the Ohio, they had unwittingly created a route that would be used by westering Americans for

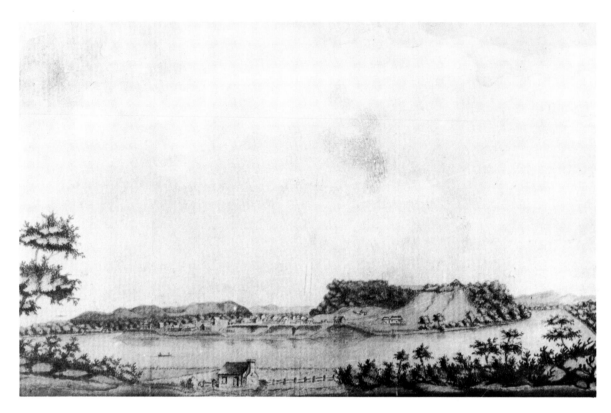

124. *Lewis Brandt. Pittsburgh. 1790. Watercolor, 5¼ × 8″. Carnegie Library of Pittsburgh*

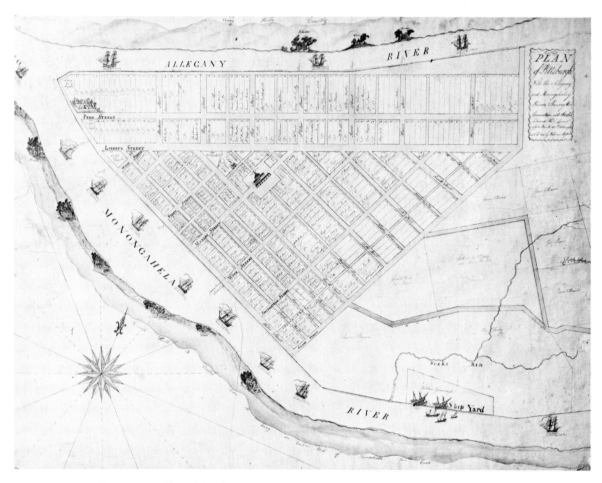

125. *William Mason.* Plan of Pittsburgh. *1805. Ink and wash, 21 × 29½″. Historical Society of Western Pennsylvania, Pittsburgh*

126. *Baroness Anne-Marguerite-Henrietta Hyde de Neuville. Angelica, New York. 1808. Watercolor, 7 × 12⅜". The New-York Historical Society*

years to come. Along this trail, at the confluence of the Monongahela and the Allegheny rivers where they form the Ohio, the little hamlet of Pittsburgh was born. By 1790 it boasted a population of a few hundred, plus a military garrison (plate 124). One visitor at this time complained that it was already a smoky place. Within a decade it was four times larger and its newly built iron foundries, glass factories, and mills were adding even more smoke to the scene.

By then, also, seagoing vessels laden with produce and manufactured goods were sailing from the fledgling town for distant ports in the West Indies and Europe. A plan of the city drawn in 1805 shows an assortment of schooners, brigs, and other vessels, their sails aloft as they ply the rivers, and a shipyard where others are being built (plate 125). European customs inspectors were incredulous when told that such square-rigged vessels had come from the interior of the American continent via the inland waterways, the Gulf of Mexico, and the Atlantic Ocean. The western rivers were indeed formidable barriers for such unwieldy oceangoing craft, and their unlikely but successful passage could have been just one more of the tall tales that grew to such outrageous heights in the American West.

Two broad river valleys in New York State, the Hudson and the Mohawk, provided an easier way to the interior; they were the only water-level routes between Georgia and the St. Lawrence River. The first emigrants from the East had edged their way westward along these channels in the eighteenth century. After the Revolution, in what could be called America's first real land rush, speculators from foreign lands—stolid Dutch bankers, titled Englishmen, and distinguished French émigrés—vied with Yankees, New Yorkers, and naturalized countrymen for the acquisition of property in New York State.

Early in the nineteenth century the baroness Hyde de Neuville visited the southwest corner of the state, where she sketched Angelica (plate 126), an agricultural complex that had recently been formed in a clearing of the forest. The founders of that infant community had included some of her

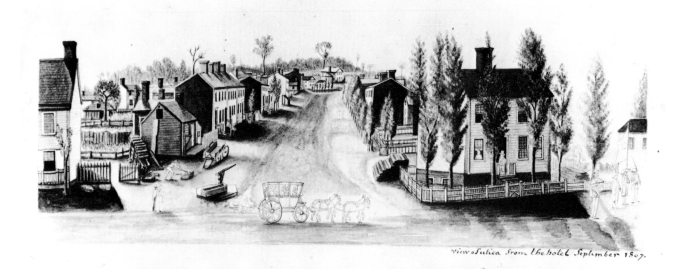

View of Utica from the hotel September 1807.

exiled French countrymen, and members of their families may be among the subjects in the baroness's drawing. In 1807 she also pictured the burgeoning town of Utica (plate 127), which, in her drawing, appears much as it was described by an English tourist in the following year. The latter observed that in little more than twelve years this settlement had grown from a wilderness site with but two houses into "a great emporium of European and other foreign goods" where traders came to fill the orders received from the farther West. Yankees, he explained, had given Utica the tonic of their industry and the neat appearance of a New England village.

Years earlier, about 1790, James Fenimore Cooper's father had founded and moved his family to a frontier site that would later become known as Cooperstown. By the time the younger Cooper was a well-known novelist, swarms of people had descended upon this neighborhood, provoking in him a reaction of sharp annoyance. He disdainfully referred to these people as "locusts of the West," who, with their busy axes, were "lacerating" the sylvan countryside near his home and giving it the character of a New England colony. In 1816 an artist by the name of George Freeman sketched the writer's aging mother in the large entrance chamber of Otsego Hall, the Cooper homestead (plate 128).

The way along the Mohawk Valley and through the Genesee country that led to the Great Lakes and the farther West, became in time, and not a long time, a major thoroughfare—culminating in one of the most heavily traveled migrant routes in history. An incalculable impetus to this traffic came with the opening of the Erie Canal in 1825. When it was first proposed in 1806, Thomas Jefferson had viewed the prospect of cutting a canal through over three hundred miles of wilderness as "little short of madness." Many others shared this view, but with daring underwriting and eight years of mass labor, the impossible became a reality (plate 129). The canal paid off with huge dividends. A year after it was opened to its full length, the income from its tolls far exceeded the interest charges on the debt the state had

127. Baroness Anne-Marguerite-Henrietta Hyde de Neuville. View of Utica from the Hotel. 1807. Watercolor, 7 × 12⅜". The New-York Historical Society

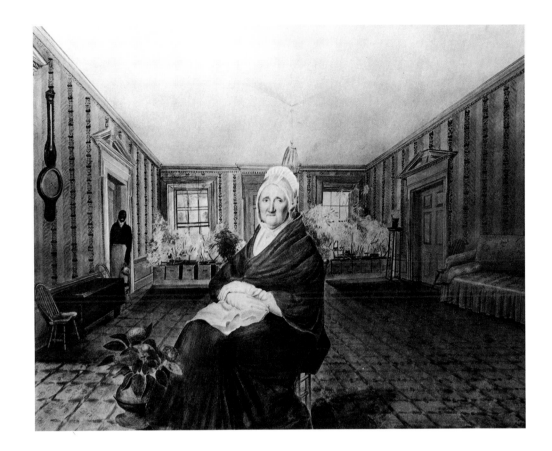

128. George M. Freeman.
Elizabeth Fenimore
Cooper. 1816.
Watercolor, 25 × 30".
New York State Historical
Association, Cooperstown

129. John William Hill.
Erie Canal. 1831.
Watercolor, 9½ × 13½".
The New-York Historical
Society

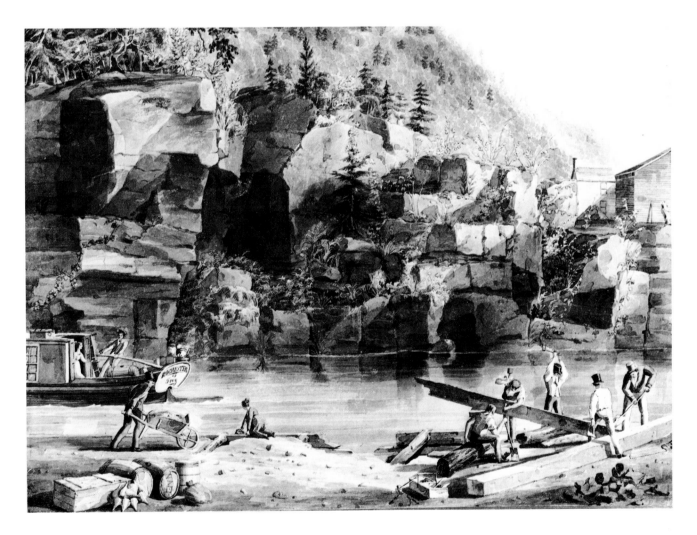

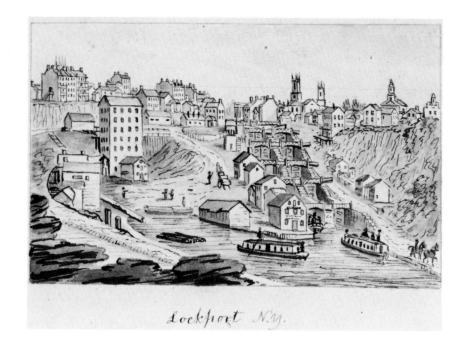

130. John W. Barber. Lockport, New
York. 1840. Pen and ink wash, 2¾ × 4".
New York Public Library, I. N. Phelps
Stokes Collection

incurred. That same year, nineteen thousand boats passed one town along
the route. It had been the greatest engineering feat achieved in America up
to that time—"the most stupendous chain of artificial navigation" in the
world, as one reporter described it—extending across central New York from
Albany to Buffalo and linking the Hudson River with Lake Erie. The most
amazing of its accomplishments was Lockport, with its five ascending and
five descending locks (plate 130). This was a key point on the canal, and
the town of Lockport—the temporary headquarters of construction—rock-
eted into importance. Within a score of years or so, the business that the
canal generated at Albany was greater than that generated by the entire
Mississippi River system at New Orleans.

Wherever the canal reached, it brought thriving new towns to life and
new life to old settlements. In 1803 land promoters had laid out a tiny
village on the shores of Lake Erie, at the site of what was to become the
city of Buffalo. Ten years later, during the War of 1812, the community
was devastated by a fire from which it only slowly recovered. With the
completion of the canal, Buffalo became its western terminus and the city
shot up with such explosive speed that it reminded the English novelist
Captain Frederick Marryat of Aladdin's magic palace.

The Great Lakes formed a natural extension of the canal, leading far
into the interior. Along those navigable lakes, town and villages felt the
magic touch of commerce borne back and forth from the Erie. Cleveland,
Ohio, founded in 1796, was an outpost one day and a flourishing port the
next. Cincinnati, already flourishing, suddenly boomed into the city pictured
by the Swiss-born artist John Caspar Wild about 1835 (plate 131). And so
it was everywhere along the shores of the western lakes and rivers.

Until the advent of the steamboat, and for decades after, much of the
traffic in people and merchandise up and down these rivers was carried by
flatboats and keelboats. The former were more quickly constructed, at about
a dollar or a dollar and a half per foot, and served as floating log cabins,
country stores, and barnyards for the passengers traveling on them, as they
drifted downstream with the current (plate 132). Often they traveled in
fleets for mutual protection. "I could not conceive what such large square
boxes could be, which seemed to be abandoned to the current," wrote one

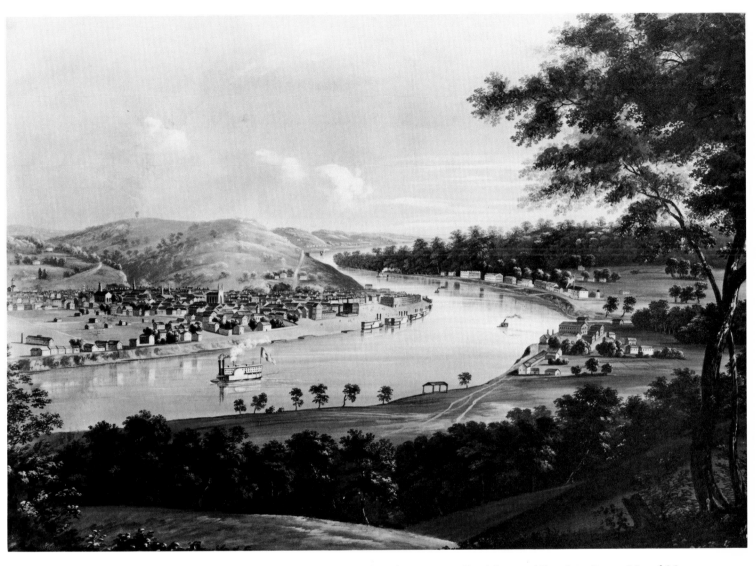

131. *John Caspar Wild. View of Cincinnati. c. 1835. Gouache, 21¾ × 31⅜". Museum of Fine Arts, Boston. M. and M. Karolik Collection*

132. *Charles-Alexandre Lesueur. Cotton Boat. 1829. Pencil. Museum of Natural History, Le Havre, France*

133. *Charles-Alexandre Lesueur. Interior of a Flatboat. 1826. Watercolor and pencil. Museum of Natural History, Le Havre, France*

French observer, "presenting alternately their ends, their sides, and even
their angles." There were families aboard, he noted, with all the equipment
needed to start farming wherever they found the right spot, "furniture,
ploughs, carts, and livestock included." Flatboats were not designed to work
their way upriver and were commonly broken up at the end of a journey
and sold for house timber.

Keelboats were double-ended, more easily directed, and could be poled
or towed upstream by men strong enough and tough enough to handle the
assignment. In his long forays up and down those rivers between 1826 and
1837, the French artist and naturalist Charles-Alexandre Lesueur observed
and recorded this passing scene with a sharp eye and a practiced pencil
(plate 133).

The boatmen who manned these miscellaneous craft were a rough breed,

hardy rivermen with an inexhaustible capacity for work and play. They were, wrote Mark Twain, "rude, uneducated, brave, suffering terrific hardships with sailor-like stoicism; heavy drinkers, coarse frolickers in moral sties . . . heavy fighters . . . foul witted, profane, prodigal of their money . . . prodigious braggarts, yet in the main, honest, trustworthy, faithful to promises and duty, and often picturesquely magnanimous." George Caleb Bingham, known at the time as "the Missouri artist," observed such types in their various moods and drew their likenesses from life (plate 134).

The arrival of the steamboat on western waters revolutionized commerce and traffic throughout that vast inland world. "The invention of the steamboat was made for us," reported a Cincinnati newspaper in 1815. "The puny rivers of the East are only creeks, or convenient waters on which experiments may be made for our advantage." As Mark Twain pointed out, the Mississippi and its tributaries drained a territory larger than the combined areas of Spain, Portugal, Germany, Austria, Italy, and Turkey.

The web of inland waterways in the West provided ideal conditions for steamboating. There, for a time (and before the day of railroads), the lack of good roads spared the new invention competition from overland routes. Many of the rivers and lakes provided the sheltered conditions required by early steamboats, and wood for fuel was everywhere available along the banks. In no time, scores of impatient travelers were taking to the paddle-wheelers to hurry their way onward (plate 136). In 1840 one Frenchman observed that "without the intercourse made possible by the steamboat, Ohio, Indiana and Illinois would today be a desert unknown to civilization."

135. Fanny Palmer. The Mississippi in Time of Peace. 1862. Pencil, watercolor, and gouache, 18½ × 28¼″. Museum of Fine Arts, Boston. M. and M. Karolik Collection

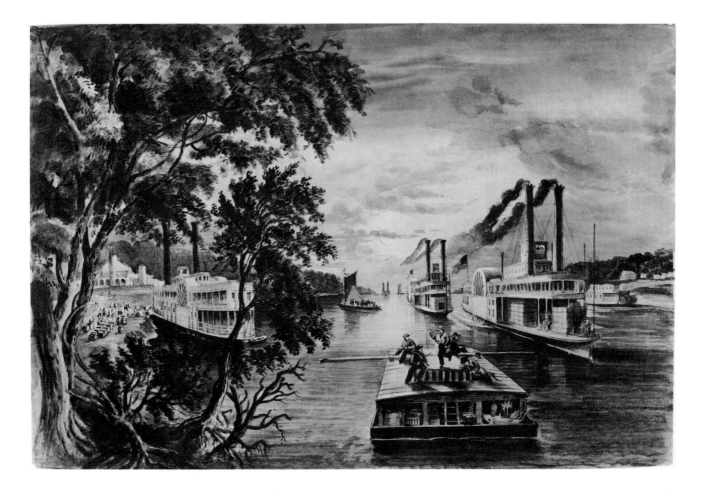

136. George Harvey. Portland Pier, Lake Erie. c. 1840. Watercolor, 8⅜ × 13⅝". The New-York Historical Society

A year later steamboats specifically designed for western rivers were described by one sharp observer as being "built of wood, tin, shingles, canvas and twine, and look like a bride of Babylon. If a steamboat were to go to sea, the ocean would take one playful slap at it, and people would be picking up kindling on the beach for the next eleven years." Nevertheless, their flat bottoms, elaborate superstructures, and high-pressure engines made them ideally suited to the needs of the place at the time. With their shallow draft, it was claimed, they could float wherever there had been a slight fall of dew. At their fastest they could travel against the current for 1,350 miles, from New Orleans to Louisville, in less than five days—a journey that required about three months by keelboat.

They became all but legendary for their appearance and performance, not only in America but around the world. Engineers from as far away as India and Russia came to study these phenomenal mechanisms contrived by Yankee designers and inventors. Even the hypercritical Mrs. Trollope had to concede that they were superior to anything of the kind she had seen in Europe. Others clearly agreed; for, during the years that followed, one Pittsburgh firm built scores of western-type steamboats for customers in such faraway places as Mongolia and the Belgian Congo.

It was in the early 1860s that Fanny Palmer, an English-born artist who drew many of the original scenes for the immensely popular lithographs of Currier & Ives, pictured a view of the Mississippi with a number of these majestic vessels passing by the flatboats and keelboats that, in spite of such competition, still worked their way along the river's treacherous currents (plate 135). But by then steamboating had already passed its heyday, and the Mississippi—"the leviathan of the North American continent"—had been reduced to a feeder of the fast-growing railways.

City and Countryside

137. Charles Burton. View of the Capitol. 1824. Watercolor and pencil, 15⅝ × 24⅜". The Metropolitan
Museum of Art, New York. Joseph Pulitzer Bequest

Attaining the Democratic Goal

WITH AN ACCEPTABLE conclusion of the War of 1812, the United States had survived its first great trial as a nation. The following year, 1815, after Waterloo, war-weary Europe laid down its arms and addressed itself to the serious problems of peace on the Continent and the seas. With the threat of interference from abroad thus allayed, the United States could finally look forward to a more independent future with confidence. "Peace and Plenty!" was a popular toast of the day. The country's mood was jubilant. A new sense of nationalism was born. The Swiss-born Albert Gallatin, who served as secretary of the treasury and, later, as minister to France, and then Great Britain, remarked of the public at large that "They are more American; they feel and act more as a nation."

The first step, both practical and symbolic, toward the assertion of this newborn patriotism was to restore and finish the uncompleted Capitol at Washington, which the British had reduced to a charred near-ruin. This task was undertaken first by Benjamin Henry Latrobe, but, upon his resignation in 1817, it passed into the skillful hands of Charles Bulfinch. The artist Charles Burton pictured the structure in 1824 as the work neared completion (plate 137). When she saw the building three years later, Mrs. Frances Trollope was "struck with admiration and surprise" at the sight of such a magnificent edifice rising from the still-raw landscape of the little town.

About 1837 a Canadian army officer, Lieutenant Philip Bainbrigge, drew a view of Pennsylvania Avenue and the distant Capitol (plate 138). Washington was even then but a growing village, its streets lined with sundry shops, restaurants, and modest boardinghouses, and its main avenue as of yet unpaved and unlighted. In 1842 Charles Dickens compared the scene unfavorably to a London slum suburb, excepting only a few handsome stone and marble buildings that had been put up in out-of-the-way places.

One of the inns, situated between Sixth and Seventh streets, was for decades known as the Indian Queen because of its reputation as a favorite stopping place for Indian chiefs who, until well after the Civil War, continued to come to Washington to powwow with the president and the lawmakers. In 1821 sixteen western tribesmen came to pay their respects to President James Monroe and, "part of them all naked," according to John Quincy Adams, staged a war dance for the Great White Father and his circle. The baroness Hyde de Neuville was on the spot and sketched those outlandish proceedings in her customary manner, which, though somewhat primitive, was always candid and revealing (plate 140).

In the years following the War of 1812, America seemed to be in a constant ferment: growing in size, in numbers, in wealth, and in strength. As early as 1817 John C. Calhoun pointed out to Congress, "We are greatly and rapidly—I was about to say fearfully growing. This is our pride and our danger, our weakness and our strength."

Nowhere was the rapid rate of that growth more apparent than in New York City, which, by the 1820s, had become indisputably the largest and most bustling urban center in the nation, as well as the most elegant. That elegance is suggested in a watercolor made about 1828 by the English artist William James Bennett (plate 139). At the time that he drew this view of Broadway as seen from the Bowling Green, that neighborhood was one of the city's more fashionable quarters as, indeed, it had been for some time. (The house shown at the extreme left of the drawing was occupied by George Washington in the early days of the Revolution.) When he visited

138. Lieutenant Philip
Bainbrigge. The Capitol
and Pennsylvania
Avenue. c. 1837.
Watercolor and pencil.
Public Archives of
Canada, Ottawa

139. William James Bennett.
Broadway from the Bowling
Green. c. 1828. Watercolor.
Private collection

the city that same year, James Fenimore Cooper wrote that Broadway was
"the fashionable mall of the city, and certainly, for gaiety and the beauty
and grace of the people who throng it . . . it may safely challenge competition
with most if not any of the promenades of the old world."

James Kirke Paulding, another well-known New York author, soon after
described the social routines that were pursued behind the facades of the
elegant houses along Broadway. He attended one party where "the real
fashionables did not arrive till about half past eleven, by which time the
room was pretty well filled. It was what was called a conversation party,
one at which there was neither cards nor dancing"—an occasion he thought
extremely dull. A few years later the *New York Mirror*, taking a more
charitable view, described such "agreeable *soirees* and coteries, where the
time imperceptibly glides on over the strains of choicest melody in the in-
tervals of literary conversation." Thus it appears in a silhouette drawn by

140. Baroness Anne-Marguerite-Henrietta Hyde de Neuville. Indian War Dance in Front of the President, James Monroe. *1821. Watercolor, 7⅝ × 12". Abby Aldrich Rockefeller Folk Art Center, Williamsburg, Va.*

Augustin Edouart in 1840, in which a reception at the Broadway residence of Dr. John C. Cheesman is depicted (plate 141).

During this time, Greek Revival styles in architecture, furniture, and decoration were enjoying a great vogue. A rendering by the prominent architect Alexander Jackson Davis indicates what an ideal interior in that fashion might look like (plate 142). His meticulous drawing shows a New York "double parlor," in which the front and back rooms were commonly separated by classical columns and fold-out mahogany doors. With this arrangement, the two rooms could be opened up into one for such large-scale entertaining as that which Paulding described.

In 1795 the master craftsman Duncan Phyfe moved his furniture shop from a less fashionable part of town to Partition Street (later named Fulton Street). It was an excellent location, close to Broadway and within easy reach of the carriage trade to which he catered, and he remained there until his death in 1854. John Rubens Smith depicted the group of structures that housed the shop and its warehouse as it appeared about 1815 (plate 143).

141. Augustin Edouart. Reception at the House of Dr. John C. Cheesman. 1840. Silhouette. Museum of the City of New York

142. Alexander Jackson Davis. Greek Revival "Double Parlor". c. 1845. Watercolor, 13¼ × 18⅛". The New-York Historical Society

143. John Rubens Smith. The Shop and Warehouse of Duncan Phyfe. c. 1815. Watercolor and pen and ink, 15¾ × 18⅞". The Metropolitan Museum of Art, New York. Rogers Fund

This picture, which has been termed "one of the best-known American drawings of the early nineteenth century"—and is, in fact, one of the most interesting architectural renderings of the period—is superbly detailed. In the center of the composition, for example, fashionably dressed ladies can be seen examining an assortment of Phyfe's elegant chairs.

For the less wealthy inhabitants of the city, shopping was conducted on quite a different scale. Along many New York streets, household products and provisions of all varieties—from charcoal, ice, and lamp oil to meat, oysters, and root beer—were hawked by a picturesque assortment of vendors whose cries, advertising their wares, were pitched above the other noises of the metropolis. Some of these hucksters were well-known characters, of both good and bad repute. Their animated performances and colorful appearance were carefully recorded by such visiting foreign artists as the Italian Nicolino Calyo (plate 144).

In its impetuous, rapid growth, the incessant bustle of its streets, and the teeming activity of its marts, New York epitomized the urbanization of America that was to become such a phenomenal development as the nineteenth century advanced. As early as 1827, to accommodate the ever-increasing concerns of businessmen, a large, marble Merchants' Exchange had been built on Wall Street. Properly known as "the money depot of the city" (which meant, in effect, of the nation), its principal room was eighty-five feet long, fifty-five feet wide, and forty-five feet high (plate 145). From its cupola, messages about arriving ships were sent to and received from other stations in a line of semaphores that reached to Sandy Hook, New

144. Nicolino V. Calyo. The Charcoal Cart. c. 1840. Watercolor, 10¼ × 14″. Museum of the City of New York

Jersey. Within fifteen years this impressive structure was replaced by an even larger and more costly building.

During these decades, American manufacturers were playing an increasingly important role in the nation's economy. The roots of this trend lay in the long disturbance of foreign trade resulting from the Revolution, the cold war with France in 1798, the Intercourse and Embargo acts that followed, and finally the British blockade of the Atlantic coast during the War of 1812. All of these events had practically obliged this country to manufacture for itself many articles, especially fabrics, that for centuries had been imported from England and the Continent. The support of native industries was motivated by more than practical considerations; for many it became an important patriotic gesture. In 1811 the Kentucky legislature pointed out that Americans would never be a truly free people until they were independent of England commercially as well as politically. (Washington had conspicuously made that point when, at his inauguration, he wore a suit of Connecticut-made broadcloth, especially ordered for the occasion.) Even Thomas Jefferson, champion of an agrarian society, with unwonted hyperbole conceded that Americans would have to go clad in skins if they did not develop their own clothing factories.

About 1815 the French-born architect Maximilian Godefroy sketched the complex of buildings that housed the Union Manufactories of Maryland, situated at Patapsco Falls in Baltimore County (plate 146). This operation had been initiated during the embargo of 1807 and, by 1825, it employed six hundred hands to tend eighty thousand spindles driven by sixteen waterwheels. Commenting on such enterprises, a Connecticut newspaper reported that "wheels roll, spindles whirl, shuttles fly." Jefferson believed that these advances in the economy were alone worth all that the War of 1812 would cost.

145. Charles Burton. Public Room, Merchants' Exchange. c. 1830. Sepia, 2¾ × 3½". The New-York Historical Society

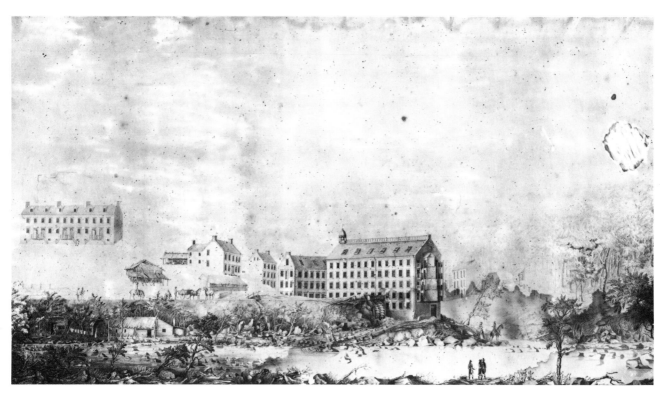

146. *Maximilian Godefroy. The Union Manufactories of Maryland in Patapsco Falls, Baltimore County. c. 1815. Pen and ink,*
25½ × 37¼". Maryland Historical Society, Baltimore. Gift of Mrs. John J. Schwarz

147. *Edwin Forbes. Old Mill at Sandy Hook, Maryland. 1863. Pencil, 4⅜ × 7¼". Library of Congress, Washington, D.C.*

For decades the relatively small, clean, semi-rural character of the villages where so much was produced struck an agreeable note on the American landscape. For a while yet, America would be spared the blight that had darkened England's industrial centers. American factories were, for the most part, located at isolated points along swift-running streams that supplied an abundance of waterpower (plate 147), and this would continue to be the case until the increased use of coal and steam rendered such advantages obsolete.

To spur manufacturers to ever greater performance and to initiate the public to the new products that were ready for the market, in 1828 the American Institute inaugurated a series of annual fairs to be held in New York City (plate 148). The day of mass production was dawning. After returning from a trip to America, one group of British manufacturers reported

148. *B. J. Harrison.* Fair of the American Institute at Niblo's Garden. *c. 1845. Watercolor, 25½ × 32⅞". Museum of the City of New York*

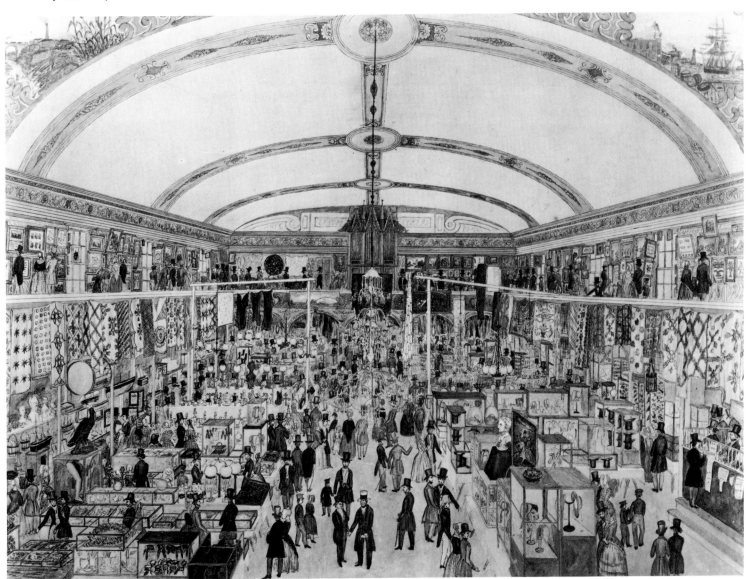

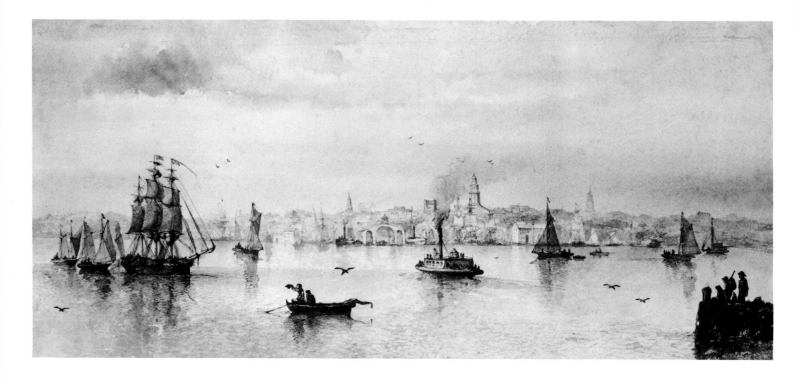

to Parliament that of the new ideas and inventions changing the nature of industry, a large percentage had originated in the United States.

The new machinery of American industry needed lubricants, and these were generously supplied by the whalers that ventured out of such north-eastern ports as New Bedford, which by the 1850s had become the whaling metropolis of the world (plate 149). Before the advent of kerosene and gas lighting, the nation also depended heavily on whale oil for lamps and candles. Herman Melville observed that the opulent houses of that town were "one and all . . . harpooned and dragged hither from the bottom of the sea." By 1857 New Bedford had more than three hundred vessels combing all the seven seas for blubber—exploring, as Melville wrote, "the remotest secret drawers and lockers of the world." In later years those explorations would play an important part in the territorial expansion of the United States, in the management of its diplomatic relations, and even in the development of its trans-Pacific air routes.

Looking around him at the teeming and increasingly hectic metropolis of New York, Washington Irving (plate 150) liked to imagine "a retreat whither I might steal away from the world and its distractions, and dream quickly away the remnant of a troubled life." Many other Americans must have sympathized with these sentiments as they witnessed the almost vi-olent change from old values to new that was taking place. Irving found his retreat at Sunnyside, his Tarrytown home (plate 151), a building which he had the artist George Harvey fashion into "a little nookery somewhat in the old Dutch style, quaint and unpretending." As remodeled in accordance with Irving's wishes, more or less in the Gothic Revival style, Sunnyside was, and still remains, a picturesque reminder of a past that can never be recovered.

The growing turmoil of urban life that disquieted Irving (and James

149. Albert van Beest. New Bedford from Fair Haven. c. 1848. Pen and ink and wash, 12½ × 28⅜″. Museum of Fine Arts, Boston. M. and M. Karolik Collection

150. John Wesley Jarvis. Washington Irving. 1800. Wash, 3⅝ × 5¼″. Yale University Art Gallery, New Haven, Conn.

151. John Henry Hill. Sunnyside. c. 1860. Watercolor, 10 × 13½″. Museum of Fine Arts, Boston. M. and M. Karolik Collection

152. *George Harvey.* Boston Common from Charles Street Mall. *1835–40. Watercolor, 8⅜ × 13⅝". The New-York Historical Society*

Fenimore Cooper) was not, of course, everywhere apparent. For some years still to come, America remained predominantly a land of farms and villages. A rural atmosphere was discernible just beyond the borders of such major cities as Boston (plate 152) and New York. Many of the inhabitants of those cities were only recently removed from farms and small villages, and they continued to think and behave like country folk in their new urban environment. This waning agrarian legacy is recalled in many of William Sidney Mount's drawings of rural scenes on Long Island. In these drawings Mount sketched the farming landscape that was all around him, and his rural neighbors at work and play (plates 153, 154). Some thought he presented a view of American life that was too idyllic. Others, already apprehensive of the encroachment of urban values on a traditionally agricultural society, viewed Mount's pictures with an appreciation that was not without some nostalgia for a vanishing past.

At the same time, the farming scene was itself undergoing changes. In the Southeast, many planters were moving west in search of fresher fields to cultivate. All over the land, in fact, the movement west was gaining momentum, and many feared that this steady migration would dangerously threaten long-established communities. "Old America seems to be breaking

up and moving westward," reported one British traveler who, in the im-
mediate aftermath of the War of 1812, had observed the continual traffic of
emigrants along the route to Ohio. So it also seemed to the Harvard-edu-
cated missionary Timothy Flint, who, about the same time, spotted the
abandoned farms of Yankees who had moved on to fresh soil farther inland.
"Our dwellings, our schoolhouses, and churches will have mouldered to

*153. William Sidney
Mount. Study for Ringing
the Pig. 1842(?). Pencil, 9
× 13⅜″. The Museums
at Stony Brook, N.Y.
Bequest of Ward Melville*

*154. William Sidney Mount.
Dancing in a Barn. 1849. Pen
and ink, 4⅞ × 6⅞″. The New-
York Historical Society*

ruins," he moaned, "our graveyards will be overrun with shrub-oak, and but here and there a wretched hermit, true to his paternal soil, to tell the tale of other times."

In Virginia, where the economy and way of life had been determined by tobacco culture, only planters with very large holdings could continue to grow the "evil weed" which so quickly exhausted the soil (plate 155). The rest moved ever "backward" to fresher fields in the Piedmont and the farther West. By 1840 more tobacco was grown west than east of the Alleghenies.

The same was true for the cultivation of cotton. As long as new lands remained cheap and plentiful in the West, cotton plantations moved inex-orably in that direction—toward the Piedmont, then into the rich lands of the Alabama and Mississippi Black Belt, and so on to Texas. The whole western world provided a profitable market for American cotton, and it was grown wherever weather and soil conditions permitted. A Texas cotton farm depicted in the late 1830s by William Bollaert (plate 156) presents a picture far different from our accepted conception of an antebellum southern

155. August Köllner. Virginia Planter's Family. 1845. Watercolor. Kennedy Galleries, Inc., New York

156. *William Bollaert.* Texan Farm in Montgomery County. *Late 1830s. Pencil, 7¼ × 11¾". Newberry Library, Chicago*

plantation with its white-columned facade. The rude buildings made of logs, raised amid the still-rooted trunks of old trees, resemble a primitive frontier community—which indeed it was. Nevertheless, with the yield from communities such as this and from other, more finished complexes, the output of Texas's cotton farms increased at a prodigious rate. In the 1850s, when "Cotton was King," or so it seemed, profits from it accounted for more than half of the total revenue received from all other American exports combined. And, fatefully, three quarters of the country's slaves were engaged in its production.

Sugar had been cultivated under French rule in Louisiana in the eighteenth century. Before the Civil War, well over a thousand plantations spread out along the banks of the Mississippi and its bayous, were devoted to its production (plate 157). The nature of the refining operations called for large-scale cultivation and the employment of many slaves in the fields to cut the cane. The latter were commonly clad in striped clothes to identify them as they literally slaved under the watchful eye of the overseer (plate 158). It was a highly profitable enterprise and, along with cotton, largely

157. *Adrien Persac.* Olivier Plantation. *1861. Watercolor and collage. Louisiana State Museum, New Orleans*

accounted for the prosperity of the state. Because of the character of its commerce, Louisiana had strong economic ties with the North, a major buyer of its produce. With the outbreak of the Civil War, this interdependency further complicated the already awesome issues raised by that tragic conflict.

For all this produce, as well as for the immense traffic in all manner of things that floated or steamed down from upriver, New Orleans was the entrepôt, as John Law had planned it to be so many years earlier. In the 1840s the English lecturer James Silk Buckingham wrote: "It may be doubted whether any river in the world can exhibit so magnificent a spectacle as the Mississippi—even New York, splendid as is the array of ships presented by her wharfs, is not so striking as New Orleans where a greater number of large, handsome, and fine vessels seemed to me to line the magnificent curve of the Mississippi, than I had ever before seen in any one port" (plate 159). New Orleans had indeed become one of the great ports of the world.

During these decades an increasing tide of European immigrants was flowing through all the major ports of America. What was at first a trickle of humanity soon became an almost overwhelming torrent. By mid-century literally millions had arrived. Some spread out into the farmlands; others, in large numbers, paused or stayed on at their point of entry. Some had sailed overseas jammed into airless holds; others, more affluent, traveled in style

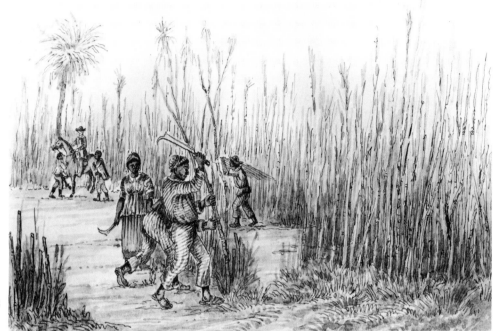

158. *Franz Holzlhuber. Sugar Harvest in Louisiana and Texas. 1856–60. Watercolor, 5⅝ × 8⅝". Glenbow Foundation, Calgary, Canada*

159. *Thomas Kelah Wharton. River and Levee at New Orleans. 1855. Pen and ink, 8⅝ × 11¾". New York Public Library, Manuscripts Collection*

160. John A. Rolph. Scene on the Forward Deck of the Cornelius Grinnell. 1851. Ink wash, 9⅞ × 16". Collection J. Welles Henderson, Philadelphia

and enjoyed the deck privileges—as had the group pictured aboard the *Cornelius Grinnell* en route from Liverpool to New York in 1851 (plate 160).

"All Europe is coming across the ocean," it seemed to one observer in 1836, "all that part at least who cannot make a living at home; and what shall we do with them?" Alexis de Tocqueville, the author of the seminal *Democracy in America*, pondered that same question. He believed that the incoming swarms, swelling the population of cities and adding to the turbulence of the changing urban scene, posed a serious threat to the democratic institutions of the United States. As an indication of this, he noted that riots had recently broken out in the streets of several major cities. A number of these were caused by the resentment felt by "real Americans," that is, those who by chance had arrived here earlier, toward those who by different chance came later. In mid-century shameful demonstrations of prejudice and intolerance greeted the incoming floods of Irish Catholics and Germans—and all in the name of patriotism. John McLenan, a popular illustrator of the time, satirized these feelings in a sketch showing a young bootblack bowing with mock courtesy to a newly arrived Irish family (plate 161). In 1856 another artist caricatured a riotous display that had been mounted at Baltimore by the Know-Nothings (officially known as the Native American party)—an ultranationalist, anti-immigrant, anti-Catholic, anti-Irish, and anti-German group (plate 162). The Know-Nothing party was so called because its members were sworn to secrecy about their purpose to keep America under the rule of "real Americans."

However, the growing nation sorely needed and put to good use the brawn, muscle, and determined spirit of such newcomers; and, for the most part, they were relatively soon assimilated into the American society at large. The question then became one of how to hold the social and political fabric intact during a period of such rapid and vital change. The answer to that question would become the first true gauge of the new democracy in action, and would challenge both individuals and government alike.

161. *John McLenan. Our Foreign Relations. c. 1864. Pen and ink, 9⅛ × 28″. Museum of Fine Arts, Boston. M. and M. Karolik Collection*

162. *Artist unknown. A Know-Nothing Demonstration at Baltimore. c. 1856. Pen and ink and wash, 10½ × 9¼″. Maryland Historical Society, Baltimore*

163. *Lewis Miller. The Old Lutheran Schoolhouse in 1805. c. 1815. Watercolor, 9¾ × 7⅝″. York County Historical Society, York, Pa.*

164. *George Harvey. The Apostle's Oak. 1844. Oil on wood panel, 17 × 14″. The New-York Historical Society*

One of the brightest assurances for America's future stemmed from the deep concern of the Founding Fathers for the education of the people—for "every class and rank of people, down to the lowest and poorest," as John Adams asserted. These men held that, if their new experiment in government were to succeed, teaching and learning must be free and available to all. This was then an untried principle, and to some it seemed a dangerous one, like the idea of universal suffrage. During his stay in America, early in the nineteenth century, Pavel Svinin observed that every *muzhik* ("Russian peasant") in America, who had been schooled side by side with bankers' children, was informed about subjects that would have been incomprehensible to his counterpart in Russia.

The development of a good common school system was slow and erratic. Even so, Tocqueville believed that this country had more and better schools than any other nation. Some of these were traditionally administered at college as well as elementary levels by the various religious denominations (plate 163). But it was the gradual evolution of a universal public school system that became one of the hallmarks of American democracy. The one-room country schoolhouse, so long one of the characteristic supports of that growing system, had its very real limitations as an educational device. But schooling in this land has always had important social purposes. In urban communities, for instance, schools at the elementary level provided a way to convert immigrants' children to an understanding of the ideals of democracy as they were practiced in the "sweet land of liberty" in which they suddenly found themselves. As an aside to such functions, Ralph Waldo Emerson pointed out that although youngsters were dutifully sent to a schoolmaster for instruction, often it was the children who educated *him*. Much of their education, he philosophically suggested, came on their way to school (plate 164).

Onlookers of the American scene at mid-century were astonished by the earnestness with which adults—natives and newcomers alike—carried on their education or made up for their lack of formal schooling by whatever means they could find. The Lyceum movement, organized in 1826 to promote the "general diffusion of learning," covered virtually the entire country with programs of lectures on every conceivable subject. "It is a matter of wonderment . . ." wrote one startled Englishman, "to witness the youthful workman, the overtired artisan, the worn-out factory girl . . . rushing . . . after the toil of the day is over, into the hot atmosphere of a crowded lecture room" (plate 165).

165. Artist unknown. Lyceum Lecture by James Pollard Espy at Clinton Hall. 1841. Pen and ink, 7½ × 10¼". Museum of the City of New York

The proliferation of inexpensive newspapers in what has been termed "the land of the general reader" played an increasingly important role in the spread of information (and misinformation). With "scraps of science, of thought, of poetry . . . in the coarsest sheet," wrote Emerson, the daily newspaper brought the university to every poor man's door—along with trash and scandal, it should be added. Foreign visitors were struck by the American's addiction to his newspaper (plate 166) and by the frenetic energy of the cities' newsboys as they peddled their wares. "You are amazed,"

above left: 166. Nicolino V. Calyo. Reading Room, Astor House. c. 1840. Watercolor, 8⅞ × 12¼″. Museum of the City of New York

above right: 167. A. H. Extra, Sir? c. 1850. Watercolor. Museum of the City of New York

below: 168. Thomas Waterman Wood. American Citizens at the Polls. 1867. Watercolor, 21 × 39″. Wood Art Gallery, Montpelier, Vt.

wrote an English visitor, "at the energy of the newsboys . . . as they rush hither and thither with their arms full of wisdom, at a penny an instalment" (plate 167).

Emerson believed that at its best the omnipresent newspaper made a vital contribution to the freedoms Americans enjoyed. Years before, Tocqueville had reflected in a similar vein that only through this medium could all the "little people" constituting a democracy meet and unite in their opinions and feelings. By the middle of the century these people were in the ascendant. In the wake of Jackson's presidency (1829–37), American democracy had developed into a unique political phenomenon, without precedent in world history.

By mid-century, "We, the people" had become the sovereign of the nation and they swarmed to the polls in large crowds to exercise their authority (plate 168). They also held what were frequently almost riotous demonstrations on the streets to bolster the cause of the "right" candidate proposed by one or the other of the recently organized Democratic and Republican parties (plate 169). The United States had become a large federal system, made up of various sections with different problems and with a population of multitudinous interests, pursuits, beliefs, classes, religions,

169. Alfred Jacob Miller. Election Scene at Catonsville, Maryland. 1845. Pencil and wash, 8⅛ × 10¾". Museum of Fine Arts, Boston. M. and M. Karolik Collection

170. George Caleb Bingham. Study for Stump Speaking. 1853–54. Pencil, brush and ink, and wash, 11⅝ × 9⅝". St. Louis Mercantile Library Association

local attachments, and racial backgrounds. It was charged with potentially destructive centrifugal forces. The political parties had become the essential adhesive that held the Union together through endless bargains, compromises, and often bitter controversies. After the candidates had had their say (plate 170) and the verdict of the people was proclaimed, political tempers that had flared to a white heat during a campaign immediately cooled. As the psychologist and philosopher William James once observed, Americans had developed "the habit of trained and disciplined good temper toward the opposite party when it fairly wins its innings."

By the 1850s the Industrial Revolution was in full swing. Conditions of life were changing more rapidly than they had for the past millennium. Although westward expansion was gathering enormous momentum, the nation had not yet digested nor even explored the vast new territories that had been added to the Union, and each new addition brought with it sectional rivalries that ineluctably focused on the problem of slavery.

The Farther West

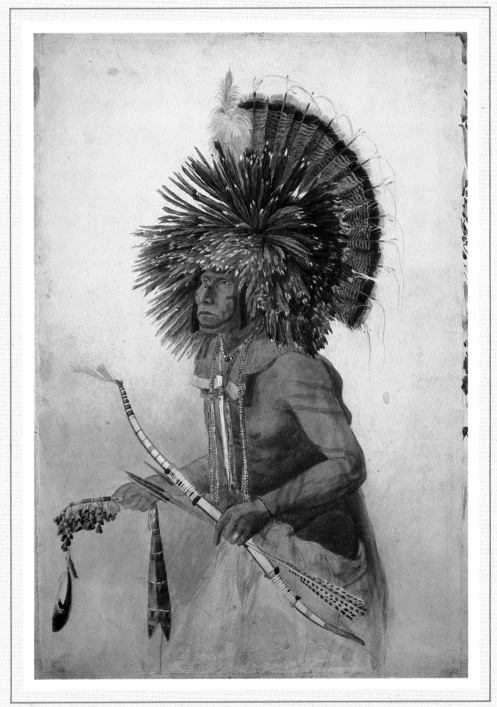

171. *Karl Bodmer.* Pehriska-Ruhpa ("Two Ravens"), Chief of the Hidatsa, in the Costume of the Dog Dance. 1834. *Watercolor, 17 × 11¾". The InterNorth Art Foundation, Joslyn Art Museum, Omaha*

Crossing the Wilder Reaches

WITHIN LESS THAN three generations following the birth of the nation, gigantic chunks of land had been added to its holdings. The acquisition of the Louisiana, Florida, Texas, Oregon, California, and New Mexico territories, each as large as a fair-sized European country, brought the full breadth of the continent within the United States. Each addition hurried more emigrants farther westward. The frontier set its own pace. Passing the Mississippi and Missouri rivers, invading lands "forever" set aside for the Indians, crossing lands that were "impassable," opening up areas for settlement that were "uninhabitable," finding paths over "unconquerable" mountains, the advance guard led the way to the shores of the Pacific Ocean.

Even before the United States had officially claimed jurisdiction over that vast segment of the continent, intrepid souls had been tackling the journey to the Far West. Every advance in that direction brought novel problems that concerned both individual pioneers and the government alike. In the 1820s and 1830s, foreign powers were still very much in evidence in parts of Oregon, California, and elsewhere, and, with the question of ownership not yet resolved, there existed a delicate balance at best. In addition, the adventurers and emigrants, once they left the wooded lands of the eastern regions behind them, faced a land that, like the sea, held little or no shelter. On the illimitable Great Plains—the "biggest clearing on the Almighty's footstool"—and in the mountains beyond, they met a new world of wild creatures whose ways they must know if they were to survive and subsist. Here, too, they encountered the mounted Plains Indians—Arapaho, Blackfoot, Crow, Comanche, Apache, Sioux, and still other tribes—whose ways it was also wise to know, for these roving Indians would become the white man's toughest adversaries, standing in the path of his continued westward march.

Some of the finest drawings of these western Indians, both accurately and dramatically rendered, were the work of Karl Bodmer. His portrait of a chief of the Hidatsa leading a ceremonial dance in full regalia (plate 171) is just one more notable example of the skilled observations that he made under the knowledgeable direction of Prince Maximilian. Bodmer's work was not always easy: at times of a wintry day, his inks and watercolors froze solid; at other times his Indian subjects made it the more difficult, either because of their inordinate vanity or because of their dread of this strange white man's magic that could produce a "clone" on paper.

For the Indians, this was strong medicine indeed; that it was good or bad medicine was determined only after tribesmen had deliberated the matter in solemn council—and even then there remained misgivings. Bodmer tried to explain that his pictures produced no ill effects and, as proof of this, he pointed out that of the Indians whose portraits he had drawn not one had been killed or wounded by his enemies. But, with intertribal wars threatening the whole countryside with bloodshed and confusion, these remonstrations inspired little confidence. Even after permission for the drawing had been granted, new difficulties often emerged. The artist might be threatened for having mistreated his subject—for having represented him in something less than his finest trappings, perhaps, or for some other imagined slight. Years after Bodmer had returned to Europe, the French artist Paul Frenzeny made a drawing entitled *The Big Medicine Man* (plate 172), in which he pictured himself before his easel, surrounded by a group of fascinated, curious, and somewhat incredulous Indians.

White men, too, were at first incredulous at the exploits of the Indian.

172. Paul Frenzeny. The Big Medicine Man. 1873–80. Pencil, watercolor, and gouache, 12½ × 18⅝". Museum of Fine Arts, Boston. M. and M. Karolik Collection

In play, as in strife and chase, the Indian measured his worth in terms of his stamina. One witness described a lacrosse game ("le jeu de la crosse") that lasted virtually an entire day, in which the colorfully painted, half-naked participants ran as many as forty or fifty miles before their sport was ended (plate 173). He likened their muscular bodies to "so many Mercuries," as they ran, vaulted, and sprang into the air on the lawnlike prairie.

Even more impressive was their phenomenal ability on horseback. To the white man, the Indian and his mount seemed to be a single lithe creature. "The wild horse of these regions," wrote the artist George Catlin, "is a small, but very powerful animal; with an exceedingly prominent eye, sharp nose, high nostril, small foot and delicate leg" (plate 174). It was reported that these creatures could outrun the best blooded horses from Kentucky.

above: 173. Frank Blackwell Mayer. Indian Lacrosse Player. 1851. Pencil, 7⅛ × 4⅛". Newberry Library, Chicago. E. E. Ayer Collection

left: 174. Rudolph Friedrich Kurz. Blackfoot Pony. 1852. Pencil and ink, 10¼ × 13¾". National Anthropological Archives, Smithsonian Institution, Washington, D.C.

The Indian's war-horse, or buffalo horse, was his most cherished possession, his pride made manifest, and his greatest security in a hazardous life.

In 1837 another artist of the Plains, Alfred Jacob Miller of Baltimore, made a sketch of a party of mounted Blackfeet on the warpath, which he subsequently worked up into a watercolor (plate 175). The Blackfeet, he observed, "have the worst reputation for war and aggression of all the Indians of the North-West. Their very name is a terror to most of the Indian tribes, and are so strong in numbers, so determined in their vengeance, that indiscriminate slaughter follows victory."

Their hatred was directed at the white man, also, especially at those who trespassed on their beaver streams, robbing them of the wealth in trade that they gleaned from those preserves. However hazardous that made the trapper's quest, it did not deter him: "No toil, no danger, no privation can turn the trapper from his pursuit," wrote Washington Irving. "In vain the most vigilant and cruel savages beset his path." Miller, too, noticed their undaunted spirit and pointed to it in a number of drawings (plate 176).

The trapper's most highly prized quarry was the beaver, whose pelt was a prime commodity in eastern and, especially, European markets, where it was used to make fashionable hats (plate 177). By 1840, however, the

175. Alfred Jacob Miller. Blackfoot Indians on the War Trail. 1850s. Watercolor, 9⅞ × 13⅛". Walters Art Gallery, Baltimore

vogue for beaver hats was waning, and silk hats came into style just in time to save the little "varmints" from extinction.

The wild western backcountry was a cosmopolis of sorts, peopled by adventurers who, in the 1820s and 1830s, came from many different lands, to reap, among other things, the harvest of furs that were in demand all

176. Alfred Jacob Miller. Trapping Beaver. 1850s. Watercolor, 8⅞ × 13¾″. Walters Art Gallery, Baltimore

177. Alexander Jackson Davis. Leonard Bond's Hat Warehouse. c. 1828. Watercolor, 7⅜ × 9″. Museum of the City of New York

178. George Caleb Bingham. Study for *Fur Traders Descending the Missouri.* 1845.
Pencil, brush and ink, and wash, 11⅞ × 9½". *St. Louis Mercantile Library*
Association

over the world (plate 178). Of all that international proletariat, the most picturesque were the French-Canadian and half-breed *voyageurs* (plate 179) who had early been on the scene and whose colorful garb, endless stamina, volatile personalities, and finesse with paddle and trap were a never-ceasing wonder. They knew the routes by waterway and portage that led from Montreal to the farthest reaches of the West. They wore red caps and sashes, blue cloaks, and deerskin leggings and sang gay and bawdy songs to the beat of their paddles.

The plainsmen and the mountain men who worked that western wilderness came to know it in all its moods and patterns. The best of them knew it more keenly and sensitively than the native Indians and the wild beasts that they had to outwit if they were to make their living—and live. Before their day was over, those lands had yielded to them not only their furs but also their innermost geographic secrets. These men blazed the trails for the invasion of emigrants that would follow.

Shortly after the War of 1812, the War Department had undertaken to build a series of garrisons that would guard the advance of civilization starting to move westward into those parts (plate 180). These outposts, and others set up by competing trading companies as fortified depots, served as rendezvous for hunters, Indians, traders, explorers, and passing emigrants.

179. *Frank Blackwell Mayer. Henry Belland, Voyageur. 1851. Pencil, 7⅛ × 4⅛". Newberry Library, Chicago. E. E. Ayer Collection*

180. *Alfred Jacob Miller. Fort Laramie, Wyoming. 1850s. Watercolor, 8½ × 11¾". Walters Art Gallery, Baltimore*

Here were the crossroads of culture, where Indians and white men who were a bare cut above the wild creatures that they hunted mingled with postgraduates of Europe's salons and studios, eager for sport or study. From these fortified enclosures a lively trade was conducted; furs were swapped for blankets, firearms, whiskey, trinkets, or for whatever else was needed or wanted out beyond.

By the middle of the nineteenth century, the "great migration" to the farther West was well under way. It became a phenomenal wandering of peoples, which Horace Greeley opined wore "an aspect of insanity." The story of that wandering has become America's great romantic saga. But the crossing of over two thousand miles of raw country to reach distant goals in Oregon, California, and way points was full of very harsh realities that had little to do with romance. Every one of those miles exacted a toll of hardships endured, dangers suffered, lives lost, and spirits crushed. Before it was over, pioneering, grim as it so often was, had become the common experience of countless Americans.

Greeley was not the only one to question such adventuring. In 1828 one representative derisively asked Congress, "What can lead any adventurer to seek the inhospitable regions of Oregon unless, indeed, he wishes to be a savage." For most Americans, that then seemed too remote a matter for concern. Within a score of years, the Oregon Trail (which extended from Independence, Missouri, to the Willamette Valley in Oregon) had become a heavily rutted thoroughfare, traveled by more than three thousand emigrants in 1845 alone. By 1846 the American settlement of Oregon City

181. Henry James Warre. American Settlement of Oregon City. 1846. Watercolor, 6⅞ × 10″. American Antiquarian Society, Worcester, Mass.

could boast of "two churches, and 100 houses, stores, & all of which have been built within five years" (plate 181).

In the summer of the following year, Brigham Young led the first contingent of Mormons toward what he deemed would be the promised land. He felt sure that this sanctuary for his harassed followers lay somewhere in the little-known Mexican territory beyond the Rockies. At the Council Bluffs crossing of the Missouri River, on the overland trail, he left a forwarding station so that other Mormons could follow him westward—which they did in large, well-disciplined numbers. Young found the land he had envisioned on the shores of the Great Salt Lake, beyond reach (for a short while) of American authority. Within a very few years, these earnest and industrious folk had transformed what appeared to be a desolate wasteland into what one man called a "Diamond of the Desert." Salt Lake City had become a flourishing community (plate 182) and, under Young's patriarchal direction, the State of Deseret, as the area was known, proved to be an unprecedented example of state socialism. In the 1860s Mark Twain admired the "pleasant strangeness" of the neat, orderly, and productive community, a healthy place where, he jested, there was but one doctor, who was arrested once a week for having no visible means of support.

Within two years of its founding, the little city at Great Salt Lake was serving as a welcome resting and provisioning stop for forty-niners headed

182. Frederick Piercy. Great Salt Lake and Salt Lake City. 1853. Pen and ink washed in sepia, 6⅜ × 10⅜ ". New York Public Library, Print Collection

183. *George Catlin.* Indian Scalping an Enemy. *n.d. Pencil, 6⅜ × 8¾". Museum of Fine Arts, Boston. M. and M. Karolik Collection*

for the gold mines in California. Gold had first been discovered there in January 1848 at John Sutter's sawmill, near Coloma. The news of this strike set off the largest migration that had yet occurred to the West Coast. In the first six months of 1850, the roster at Fort Laramie—where the emigrants were supposed to register before they moved on—listed the arrival of some forty thousand persons, almost ten thousand wagons, and far more thousands of livestock. Men, women, and children hurried onward despite the fact that, in 1835, Congress had banned all white persons without a special license from intruding on Indian territory west of the Missouri River. "A barrier has been raised for their protection against the encroachments of our citizens," solemnly pronounced President Andrew Jackson. The utter futility of that edict had been apparent almost as soon as it was passed.

All those who took the overland trails faced similar problems and perils. The Indians were still there, of course, in abundance, threatening the progress of these westering people. George Catlin, who knew the ways of the Indians better than any other artist, pictured a native at work on an enemy (plate 183)—a fate that all too many whites had encountered as well. Although several traveled on foot, walking beside their pack mules, by the

184. William M. Cary. Covered Wagon
Caravan. *n.d. Wash, 7½ × 9¼". The
Thomas Gilcrease Institute of American
History and Art, Tulsa*

time these migrations were well under way the covered wagon, or prairie
schooner, had become a standard vehicle on the plains. For safety's sake,
the emigrants formed caravans of such wagons (plate 184) before they trun-
dled across the landscape—a landscape that was often littered with excess
paraphernalia, from cooking utensils to household furniture, abandoned by
earlier emigrants for want of strength and means to carry them farther.
Notes of advice and warning to those who followed were scribbled on the
skulls of dead oxen, and abandoned sites were often filled with the nauseous
stench from the rotting corpses of such animals (plate 185).

185. Joseph Goldsborough Bruff.
Scene on the Emigrant Trail, near
Settlements. 1849. Pen and ink and
pencil, 7¼ × 10¼". The
Huntington Library and Art
Gallery, San Marino, Calif.

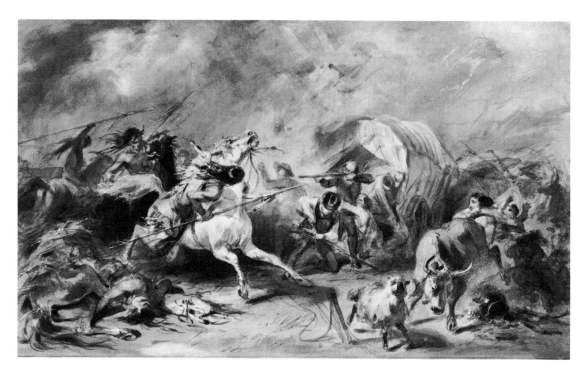

186. *Felix O. C. Darley.* Indian Attack on an Emigrant Train. *n.d. Wash over pencil on board, 10¼ × 18⅛″. Museum of Fine Arts, Boston. M. and M. Karolik Collection*

187. *James F. Wilkins.* Crossing the South Platte. *1849. Wash, 8⅜ × 20″. State Historical Society of Wisconsin, Madison*

Small groups of emigrants, stragglers from large caravans who could not keep up the pace, were the principal prey of marauding Indians. Felix O. C. Darley's sketch of such an episode (plate 186) was undoubtedly drawn from his informed imagination, but it accurately reflects the popular image of what might be expected by those who took their chances en route to dream's end. (Darley was a popular illustrator of the times; at the height of his career the phrase "Illustrated by Darley" was about enough to ensure a book's success.) Murderous as such incidents could be, the main purpose of the Indians' assaults was thievery of livestock and other valuables rather than the slaughter of human beings.

If anything, the routine rigors of travel presented greater perils to a safe passage across plains and mountains. "Instead of turning up the golden sands of the Sacramento," wrote one forty-niner, "the spade of the adventurer was first used to bury the remains of a comrade." Attempts to cross swift-running streams that had treacherous bottoms of slippery mud or quicksand often ended in death by drowning. Fording the shallow South Platte River, a necessary crossing on the way to Oregon and California, tried the endurance, the skill, and the nerves of wagoners (plate 187). For a while, the Mormons did a thriving business ferrying apprehensive Gentiles (their name for non-Mormons) from one shore to the other. To save the fare that

188. *Joseph Goldsborough Bruff.* Ferriage of the Platte, Above Deer Creek. 1849. *Pen and ink and pencil, 7⅜ × 11″. The Huntington Library and Art Gallery, San Marino, Calif.*

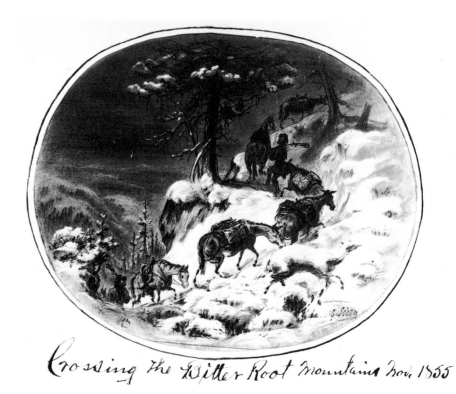

189. *Gustavus Sohon.* Crossing the Bitterroot Mountains. 1855. *Pencil, 5 × 6″. Washington State Historical Society, Tacoma*

the Mormons charged, emigrants sometimes improvised their own ferries, constructing rafts by lashing canoes together (plate 188).

As Lewis and Clark had learned in 1805, getting across the Rocky Mountains could be a formidable trial for men and beasts of burden alike. This the Donner Party also discovered, in November 1846, when forty of its eighty-seven members perished on the snowy heights at Truckee Lake—some of the survivors reduced to cannibalism to stay alive. In 1855 Gustavus Sohon, a private in an army contingent sent to preserve peace with the Indians in the Washington Territory, left a graphic depiction of crossing the Bitterroot Range (plate 189).

News of the gold strike in California spread like a fever throughout the world. Companies were organized, not only in the eastern states (plate 190), but all around the globe, in the hope of taking the diggings by storm and thus ensuring a golden future. John Audubon's son, John Woodhouse Audubon, joined one such profit-sharing company of eighty men, in the hope of salvaging his family's diminishing fortune. Like so many others, he was stricken by cholera en route and, although he survived that illness, he returned home after an absence of a year and a half without a speck of gold

190. Lewis Miller. The California Company Going from the Town of York in 1849. *c. 1850. Watercolor, 7⅝ × 9¾".*
York County Historical Society, York, Pa.

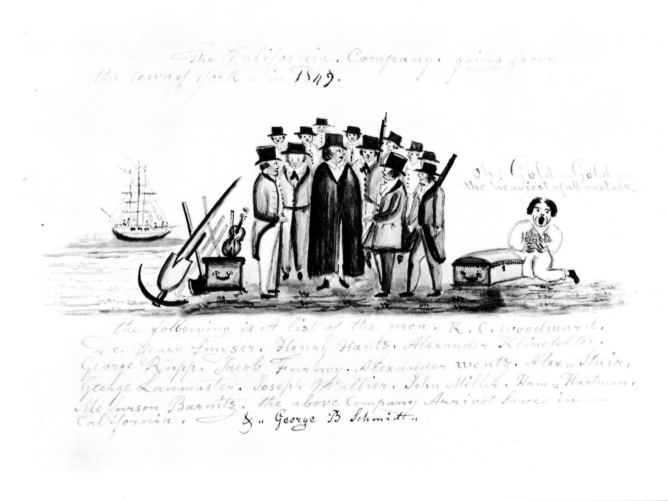

191. *John Woodhouse Audubon. A Forty-Niner. c. 1849. Pencil and watercolor, 10 × 13″. Southwest Museum, Los Angeles*

dust. Only a few of the sketches he made on that expedition survive (plate 191); the rest were lost at sea while being shipped from the West Coast.

When the remnants of young Audubon's disorganized company arrived in San Francisco, they found what had been a sleepy little Mexican village (plate 192) suddenly stirring to activity as a result of the tremendous influx of gold seekers. Years earlier the sometime poet, lawyer, and seaman Richard Henry Dana had visited the California coast and observed, "In the hands of an enterprising people what a country this might be." California then hung like a ripe plum at a remote end of the continent, a land of decaying missions (plate 193) and tranquil ranchos. Boston ships sailed into its ports, collecting tallow and hides for New England shoe factories. In exchange,

192. *William Rich Hutton. San Francisco in 1847—from the Hill Back. 1847. Pencil, 5½ × 8¾″. The Huntington Library and Art Gallery, San Marino, Calif.*

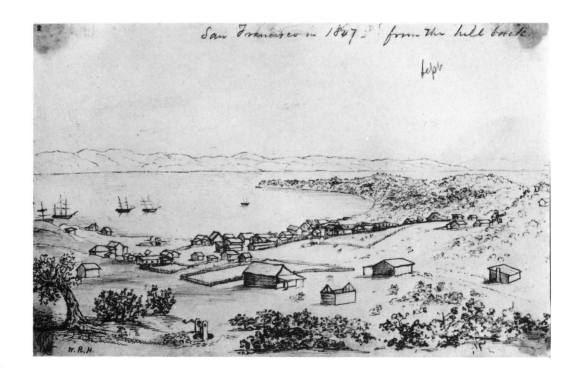

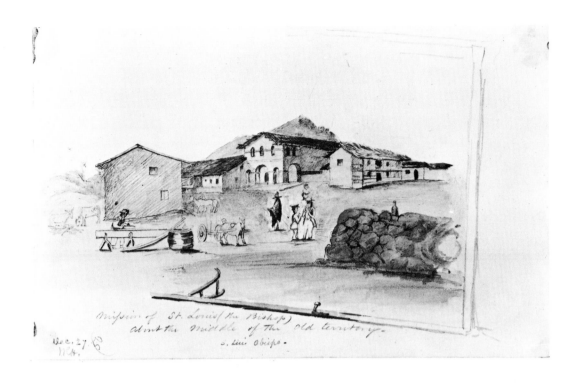

they brought back the finished products made from those hides, along with "everything that can be imagined from Chinese fireworks to English cab-wheels." American warships of the Pacific squadron (plate 194), eager to improve their country's position up and down the coast, kept watch on the war vessels from Russia, France, and England that were plying those waters with the same objective. In 1848, after a bitter war with Mexico that lasted for two years, the territory was finally ceded to the United States. Ironically, the Treaty of Guadalupe-Hidalgo, formalizing this arrangement, was signed only nine days after gold was first discovered in the area. Those "enterprising people" whom Dana had previsioned now moved into California in earnest.

193. William Rich Hutton. Mission of San Luis Obispo. 1848. Pencil and watercolor, 5½ × 8¾". The Huntington Library and Art Gallery, San Marino, Calif.

194. William H. Meyers. U.S. Ship Dale Lying at La Paz—Lower California. 1847. Pen and ink and wash, 10½ × 16½". Franklin D. Roosevelt Library, National Archives and Records Service, Hyde Park, N.Y.

Few of those who came to the gold fields were experienced miners, nor did they feel they had to be. But mining as they practiced it did take more brawn and endurance than many could bring to the task. To make a living, no less a fortune, with a pick and shovel or a placer (plate 195) also required some degree of luck, which no amount of preparation could provide. Many prospectors, like John Woodhouse Audubon, gave up the search after a relatively brief try and took the long road home with nothing to show for their efforts. Nonetheless, during the first six years of mining in California, the gold production of the nation grew to seventy-three times its former output. By 1855 almost half the gold mined in the world came from California. Five years later that particular flow of gold had diminished, and speculators looked elsewhere in the West for hidden treasure, backtracking across the mountains into areas such as the newly formed Nevada and Colorado territories, where new mines were quickly found and exploited by more efficient methods.

Although gold fever had indeed consumed the nation's interest, its attention increasingly turned to a growing division occurring within its own ranks. In 1850 a compromise had been enacted between proslavery and free states, with California entering the Union on the latter side. The gravest question facing the nation then became whether, having extended itself so far and so fast and seething with so many contrary interests, it could hold itself together as a viable political entity.

195. Artist unknown. Washing Gold, Calaveras River, California. 1853. Gouache, 16⅛ × 22″. Museum of Fine Arts, Boston. M. and M. Karolik Collection

The Civil War

196. *Felix O. C. Darley.* "Border Ruffians" Invading Kansas. *n.d. Pen and ink and brown wash, 10⅛ × 14¾".*
Yale University Art Gallery, New Haven, Conn. The Mabel Brady Garvan Collection

The Pathos of an Inevitable Conflict

WHEN MICHEL CHEVALIER, a perceptive Frenchman, visited the United States in 1834, he noticed the serious rift that was already developing between the southern and northern states and wrote: "The dissolution of the Union, if it should take place, would be the most complete of all revolutions." He felt comforted, however, by his "firm faith, that a people with the energy and the intelligence which the Americans possess . . . cannot be born of yesterday to vanish on the morrow." Twenty-five years later Alexis de Tocqueville, that other Frenchman and most understanding critic of American democracy, wrote from abroad that should the Union split apart "it would be the end of political liberty in our world." And in January 1861 that deeply concerned Southerner, Robert E. Lee, wrote his son, "I can contemplate no greater calamity for the country than a dissolution of the Union." This observation underlines the agony that Lee must have suffered when, only three months later, he decided to side with the Southern cause in defiance of the federal government.

By that time, a bloody rehearsal of civil war had already been staged in Kansas, where opposing factions from North and South had taken up arms to ensure that the borning state would enter the Union on the "right" side of the slavery controversy. In 1854 men later known as "Border Ruffians" crossed over from Missouri to force the issue in favor of the Southern cause (plate 196). Northern emigrants followed suit, swarming into the territory to counter such activities in the name of Free-Soilers. Guerrilla warfare broke out, spilling blood on both sides, as happened at the Battle of Hickory Point in 1856, when Free-Soilers fired on a proslavers' settlement (plate 197). This was but one of the many gory skirmishes that reddened the soil of Kansas.

In the following year, a Kansas proslaver wrote that trainloads of people were pouring in from the free states. "I had once thought . . ." he wrote a friend, "that Kansas would be a Slave State, but I am now forced to alter my opinion." As it turned out, his fear proved to be well justified.

Such episodes foreshadowed the "irrepressible conflict" that began in dead earnest in April 1861, when Confederate batteries bombarded the Federal stronghold of Fort Sumter (plate 198). All of Charleston's fashionable society flocked to witness that explosive event as to a gala to be enjoyed. With the firing of those first shots, however, the disagreement had reached a point far beyond the scope of political or judicial arbitration. The agonizing controversy could now be decided only on the battlefields of what was to become one of the most sanguinary wars in history.

Neither North nor South was prepared for any such conflict. Until recent years, indeed, it has been the habit of America to prepare for war only after it has been declared. In 1861, in 1917, and, even to a degree, in 1941, new armies had to be created, equipped, trained, and battle-tested. Two days after the Federal forces capitulated at Fort Sumter, President Lincoln, with no army to speak of, issued a summons for seventy-five thousand volunteers. Jefferson Davis, the president of the Confederacy, was only slightly better prepared; he had earlier called for, and quickly obtained, a hundred thousand volunteers. These were the first in a series of enlistment efforts that would continue, on one basis or another, throughout the war, with both sides increasingly calling for an ever-greater number of troops (plate 199).

Every Northern state had some sort of volunteer militia force, but few were so well trained as the Seventh Regiment of New York, which, on

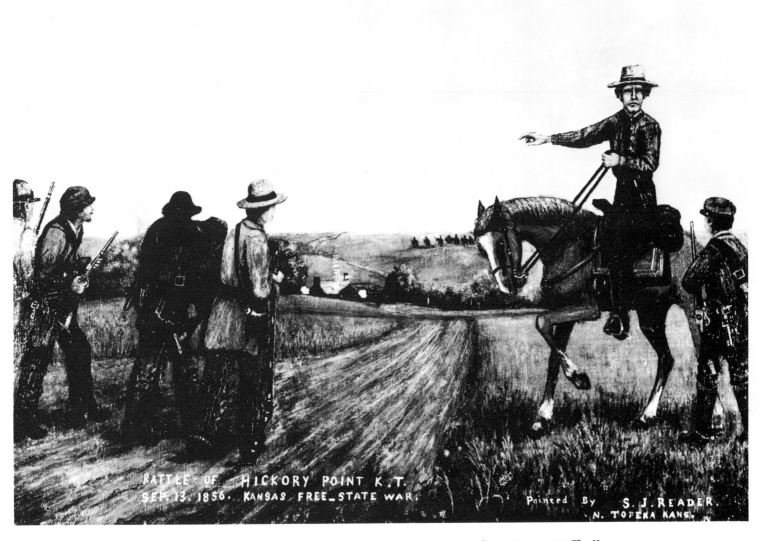

197. S. J. Reader. Battle of Hickory Point. 1856. Pen and ink and watercolor, 15¼ × 21¾". The Kansas
State Historical Society, Topeka

198. *Theodore R. Davis. The Opening of the Civil War. 1861. Pen and ink and watercolor, 4¾ × 15¼″. American Heritage Publishing Company, New York*

April 19, 1861, smartly paraded through the streets of that city while en route to Washington (plate 201). The press reported that the buildings lining the route were covered with flags and bunting. "Thousands upon thousands lined the sidewalks," noted the *New York Herald* the next day, "and the entire line of march was a perfect ovation."

Few Americans had ever even seen a soldier, nor had they had any reason to give serious thought to military matters. The average soldier in the Northern army was recruited from the sons of farmers. To convert such raw material into disciplined troops as quickly as possible proved to be a major problem for drill sergeants (plate 200). In order to teach unlettered farm boys how to perform a close-order drill, drillmasters had each of them tie a tuft of hay to his left foot and one of straw to his right. They were then marched to the chant of "Hay-foot, Straw-foot." Soon, any new, untrained recruit became known as a "Straw-foot."

Those who fought in the war, both Northerner and Southerner alike, were civilians drawn from what had been an overwhelmingly civil society; and, five years after the outbreak of the war—if they lived through that

199. Charles W. Reid.
Recruiting Office,
Boston. 1862. Pencil,
7⅛ × 9″. Library of
Congress, Washington,
D.C.

200. Walton Taber.
The Awkward Squad.
c. 1861. Pen and ink,
7 × 13″. American
Heritage Publishing
Company, New York

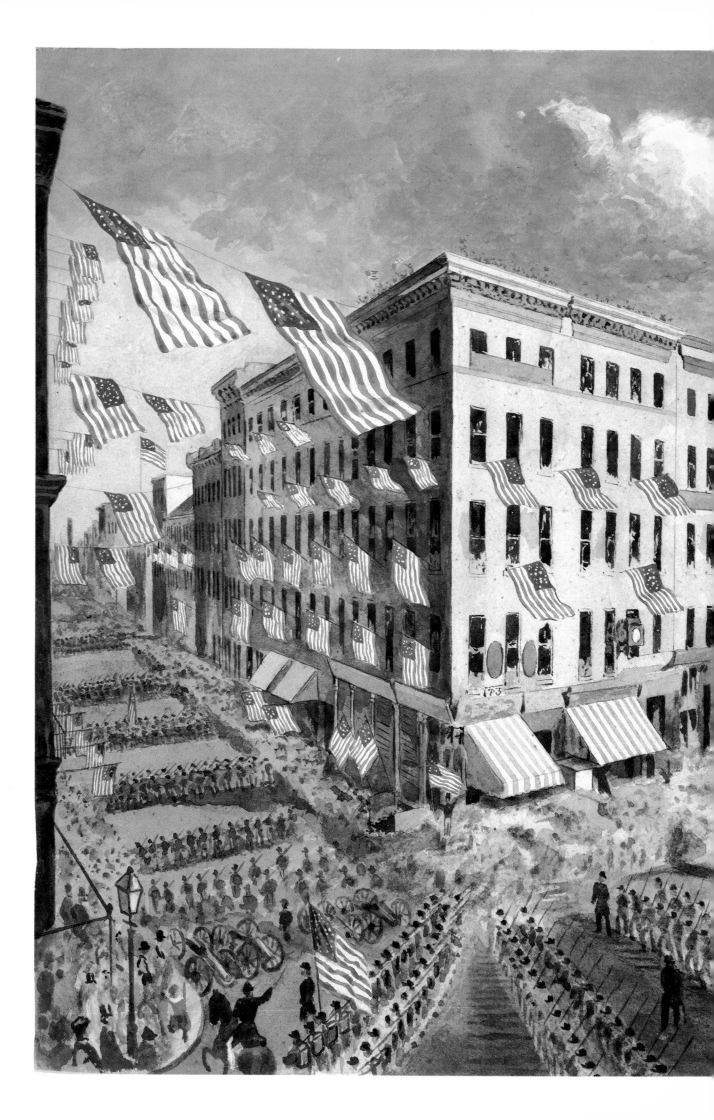

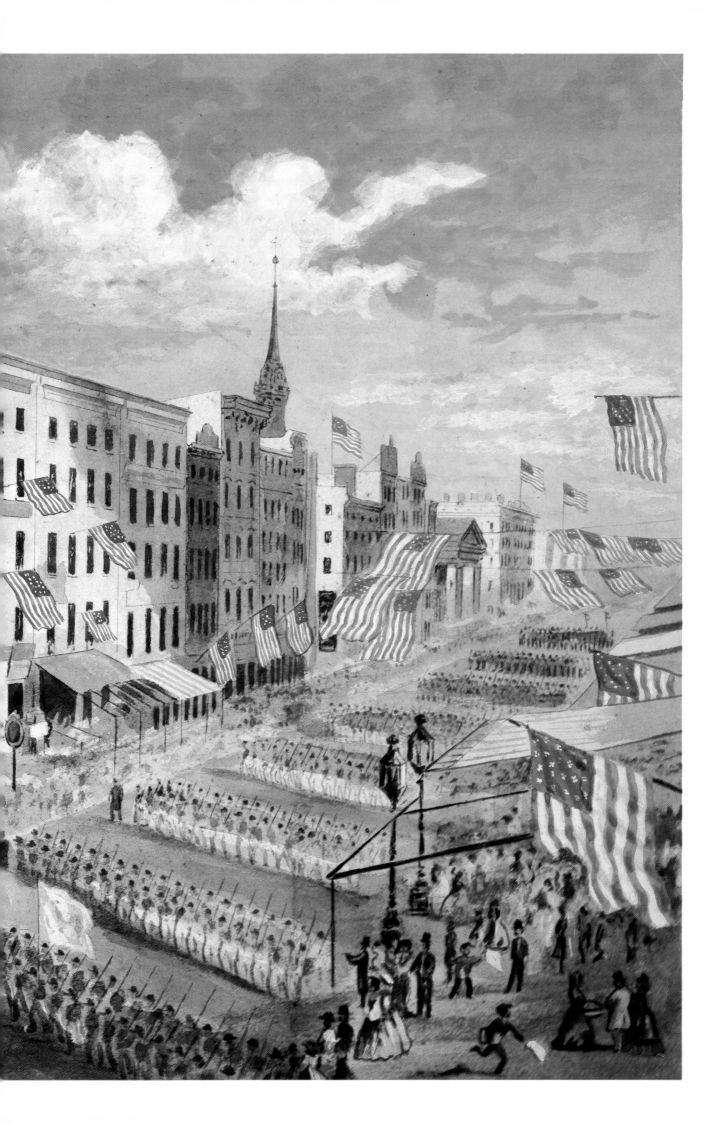

bloody interim—they would return to just such a civilian life. In the mean-time, however, they constituted what Walt Whitman referred to as "the unnamed, unknown rank and file" of the largest military force ever assem-bled—consisting of no less than two-and-a-half million men in all.

No other war in history had been so thoroughly and intimately covered by artists (and photographers) in the field. Unlike the artists who recorded the Napoleonic Wars—court painters commissioned to glorify the great deeds of princes, marshals, and emperors—those of the Civil War were, for the most part, journalists sent to the camps and battlefields by magazines to provide on-the-spot coverage of every- or anything that would inform the public at home. This they did in a torrential flow of illustrations. Those few reproduced here can only hint at the variety of incidents and circumstances included in their work. The principals in their drawings were more often than not those "unnamed, unknown" troops who bore the brunt of the action. It was a people's war, and here were the people who carried it on to its bitter end (plates 202–4).

PRECEDING PAGES:
201. George Hayward. Departure of the Seventh Regiment. 1861. Pencil, watercolor, and gouache, 14½ × 20⅛". *Museum of Fine Arts, Boston. M. and M. Karolik Collection*

202. Conrad Wise Chapman. Picket Post: Self-Portrait. 1863. Pencil and wash, 5½ × 4½". Valentine Museum, Richmond, Va.

203. Winslow Homer. Union Drummer Boy. c. 1864. Charcoal and chalk, 16¾ × 11⅜". Cooper-Hewitt Museum, the Smithsonian Institution's National Museum of Design, New York

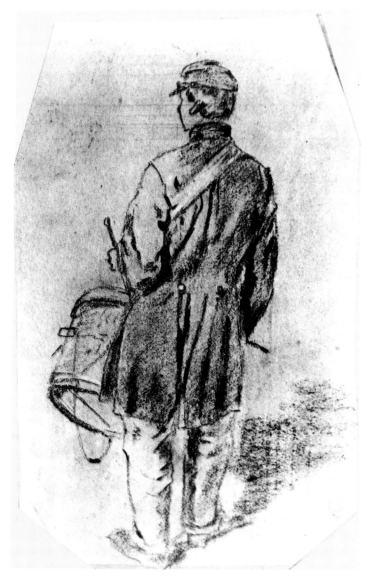

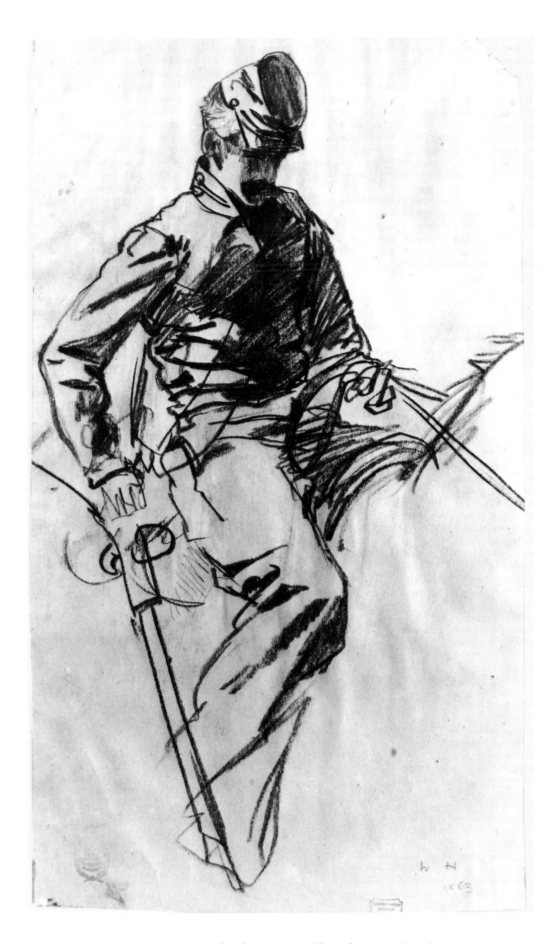

204. *Winslow Homer. Union Cavalryman. 1863. Charcoal, 14¼ × 7⅞ ". Cooper-Hewitt Museum, the Smithsonian Institution's National Museum of Design, New York*

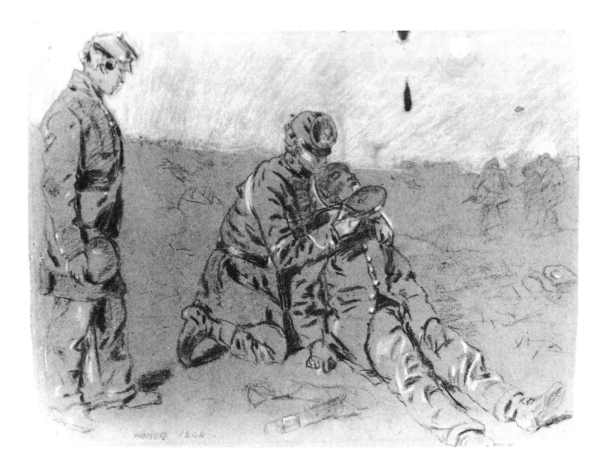

205. Winslow Homer.
Wounded Soldier
Being Given a Drink
from a Canteen. 1864.
Charcoal and chalk,
14⅜ × 19½".
Cooper-Hewitt
Museum, the
Smithsonian
Institution's National
Museum of Design,
New York

206. Edwin Forbes.
Rebel Pickets Dead in
Fredericksburg. 1862.
Pencil, 5 × 7¼".
Library of Congress,
Washington, D.C.

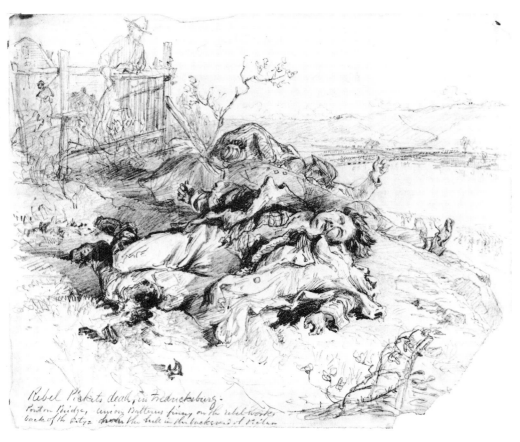

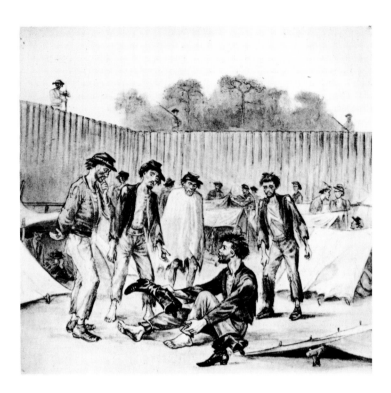

207. *James E. Taylor.* Prisoners of War in
Andersonville Prison, Georgia. *c. 1890.*
Colored inks on glass, 3 × 3".
*Lackawanna Historical Society, Scranton,
Pa.*

Almost one quarter of the total number of combatants lost their lives
before the strife was over, not to mention the hundreds of thousands who
were wounded or made permanent invalids—a point poignantly registered
in many of the drawings (plate 205). After the fierce Battle of Shiloh, which
took place in 1862 in Tennessee, one could barely see the field for all the
corpses that had been strewn there. That same year, Walt Whitman, who
for part of the war served as a volunteer nurse, was appalled at the sight
of the "heap of feet, arms, legs, etc." that greeted him at one of the camps
he visited. A year later he wrote his mother that the war scene seemed to
him like a great slaughterhouse where men mutually butchered one another
(plate 206). Then he added, reflectively, "I feel how impossible it appears,
again, to retire from this contest, until we have carried our points. . . ."

Prisoners of war on both sides had good reason to remember their
captivity—if, that is, they survived it, for thousands did not. In the twenty-
four months that the Point Lookout Prison in Maryland was in operation,
nearly twenty thousand Confederate prisoners were crammed in enclosures
on its sandy and swampy ground, and almost two thousand died there.
Conditions for Union prisoners were no better. Almost thirty years after
his release from a Confederate-run camp, Ezra H. Ripple, of the Fifty-second
Pennsylvania Infantry, wrote an account of his grueling experience and then
commissioned an artist to illustrate it, carefully checking the sketches for
accuracy down to the last detail (plate 207). In this memoir, Ripple candidly
remarked, "If all those who went through prison life in the South during
the Civil War could relate their experiences [mine] would be found to be
very tame in comparison with many others." In a laconic summary, he wrote,
"We all suffered; some . . . suffered more than others."

Military men were not the only ones to experience the miseries of war
firsthand, as civilians in the South and, especially, those in the path of
Sherman's "march to the sea" could testify. Even before that the war had
been brought to their doorstep when, in 1864, General Philip Sheridan,

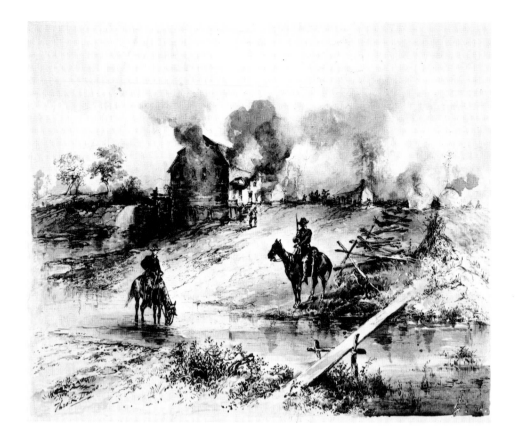

208. *Theodore R. Davis.*
Laying Waste the
Shenandoah Valley. 1864.
*Pen and ink and wash, 9 ×
11". American Heritage
Publishing Company, New
York*

ordered to reduce the Shenandoah Valley to "a barren waste," all but did
so (plate 208). On October 7 he reported to General Ulysses S. Grant: "I
have destroyed over 2,000 barns filled with wheat, hay, and farming imple-
ments; over seventy mills filled with flour and wheat; have driven in front
of the army over 4,000 head of stock, and have killed . . . not less than
2,000 sheep. . . . The Valley, from Winchester up to Staunton, ninety-two
miles, will have little in it for man or beast."

When Union forces entered Charleston in February 1865, they found
a city that had been hideously scarred by bombardment from their own guns
(plate 209). As one witness remarked in the immediate aftermath of the
war: "Those ghostly and crumbling walls and those long-deserted grass-
grown streets show the prostration of a community—such prostration as
only war could bring."

On April 9, 1865, at the village of Appomattox Court House, General
Robert E. Lee gave up what had become a hopeless cause, even though
some would have fought on. "But," wrote Lee, "it is our duty to live, for
what will become of the women and children of the South, if we are not
here to support and protect them?" After signing the terms of surrender at
the home of Major Wilmer McLean, Lee, infinitely saddened but with great
poise and dignity, rode away from the scene (his aide, Colonel Charles
Marshall following behind him), ready to pursue a civilian life (plate 210).

Three days later, in one of the most touching scenes in American
history, the Confederate Army of Northern Virginia formally surrendered
its weapons and battle flags to the Army of the Potomac. After ceremoni-
ously stacking their arms before their Union captors, the Confederates com-
pleted their last act of war. "Lastly—reluctantly, with agony of expression,"
wrote Grant, the Union general, "they tenderly folded their flags, battle-
worn and torn, blood-stained, heart-holding colors, and lay them down."

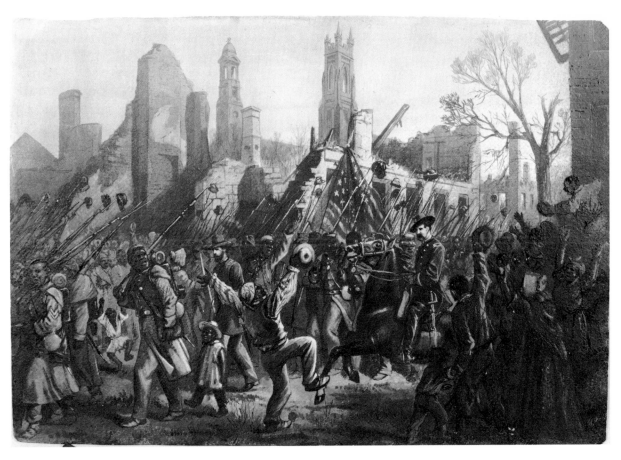

209. *Thomas Nast.* Entrance of the Fifty-fifth Massachusetts Regiment into Charleston. *1865. Pencil, wash, and oil on board, 14¼ × 21¼". Museum of Fine Arts, Boston. M. and M. Karolik Collection*

210. *Alfred R. Waud.* General Lee and Aide Leaving Appomattox Court House After Surrender. *1865. Pencil, 10¼ × 8¾". Library of Congress, Washington, D.C.*

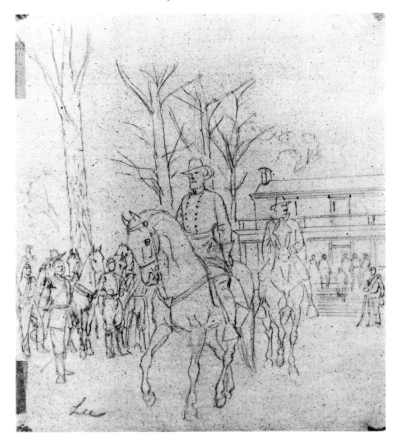

SECTION THROUGH DOME OF U.S.CAPITOL

211. *Thomas U. Walter.* Cross-section
Plan of the Enlarged Dome of the
Capitol. *1859. Watercolor, 46½ × 26″.*
Office of the Architect of the Capitol,
Washington, D.C.

The nation had been all but torn apart, but it had survived, and slavery
had been abolished. Even while the outcome of the conflict had been in
doubt, the architect Thomas U. Walter was placing a great new dome on
the Capitol—a monumental symbol of an enduring Union (plate 211). Lincoln
had insisted that work on the project be continued during the war. "If people
see the Capitol going on," he told a visitor, "it is a sign we intend the Union
shall go on."

Peace and Prosperity

212. Alfred R. Waud. The New Orleans Waterfront. 1872. Pencil and watercolor, 7¼ × 9¾". The Historic New Orleans Collection

Toward a More Abundant Life

BY WHATEVER NAME it may be called—the Civil War, the War between the States, the War of Secession, the War for Southern Independence—that conflict of compatriots was by far the most prodigious experience in the nation's history. Many years earlier, noting the persistence of slavery in "the land of the free," John Quincy Adams had declared that the seeds of the Declaration of Independence were yet maturing, and that the ultimate harvest would be a terrible but sublime day in the annals of America. It was indeed both.

The slaves had been declared free persons at long last. But, in the count of the dead and the mutilated, the cost of their liberation had been almost insufferably high on both sides. North and South were reunited in the body politic, but each section had undergone a spiritual crisis that scarred the memories of thoughtful men and women for years. The North could take satisfaction in what it considered a moral victory, as well as a military one; the South could take what solace it found in having suffered unflinching martyrdom for a cause it had deemed just. In that sense, both sides had won.

The Southern economy had been incalculably damaged. Yet, in spite of the trials and burdens of the ensuing Reconstruction, the states of the vanquished Confederacy set about the restoration of their fortunes with a resolution born of dire necessity. "The soldier stepped from the trenches into the furrow," reported one Southern leader; "horses that had charged Federal guns marched before the plow, and fields that ran red with human blood in April, were green with the harvest in June." However, those harvests were pitifully meager by prewar standards and remained so for more than a decade. A number of the South's proudest cities—Columbia, Charleston, Richmond, Atlanta, Vicksburg, and others—had, in varying degrees, been ruined by bombardment, fire, and plundering.

New Orleans had largely been spared such destruction. It had early fallen to Northern troops, in the spring of 1862, and three years later a visiting New York journalist reported that it "showed no traces of war." In 1872 the artist Alfred R. Waud visited the city and found familiar scenes in its busy wharves (plate 212) and its colorful old French quarter. "The city abounds in the picturesque," he wrote, commenting on a sketch he had made of the backyard kitchen of one of the city's celebrated French restaurants (plate 213).

That same year, the eminent French painter Edgar Degas came to New Orleans, where his mother had been born and where his uncle was a prosperous cotton broker. Here, he wrote, "everything attracts me." His two brothers were also in the cotton business there and the artist paid numerous visits to his relatives' brokerage offices (plate 214), in addition to exploring the other sights around town. (He conceded that his contemporary Edouard Manet would see even more in that milieu than he did.) "One does nothing here," Degas wrote. "It lies in the climate, so much cotton, one lives for and by cotton." Indeed, by 1879, only fourteen years after Appomattox, the cotton crop was larger than it had ever been.

Before the end of the war, the Middle West had developed into a third regional force, powerfully influencing the nation's economy. It had raised, equipped, and fed a large part of the Union armies and had substantially helped to feed the civilians of the North as well. In "the man from Illinois," as Lincoln was sometimes called, it had given the Union cause its leader. Indeed, the agrarian communities of the western heartland (plate 215) had all but won the war with their enormous resources. Western production

213. *Alfred R. Waud. The Kitchen of the Restaurant. c. 1872. Pencil and watercolor, 7¾ × 10¾". The Historic New Orleans Collection*

was so great that, as the war progressed, the nation was able to export 138 million bushels of grain. The spectacle of a nation producing a surplus of foodstuffs while, at the same time, engaged in a great internal conflict and with a large number of its farmers in service seemed to defy logic (plate 216). The English novelist Anthony Trollope visited the Midwest during the war and wrote: "And then I believed, understood and brought it home to myself that [here] had God prepared the food for the increasing millions of the eastern world, as also for the coming millions of the Western."

Less than thirty years before the war, Chicago had been a tiny hamlet, almost invisible in the midst of a vast, undeveloped prairie. But, by 1855, the rising city could rightly claim to be the greatest primary grain market in the world. Because of its size, achieved with such extraordinary rapidity, and its apparently boundless vitality, Chicago was considered by many to be one of the wonders of the New World.

Then, in October 1871 a fire broke out, leveling a large portion of the booming young city practically overnight. The heart of the city—some eighteen thousand buildings—was reduced to ashes and almost a third of its roughly three hundred thousand inhabitants fled from homes to which they

214. *Edgar Degas.* Monsieur Hermann de Clermont on the Balcony of Cotton Broker Michel Musson's Office, New Orleans. 1872–73. *Chalk, 18⅞ × 12⅜". Statens Museum for Kunst, Copenhagen*

215. Jules Tavernier. Parsons, Kansas. 1873. Watercolor, 6 × 9⅛ ". The Kansas State Historical Society, Topeka

216. William M. Cary. Montana Haymakers. 1860s. Wash, 8¼ × 8¼". The Thomas Gilcrease Institute of American History and Art, Tulsa

would never return. Vehicles of every description, piled high with household goods, raced through the scorching streets toward safety near the lakeshore (plate 217). Driven by men and drawn by horses that were alike in a state of panic, they weaved through the trudging and running men, women, and children who themselves were burdened with all the possessions they could carry.

217. Alfred R. Waud. Fire of 1871. 1871. Pencil, 5¾ × 5½". Chicago Historical Society

As the fire burned itself out, martial law was imposed to keep order among the ruins (plate 218). To some it seemed that the troops only added to the general havoc. Chicago's public prosecutor was shot to death by a sentry who mistook him for a pillager. All in all, it was by far the most catastrophic fire of the century. Yet, within a year, impressive new buildings had already risen in the most heavily damaged area of the city (plate 219).

218. Alfred R. Waud. Halt! Who Goes There. 1871. Pencil, 9¾ × 9¼". Chicago Historical Society

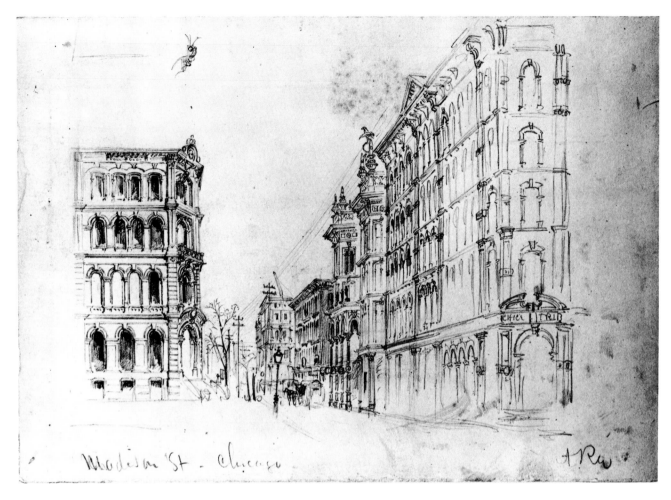

219. *Alfred R. Waud. Madison Street, Chicago. 1872. Pencil, 7½ × 10¾″. Chicago Historical Society*

Chicago was rising again with a lusty vigor that was itself almost frightening. The old city had burned so quickly and completely because it had mainly been built of wood. The new Chicago would, for the most part, become a city of steel and masonry. Here, in this adventurous community, architects found an ideal breeding ground for the revolutionary development of the skyscraper, with its tall steel supporting frame, its curtain walls, and its necessary elevators. For better or for worse, such structures would change many of the ways in which our urban world would work, live, and shop.

The first true example of such modern construction, the Home Insurance Building in Chicago (plate 220), was the work of William Le Baron Jenney. It was built in 1884–85 and razed in 1913. This ten-story building opened the way for other, taller, and more radical experiments. One of the most imaginative of the early champions of the skyscraper was Louis Henri Sullivan, who had visited Chicago just after the fire and had found it to be "magnificent and wild." He returned a few years later and proceeded to add his particular architectural genius to the scene (plate 221). By combining advanced technology and utility with poetry and beauty, he aspired to transform the towering mass of the skyscraper into "a proud and soaring

220. *William Le Baron Jenney. Home Insurance Building. 1885. Pen and ink on linen, 48 × 42". Jensen and Halstead, Ltd., Chicago*

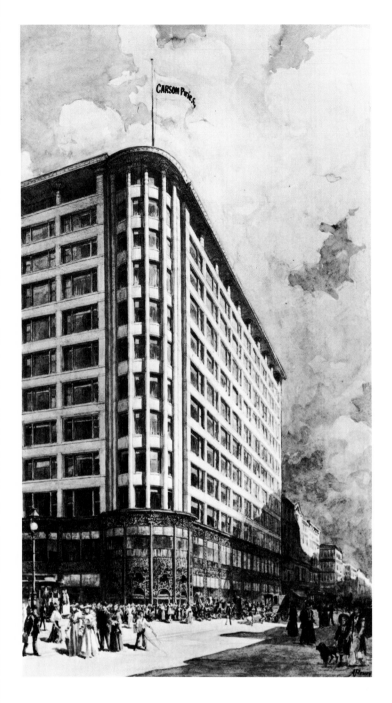

221. *Albert Fleury.* Carson Pirie Scott Department Store. *1903. Watercolor, 36 × 22". Chicago Historical Society*

222. *Louis Henri Sullivan.* Impromptu! *1922. Pencil on strathmore, 20 × 20". From* A System of Architectural Ornament: According with a Philosophy of Man's Powers, *1924. The Art Institute of Chicago*

thing." With the aid of his partner Dankmar Adler and his sometime apprentice Frank Lloyd Wright, Sullivan achieved his goal. Strictly functional in their design and construction, his buildings were typically graced by singularly effective ornamental detail (plate 222), the like of which can rarely be seen in our current generation of tall buildings.

Such structures could not have been built without steel of uniform quality, worked to exact specifications; nor could the farm products and manufactures of the West have been hauled to distant markets by railroad without the steel rails that provided the support for such heavy loads. Military needs during the war had encouraged improvements in metalworking practices, and when, shortly after the war, American manufacturers undertook to make steel by the Bessemer process, the price of such metal came tumbling down as production soared (plate 223). Within a score of years the United States had become the greatest steel-manufacturing nation in the world. When, in 1873, the Scottish immigrant Andrew Carnegie consolidated his interests in steelmaking, he was taking command of an industry of almost imperial scope.

In Europe the growth of large-scale modern industry had led to bitter international rivalries among countries in quest of both raw materials to feed their factories and of new consumer markets to buy their finished products. By contrast, for an important period in its history, America could find within its own boundaries both the necessary resources and the necessary market—a market comprised of a democratic public that confidently expected more and better equipment to live by and with. Here more than elsewhere the growth of industry was a tool to speed domestic progress. Emerson once wrote that he had never known a man as rich as all men should be, and with this sentiment most of his compatriots were in agreement, at least as far as their material well-being was concerned.

223. Otto Krebs (attr.).
American Ironworks of Jones
& Laughlin, Pittsburgh.
Lithograph, 4⅜ × 5". From
History of Allegheny County,
Pennsylvania, 1876. *Carnegie*
Library of Pittsburgh

Even before the Civil War, the mass production of consumer goods had enabled the general public to buy a variety of creature comforts that previously only people of considerable means had been able to afford. Clothes, furnishings, and other accessories of life that had once embodied the slowly evolving taste of an age now reflected the passing fashion of a season—the "period style" became the current year's mass-produced novelty. The average American was better off than his like had been in any other society. At every level, the Victorian parlor with its clutter of manufactured furnishings reflected a pervasive abundance of "things" (plate 224).

To take stock of its development in this direction, in 1853 the United States staged its first world's fair, held at New York's Crystal Palace. Proud a try as it was, this "Mighty Exhibition" was not a success and the enterprise went bankrupt. Twenty-three years later, in celebration of the nation's one hundredth birthday, another, larger fair was held at Philadelphia. The results were more impressive; the nation had reason enough to be pleased with its reflection in the centennial mirror. The main focus of attention was Machinery Hall, where it became apparent that the United States was earning itself a place among the industrial powers of the world.

A reporter for the London *Times* wrote that "the American mechanizes as an old Greek sculptured, as the Venetian painted." Nowhere was this spirit more evident than in the great Corliss steam engine—the largest and

224. A. J. Volck. Interior Baltimore Parlor Scene. c. 1863. Pencil, 7¼ × 10⅜". Maryland Historical Society, Baltimore

225. David J. Kennedy. Horticultural Hall, Centennial Exposition, Philadelphia. 1876. Watercolored lithograph, 6⅞ × 11¾". Historical Society of Pennsylvania, Philadelphia

most powerful engine that had ever been built—which provided power for all the other machinery on display with the quiet perfection of a pocket watch. A French correspondent described it as having "the beauty and almost the grace of the human form." Even the Brahmanic *Atlantic Monthly* felt obliged to concede that "surely here, and not in literature, science, or art is the true evidence of man's creative power; here is Prometheus unbound."

The fairgrounds included 30,000 exhibits from 50 nations, housed in 167 buildings—among which was a Woman's Building, an early precursor of the Women's Liberation movement of a century later. Aside from machinery, the major categories represented were agriculture, horticulture (plate 225), science, education, and, among others, the fine arts. One memorable American exhibit was Thomas Eakins's painting *The Gross Clinic,* probably the most accomplished work of America's most accomplished artist of the time—if not of any time. It was one of the very few important paintings of its kind since Rembrandt's anatomical studies, which date from two centuries earlier. However, its highly realistic, gory details (at the left of the painting the patient's mother hides her eyes from the operation and from the sight of the surgeon's bloody scalpel) were considered too shocking for display in the section devoted to American art. After some debate, it was included in the medical section of the fair because it afforded such an accurate and informed glimpse of an operation.

That the artist was informed there could be little doubt. The operation was performed in Philadelphia's Jefferson Medical College by Dr. Samuel D. Gross, a leading practitioner in that city, which had long been regarded as a center of scientific research. Eakins had himself studied anatomy and dissected cadavers at the college. During his lifetime, he was often thought

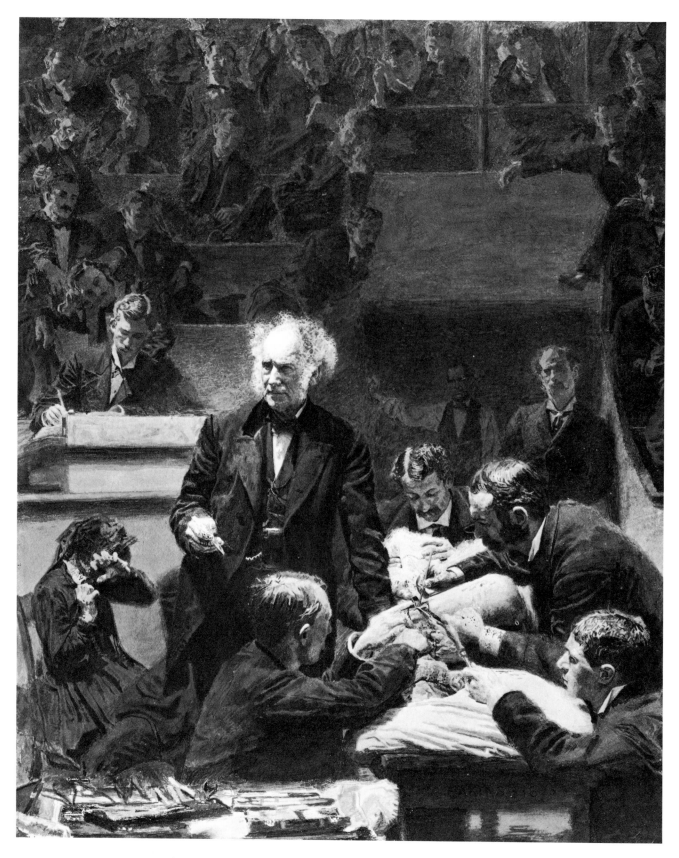

226. Thomas Eakins. Gross Clinic. 1875. Ink wash on cardboard, 23⅝ × 19⅛". The
Metropolitan Museum of Art, New York. Rogers Fund, 1923

227. *Thomas Nast. Let Us PREY. Woodcut. From* Harper's Weekly, *September 23, 1871. The Metropolitan Museum of Art, New York. Harris Brisbane Dick Fund, 1928*

of more as a scientist and a teacher than as an artist. To a degree unsurpassed by the artists of the day, he combined scientific intelligence with astonishing artistic virtuosity. He drew in order to paint better, and he made a drawing of this subject (plate 226).

The Centennial Exposition had opened in the middle of a business depression and, ironically, amid scenes of political graft and corruption that belied every principle to which the nation had been pledged at its birth. James Russell Lowell, the eminent New England critic and man of letters, sarcastically observed that while no other nation could register a century of material progress quite like the one that the United States had put on record, neither could any other produce examples of malpractice as blatant as those featured in the administration of Ulysses S. Grant.

In New York, at least, thanks in good measure to the merciless cartoons of Thomas Nast (plate 227), William Marcy ("Boss") Tweed's stranglehold on the finances of that city and state was finally broken. Nast's drawings of the Tammany tiger and the Republican elephant were wonderfully effective symbolic creations through which he leveled piercing attacks on the malefactors of both groups.

EAST RIVER BRIDGE.

Whatever the nature of the city's administration, New York continued its inexorable growth in consequence, in the size of its population, and in its ever-mounting business. In 1870 Walt Whitman referred to the noise of the city's incessant traffic as a "heavy, low, musical roar, hardly ever intermitted even at night." The year before, the city's legislature had approved plans for a huge suspension bridge (plate 228) to ease the heavy flow of traffic between Brooklyn and Manhattan that, up to that time, had been carried across the narrow East River by ferry. To some it seemed a dangerous, if not impossible, undertaking. The river was a vital waterway: it could not be blocked by piers and the elevated roadway would have to be high enough to permit safe passage for the largest ships. Under the guiding genius of the German immigrant John A. Roebling and his son Washington, gigantic stone towers (plate 229), rising 276 feet above water level, were constructed on each shore. To support these towers, massive underwater foundations had been laid by sinking huge caissons (great "boxes" that had been filled with compressed air, so that workmen could safely toil within) into place on the riverbed.

228. Wilhelm Hildenbrand. Plan of the East River Bridge (Brooklyn Bridge) (detail). 1867. Pen and colored inks, 30¾ × 185½". Municipal Archives of New York

It was a formidable, perilous, delicate, almost untried enterprise. When
the job was completed in 1883, the Brooklyn Bridge was hailed as "the
eighth wonder of the world." Manhattan's more than one million people
now had a graceful exit from their cramped little island. However, the day
after it was opened it became clear that this enormous convenience was
attracting many more travelers than had been anticipated. There was an
immediate cry for more and more bridges.

"We cannot all live in cities," observed Horace Greeley, as he watched
the hordes that flowed into New York, "yet nearly all seem determined to
do so." Indeed, in the decades following the Civil War, the number of people
flocking to the urban centers of the land increased at such a steady rate that
unprecedented social and practical problems began to emerge. It became
increasingly clear that in order to alleviate serious overcrowding and to
ensure the continued health and happiness of the city dweller, access to
some form of natural surroundings would have to be provided for.

In New York City, it had been suggested as early as 1850 that a central
park, where denizens of the crowded streets could escape for a breath of

fresh air, was essential to public health. (New York's death rate was twice that of London's.) In 1856 the city acquired the land for such a project, and landscaping was begun soon after. Following the inspired designs of Frederick Law Olmsted and his associate Calvert Vaux (plate 230), the growing park developed into a work of art—environmental art in the best and purest sense. More than that, it was an organic element in the expanding city, a breathing space for the troglodytes who could find there a respite from their crowded slums, sweatshops, and offices. For those at the opposite end of the social scale, the park provided a different kind of enjoyment. Along its

230. A. Holmgren. Boat House: Perspective View. c. 1870. Pen and ink, 22¾ × 38¼". Frederick Law Olmsted Association, New York

231. Thomas Worth. Fashionable Turnouts in Central Park. 1868. Pencil, 18⅜ × 28⅜". New York Public Library, I. N. Phelps Stokes Collection

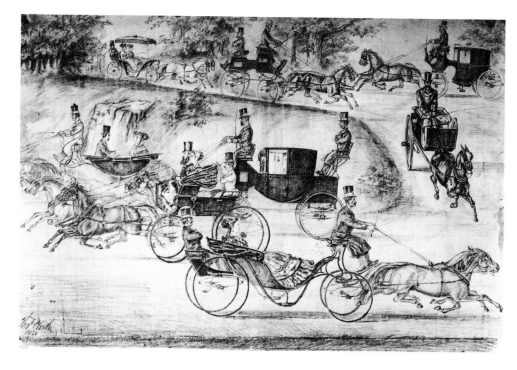

232. *Winslow Homer.* Long Branch, New Jersey. 1870. *Pencil with Chinese white, 12½ × 18¾". Private collection*

winding roads, affluent New Yorkers could drive their fashionable turnouts for all to admire (plate 231). As one periodical reported, "probably nothing more fully exhibits the wealth, luxury, and taste of New York City than [the] fancy 'turnouts' and private carriages" that thronged the grand drive on a fair day during the fashionable season.

On winter days, long before the park's landscaping was completed, the public took to its frozen lakes to enjoy skating, or, as one man referred to it, "Our National Winter Exercise" (plate 233). The sport was also known as "Higginson's revival," after the ardent Boston abolitionist and writer Thomas Wentworth Higginson had heartily recommended such "manly outdoor exercises" to readers of the *Atlantic Monthly*. From then on, thousands upon thousands of gliding devotees throughout the northern states could be seen following his advice in freezing weather.

It soon became evident that in addition to recreation within the city, the urban dweller needed vacations from the city. "The fact is," *The Nation* observed editorially in 1873, "that every man who possibly can should force himself to a holiday of a full month in the year, whether he feels like taking it or not. . . . An employer of labor should see to it." This concept, that a vacation from incessant work was not simply agreeable but was actually necessary, was a relatively novel development in American life. Only after the Civil War did retreats such as Long Branch (plate 232), Nahant, the White Mountains, and the Adirondacks begin to attract crowds of summertime guests—crowds whose numbers increased every year.

The wilderness areas of America have always been a paradise for fishermen, hunters, and vacationers in search of their favorite recreational pursuits. So, too, the call of the wild has attracted philosophers and artists. In 1858 a distinguished party that included Emerson, Louis Agassiz, and other learned and companionable persons gathered in the Adirondacks—a gathering which Longfellow refused to attend when he heard that Emerson would carry a gun. (He predicted that somebody would be shot. No one was.) For the artist, the beauty of those forested mountains with their countless lakes has had a special allure. For thirty years after his first visit

233. *Winslow Homer (attr.). Skating in Central Park. c. 1860. Watercolor and pen and ink, 16⅜ × 24⅜″. St. Louis Art Museum. Eliza McMillan Fund*

234. *Winslow Homer. The Blue Boat. 1892. Watercolor, 15⅛ × 21½″. Museum of Fine Arts, Boston. Bequest of William Sturgis Bigelow*

to the Adirondacks, Winslow Homer continued to return and to record what he witnessed there in what are some of his finest watercolor drawings (plate 234). The English dramatist and novelist Arnold Bennett came to America with a desire to see Homer's creations. "They were beautiful," he wrote, "they thrilled. They were genuine America; there is nothing like them."

Even then, however, the splendor of those abundant forests and of the "genuine America" immortalized by Homer was in peril. Following the Civil War, New York had become a major source for pulpwood and paper products, an eminence that seriously threatened to destroy the Adirondacks's magnificent stand of trees (plate 235). Ironically, the same railroad lines that carried eager vacationers to see these beautiful forests also hauled the lumber away from them.

235. Winslow Homer. Old Friends. 1894. Watercolor, 21½ × 15⅛". Worcester Art Museum, Worcester, Mass.

The concern for out-of-door recreation was not solely limited to the cities. Throughout the nation, what Emerson had once referred to as the invalidism in American life was being challenged by a new and fast-growing enthusiasm for outdoor sports and pastimes of all varieties. A primitive form of baseball had been played as early as 1845. It was then picked up by soldiers behind the lines during the Civil War. Following the war, interest in the sport developed into what one periodical described as a "mania." "Since the war," the report continued, "it has run like wildfire. Young soldiers, full of vigor, and longing for companionship and manly exercise, found them in this game. . . ." By that time, clearly, it had become America's national pastime, played by both professional athletes before thousands of spectators (plate 236) and by untold numbers of amateur and pickup teams on sandlots and playgrounds across the nation. Gone were the days when baseball had been considered a gentleman's pastime; now it was played anywhere and everywhere by tireless enthusiasts of all ranks and ages.

Among other outdoor activities favored by men, sculling had its many devotees. The most explicit pictorial references to this sport are to be found in drawings (and paintings) by Thomas Eakins. This artist once observed that he learned far more about depicting the human body from watching stripped-down athletes in motion than he did from drawing posed models in his studio. His watercolor of John Biglin in his single scull (plate 237) is the culmination of many preliminary experiments—experiments in which he painstakingly studied every detail of his subject, even down to the exact moment of the day he was recording. Indeed, few artists have made as many studies for a picture as Eakins made for this one.

236. Thomas Eakins. Baseball Players Practicing. 1875. Watercolor and pencil, 10¾ × 12⅞". Museum of Art, Rhode Island School of Design, Providence. Jesse Metcalf and Walter H. Kimball Funds

Commenting on the succession of new games and pastimes that kept Americans out in the open and entertained, in 1866 The Nation observed that "the swiftest and most infectious" of those sweeping over the land was croquet. Here was a gentle game that ladies could play in the company of their male companions, thus serving to bring the rites of courtship out of the parlor, off the front porch, and onto the playing field (plate 238). One instruction manual pointed out that young ladies tended to cheat at the game because they thought that such arch maneuvers might increase the attention that their gentlemen companions paid to the grace and pleasing attitudes with which they handled the mallet. Like bicycling, tennis, and golf, croquet played a part in liberating women from the bondage of Victorian customs and fashions—and all in the name of commendably healthful, invigorating exercise.

As the nineteenth century approached its end, American life was changing at an increasingly rapid rate. Once again, to take the measure of its achievements and to catch a glimpse of its future prospects, the nation mounted an international fair. This, the World's Columbian Exposition, held at Chicago in 1893, was the largest and most influential fair ever staged in this country and it caught the attention of the world.

Among the wonders of the "White City," as the fair was popularly known, the grounds and buildings were bathed in electric light that turned night into day—a novel spectacle that was illuminating in every sense of the

word (plate 239). The fact that power could be converted into light, heat, and motion, and dispatched through a thin copper wire to wherever it was needed, seemed to many like a supernatural revelation.

The giant Allis-Corliss steam engine was itself a miraculous sight to behold. Powering the dynamos that generated the fair's electricity, it was probably the greatest such machine in the world. Even Henry Adams, a highly enlightened prophet of his time, conceded that mysteries were here involved that far surpassed ordinary understanding. For him the dynamo became a symbol of infinity, a moral force as strong in its time as the Cross had been in earlier centuries.

239. Childe Hassam. The Electricity Building, World's Columbian Exposition, Chicago. *1893. Watercolor, 17¾ × 30". Chicago Historical Society*

240. Thomas Worth. Castle Garden, New York. *1866. Wash. Private collection*

241. August Will. The Past and the Present. 1898. Wash, 13¼ × 49⅞″. Museum of the City of New York

At the time of America's first international exhibition, in 1853, it had already been apparent that the industrial nations would inherit the earth. Forty years later the Chicago fair provided tangible evidence that the United States had become an industrial giant. As Michel Chevalier had long before predicted it would, the Union had not only survived the agonizing time of a civil war, but had gained strength and purpose in the process. For three quarters of a century following the Treaty of Ghent, America had mainly been preoccupied with problems of self-development and self-determination. Now, having established itself as a power in its own right, it could look out upon the world beyond its borders with justifiable self-confidence.

In 1898, spurred on by a sensationalist press, by a large part of the religious press, and by commercial interests, the United States assumed its "humanitarian duty" to liberate the peoples of Cuba from Spanish misrule. With that decision came the beginnings of the Spanish-American War. The real fighting started in the Philippines, where the United States successfully aided the natives in a rebellion against their Spanish rulers. From the start, it was apparent that it would be no contest. What Secretary of State John Hay referred to in a letter to Theodore Roosevelt as that "splendid little war" was over within ten weeks. The Treaty of Paris, signed that same year, officially ended the conflict, with Spain freeing Cuba and formally ceding the Philippines to the United States. When, shortly thereafter, insurgent Filipinos tried to set up their own independent government, President McKinley reacted sharply. "The presence and success of our aims at Manila," he proclaimed, "impose upon us obligations which we cannot disregard . . . new duties and responsibilities which we must meet . . . the commercial opportunity to which American statesmanship cannot be indifferent." After that pious announcement, American troops went into action against the nationalists. It took three years to "free" those islands—and to annex them. By the time peace was restored, the United States had acquired a colonial empire in the Caribbean and the Pacific, with jurisdiction over 120,000 square miles and 8,500,000 people.

During the last decades of the century, the number of immigrants, who willingly and hopefully entered the United States to build a brighter future for themselves (plate 240), surpassed even this extraordinary figure. "During the last ten years," wrote the social reformer Josiah Strong in 1891, "we have suffered a peaceful invasion by an army four times as vast as the estimated numbers of Goths and Vandals that swept over Southern Europe and overwhelmed Rome." Most of these, and most of the many millions more still to come, were siphoned through the port of New York. The skyline of that city had already begun to take on its chaotic, jagged, ever-changing,

242. Auguste Bartholdi. Pedestal Project for the Statue of Liberty. c. 1880. Pen and ink and wash. Musée Bartholdi, Colmar, France

and preposterously beautiful profile—a shifting graph of man's busiest dreams, then and for years to come (plate 241).

When he first glimpsed that spectacle, H. G. Wells is said to have exclaimed, "What a magnificent ruin it will make!" Wells was a thoroughly friendly critic of America and an inveterate Utopian. But he wondered whether all this display of concentrated wealth and might could have ominous portents. He noted that the skyscrapers of Manhattan dwarfed the Statue of Liberty (plate 242), and further wondered whether the statue might now be a symbol of liberty for property and not for men.

The Last West

243. Rufus Fairchild Zogbaum. Battle of Beecher's Island. Wash. From Scribner's
magazine, November 1901. Library of Congress, Washington, D.C.

Completion of an Epic Cycle

THE AMERICAN FRONTIER has commonly been visualized as a broad, continuous line that moved from the eastern highlands to the western limits of the continent as adventuring pioneers opened a way through the wilderness for the advance of civilization. It might rather be considered as an irregular, diminishing circle—or series of circles—that gradually closed in on the unexplored areas of the nation from all points of the compass, until those unsettled regions became so fragmented by isolated bodies of settlement that lines for a frontier could no longer be traced on the map. Finally, the wilderness areas disintegrated into a jumble of small and vanishing pockets. In 1890 the United States Census reported that the American frontier was officially closed.

Over a period of more than one hundred years before that date, the white man had signed several hundred treaties with the Indian in a futile attempt to stake a claim to the land and, at the same time, avoid retribution. The Indian rarely had any comprehension of a treaty's full significance and had no social institutions to enforce compliance with its terms. The white man in his turn had no adequate laws with which to make negotiated agreements effective. As a consequence, any alleged breach of contract was settled by force.

In less than thirty years following the Civil War, troops of the United States Army fought more than one thousand engagements with the Plains Indians in order to secure the land that had come under white control and to herd the surviving natives into reservations. In September 1868 a detachment of troopers was trapped and almost wiped out by Indians led by Chief Roman Nose, a renowned Cheyenne warrior, who was later killed in the battle. A relief column of soldiers reached the scene just in time to drive off the besieging Indians. The army remembered the standoff by the encircled whites as the Battle of Beecher's Island (plate 243), in honor of Lieutenant Frederick Beecher (nephew of the clergyman Henry Ward Beecher), who was also slain in the action.

The most dramatic of these conflicts was set in motion in 1874, when gold was discovered in the Black Hills of what is now South Dakota. As news of the strike spread, white prospectors poured into the area. Vengeful Indians, infuriated that lands which they had been assured by solemn treaty

244. Kicking Bear. Battle of the Little Big Horn. 1898. Watercolor and pencil on muslin, 35½ × 69½". Southwest Museum, Los Angeles

245. Frederic
Remington. Infantry
Soldier. 1901. Pastel,
29 × 15⅞". Amon
Carter Museum, Fort
Worth

246. *Making Medicine. Indian Prisoners En Route to Florida. c. 1875–78. Pencil and crayon, 8½ × 11″. National Anthropological Archives, Smithsonian Institution, Washington, D.C.*

would be theirs "as long as water flows and grass grows," swarmed off their reservations and took to the warpath. In response, Lieutenant Colonel George A. Custer and the Seventh Cavalry were dispatched to bring them back. Then, on June 25, 1876, more Indians than had probably ever been brought together for a single battle ambushed Custer and his troops and annihilated them to the last man. There were no surviving white witnesses of the Battle of the Little Big Horn, but Indian veterans of the grim event recalled the scene of carnage in a number of drawings (plate 244).

To break up such native resistance, the government had decided the year before to round up the most truculent Indian warriors at Fort Sill, Oklahoma, and to ship them off to St. Augustine, Florida, for detention in an old Spanish fortress. Chained to wagons, they embarked on the twenty-four-day journey into exile from their homeland. They were in the custody of Lieutenant Richard Henry Pratt, who was relatively sympathetic toward his charges and encouraged them to draw pictures of their experiences (plate 246) which they were permitted to sell to curious tourists. (Four years later Pratt would found the Carlisle Indian School, the first federally supported school for Indians to be established off a reservation.)

In December 1890 one of the last and bloodiest clashes between United States troops and Indian warriors took place at Wounded Knee Creek in South Dakota. That brief battle, in which large numbers of Indians were pitilessly slaughtered by an overwhelming force of soldiers, virtually ended Indian resistance. With the Wild West tamed at home, it went on tour overseas as a melodramatic spectacle presented by Colonel William F. Cody, a sometime army trooper and scout, better remembered as "Buffalo Bill." Also, after the Indian had been completely subdued and pushed aside, guilt and nostalgia led to his re-creation in a new, sentimental image—an image that is recalled in the handsome Indian profile that the sculptor James Earle Fraser designed for the famous buffalo nickel. In the same spirit of belated appreciation, a federal dam would be named for Chief Joseph of the Nez

Percé tribe, who, ironically, had been considered to be one of the most recalcitrant of Indian warriors.

 The artist Frederic Remington accompanied the United States Infantry on their various forays against the Indians, sketching the soldiers' likenesses in and out of action (plate 245). He also rode with the United States Cavalry and their Indian scouts (plate 247). The pictures that emerged from these

247. Frederic Remington. Comanche Scout. *1890. Pen and ink, 28 × 22". The Thomas Gilcrease Institute of American History and Art, Tulsa*

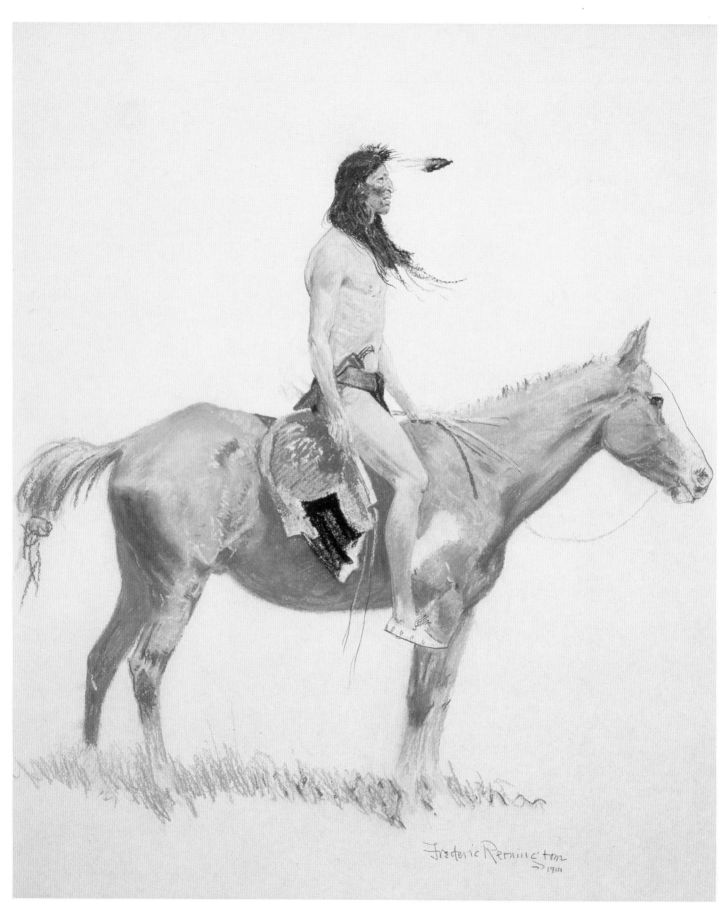

248. *Frederic Remington. Cheyenne Buck. 1901. Pastel, 28½ × 24″. National Cowboy Hall of Fame, Oklahoma City*

experiences remain a vivid guide for most of us when we try to visualize the passing of the Wild West. Remington admired both the human and the professional qualities of the soldiers, including those blacks whom he saw during their campaigns against the Apaches and Comanches in Texas. "The freemasonry of the army," he wrote, "makes strong friendships, and soldiers are all good fellows, that being a part of their business."

The closing of the frontier coincided almost exactly with the end of Indian resistance. By 1890 such great leaders as Geronimo, Sitting Bull, and Chief Joseph had either capitulated or died (plate 249), and most of their proud followers (plate 248) were dispirited. "I am tired of fighting," Chief Joseph remarked, summarizing the tragedy of his race. "Our chiefs are killed. Looking-Glass is dead. Too-hut-hut-Sote is dead. The old men are all dead. It is the young men now who say 'yes' or 'no.' He who led the young men is dead. It is cold and we have no blankets. The little children are freezing to death. My people, some of them, have run away to the hills, and have no blankets, no food. No one knows where they are, perhaps freezing to death. I want to have time to look for my children and see how many of them I can find. Maybe I can find them among the dead. Hear me, my chiefs. My heart is sick and sad. I am tired."

During the late decades of the nineteenth century, the cowboy played a prominent role on the Great Plains. He might refer to himself as an "ordinary bow-legged human" (plate 250), and others might describe him as "a man with guts and a horse," but he was something more. He was a representative of a brief-lived culture, unique in our history, that had its own

249. Frederic Remington. Surrender of Chief Joseph. Gouache, 24 × 32". From The Personal Recollections of General Nelson A. Miles, 1897. Remington Art Museum, Ogdensburg, N.Y.

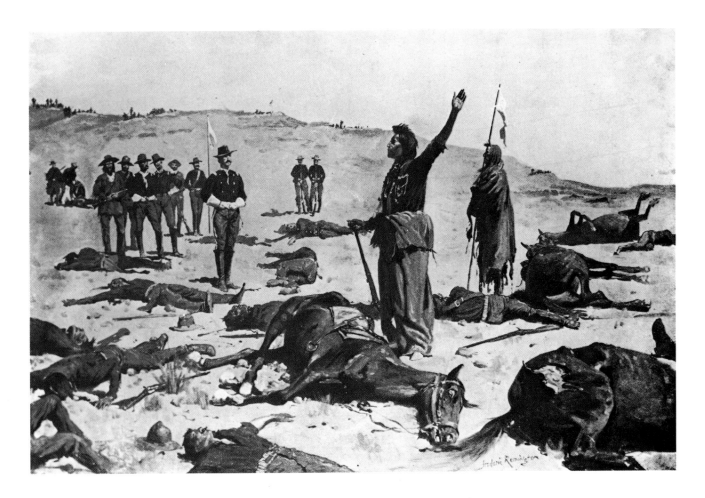

250. Olaf C. Seltzer. Horse Wrangler. n.d.
Watercolor, 12 × 7". The Thomas Gilcrease Institute
of American History and Art, Tulsa

folklore and balladry. He was drawn out onto the open range from widely
different parts of the world—from the East, South, North, and West; from
Mexico to Canada; and even from England, Scotland, and Australia. He
might be white, tawny, or, perhaps, black. But, wrote Theodore Roosevelt,
who had himself owned a ranch in the Dakota Territory, "existence in the
west seems to put the same stamp on each . . . their life forces them to be
both daring and adventurous, and the passing over their heads of a few
years leaves printed on their faces certain lines which tell of dangers genially
fronted and hardships uncomplainingly endured."

In his picturesque but entirely practical costume, from hat to spurred
boots, the cowboy of the past became and has remained a romantic symbol
of the American West—a symbol that is recognized around the world. His
image has fired the imagination of a host of artists. Among them was Thomas
Eakins, who, in the summer of 1887, went from Philadelphia to the Dakota
Territory, where he sketched the likenesses of the cowboys whom he saw
there (plate 251). Another, and perhaps the most popular, of these visiting

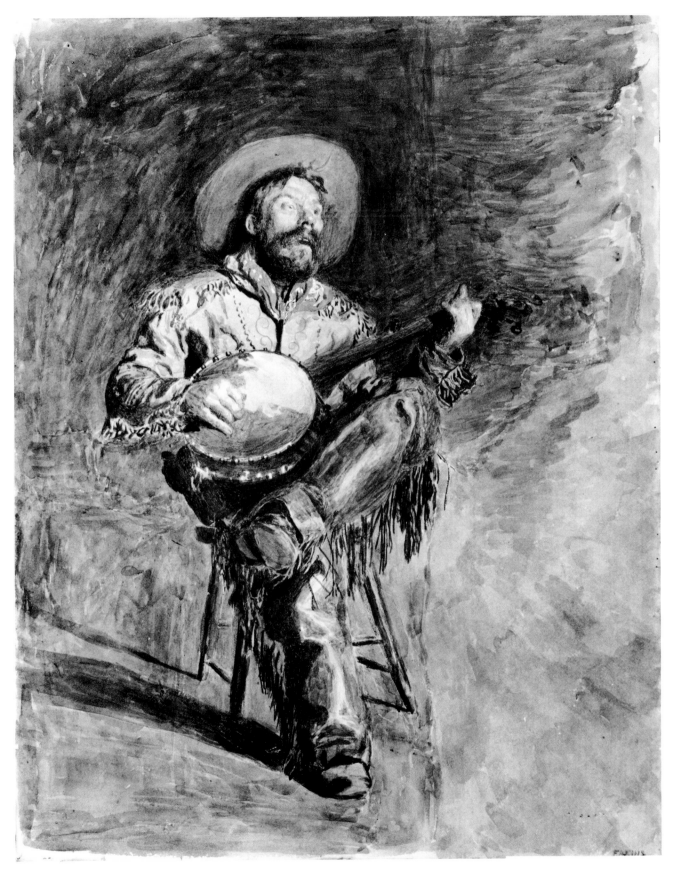

251. Thomas Eakins. Cowboy Singing. 1887. Watercolor, 18 × 14″. The Metropolitan
Museum of Art, New York. Fletcher Fund, 1925

artists was Frederic Remington. On his various trips to the West, he closely observed this special breed of pioneer at work and at play. For a year Remington tried sheepherding in Kansas, where he had purchased a small ranch (plates 252, 253). He soon realized that he was not cut out for ranching and, in 1884, he sold his holdings.

Nevertheless, and with some good reason, he considered himself *the* illustrator of the rapidly vanishing life of the western frontier. In 1885 Theodore Roosevelt observed that the cowboy would "shortly pass away from the plains as completely as the red and white hunters have vanished from before our herds"; but, he predicted, the cowboy would live for all time in Remington's art. In 1886 and 1887, when cruel winters obliterated the herds on the open range, the cowboy did indeed become a man of the past. But, as Roosevelt had foreseen, Remington's reputation as a faithful delineator of western life in its heyday remains above controversy.

252. *Frederic Remington.* Sheep Herder *(detail).*
1883–84. Pen and ink and watercolor, 11½ ×
9". Remington Art Museum, Ogdensburg, N.Y.

253. *Frederic Remington.* My Ranch. *1883–84. Watercolor, 9 × 11½".*
Remington Art Museum, Ogdensburg, N.Y.

A New Century

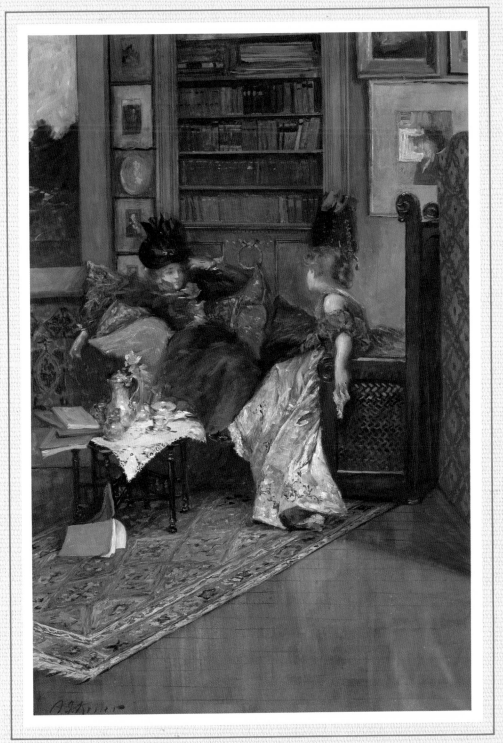

254. Arthur I. Keller. Women at Tea. c. 1890. Watercolor, 17½ × 12". Private collection

Ushering in the Modern Era

THE TURN OF A CENTURY always serves as a convenient dividing line in time. Nothing changes overnight, of course, for the currents of history flow along continuously without regard for the calendar. But the celebration of one century's end and another's beginning has a symbolic importance. It invokes some effort to comprehend what the preceding hundred years have led to and to speculate on what the next hundred years might bring.

On January 1, 1900, America could look back over a century of progress without parallel in history. A wild continent had been tamed and generously peopled by inhabitants drawn from all parts of the world. The young nation had overcome the vicissitudes of foreign and civil war and its unique political structure had been strengthened in the process. Its industry on farm and in factory was producing an abundance of food and other necessities that far exceeded its own requirements (plate 254). And, along with these material accomplishments, it had maintained and secured religious freedom, freedom of the press, and free public education for its growing millions. All these things together made the United States a prodigy among nations.

There was another side to the coin. As Woodrow Wilson would observe in his first inaugural address, the country, in its hurry to be great and prosperous, had heedlessly squandered vast amounts of the natural resources of the land, without which God-given bounty American genius and enterprise would have had far less opportunity to prove itself. America was duly proud of its industrial achievements, but, as Wilson also pointed out, it had tended to ignore the cost in human terms. The deadweight and burden of those achievements had fallen pitilessly on many unfortunate men, women, and children and had brought them misery in the midst of plenty (plate 255). If American democracy were to do justice to its name, Wilson counseled, the nation would have to give sober consideration to these issues.

255. Everett Shinn. The Ragpicker. 1909. Pastel, 19 × 26⅛". Collection Arthur G. Altschul, New York

As Tocqueville and Viscount James Bryce, the distinguished author of *The American Commonwealth,* had previsioned it might, the concentration of wealth and power in the hands of relatively few individuals and private concerns was posing a serious threat to the social health of the nation. Almost by reflex action, the increasing bigness of business called for the expansion of the government's role in protecting the public weal. That role found an evangelical advocate in "Teddy" Roosevelt, as he took up his "lance" to do battle with the giant trusts (plate 256).

Further complicating the social scene, in the first decade of the century over eight million immigrants entered the country—far more than enough to have replaced the entire population in 1776. Many of these newcomers came from lands whose very names sounded outlandish to Americans of older stock; and they included "the wretched refuse, the homeless, tempest-toss'd" people of Emma Lazarus's poem inscribed on the pedestal of the Statue of Liberty. For the most part, these men and women were welcomed to help man the factories and mines of their adopted land (plate 257) or to ply the needle in its garment houses. Henry James snobbishly referred to them as "gross little foreigners." Senator Henry Cabot Lodge likened this

256. *C.R. Macauley.* "Teddy" Roosevelt Attacks the Standard Oil Company's Monopoly. *c. 1906. Pen and ink. Ship Ahoy Restaurant, Seabright, N.J.*

257. *Joseph Stella.* Miners. *1908. Charcoal, 14⅞ × 19⅝″. Yale University Art Gallery, New Haven, Conn. John Heinz III Fund*

vast influx to a "barbarian invasion" and, with others, worried that the nation might not safely be able to absorb such a motley group. Many immigrants congregated in urban areas, where their numbers alone contributed to the problems of social engineering that characterized the rise of the modern city.

Joseph Stella, an Italian immigrant who had been commissioned in 1907 to record a mining disaster in West Virginia where half the town's workers had been killed, was sent the following year to Pittsburgh (plate 258). That city seemed to him "a real revelation. Often shrouded by fog and smoke, the black mysterious mass . . . was like the stunning realization of some of the most stirring infernal regions sung by Dante." That same year, several artists known as The Eight—Robert Henri, Everett Shinn, William Glackens, John Sloan, George R. Luks, Arthur B. Davies, Maurice Prendergast, and Ernest Lawson—or, more informally, as the "Ashcan School," gave their first group exhibition in New York City. United in their disdain for entrenched academic tradition, these men found the subjects for their art in the commonplace scenes and ordinary persons of the urban milieu. Even among the ash cans of the crowded streets they saw a poetry worth recording. A number of them were or had been newspaper artist-reporters,

258. Joseph Stella. Pittsburgh in Winter. 1908. Charcoal, 17⅛ × 23". Private collection

trained in an exacting school of realistic pictorial reportage. "We were called upon," wrote one of them, "to cover everything that is caught by the modern camera in the twinkling of an eye . . . and we did good drawing too."

They knew the metropolis in all its many moods and reported it as they saw and felt it, from the noisome slums to the fashionable restaurants and popular theaters (plate 259). As a whole, their work presents a mosaic of life in what had so swiftly become one of the world's greatest cities. To visitors, somewhat overwhelmed by the city, New York did not seem typical of American life, which in many important ways, of course, it was not and never would be. Yet, a significantly large percentage of its population had been lured to the "Big City" from other parts of the country with hopes of bettering their prospects there. As a result of this all-American represen- tation and because of the extreme diversity of its activities and its interests, New York did indeed reflect many of the attitudes and concerns of the nation at large. It had become the nerve center of the United States. En- ergized in good part by people and impulses from all over the land, it then fed back its synthesis of American experience to the rest of the country.

The city had long since become the financial capital of the nation. What happened on its Stock Exchange was news of vital interest, quickly reported around the world. About 1907 William Glackens, one of The Eight, sketched a typically frantic scene on Wall Street (plate 260). At the time, the country was in the grip of one of the financial panics and industrial depressions that

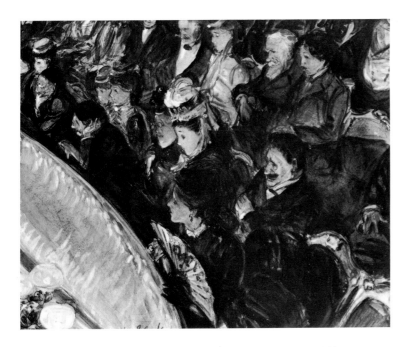

259. William Glackens. The Balcony. 1899. Sepia and black ink wash, 9½ × 12". Collection Arthur G. Altschul, New York

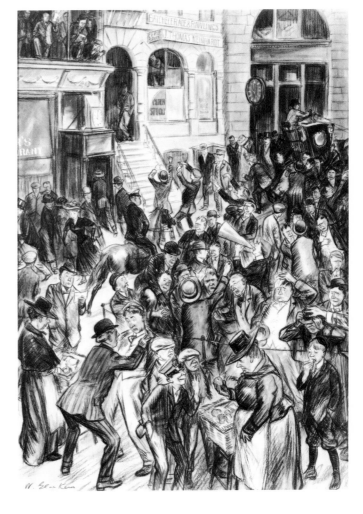

260. William Glackens. Curb Exchange No. 2. c. 1907–10. Watercolor and pencil, 24 × 17½". Collection Arthur G. Altschul, New York

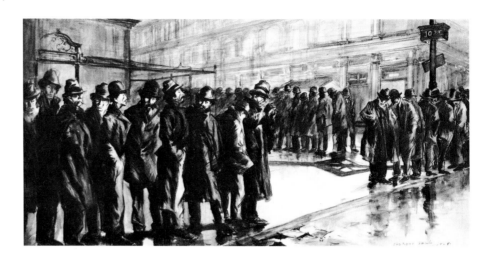

261. *Everett Shinn.* Out of a Job—News of the Unemployed. *1908. Pen and ink and wash, 13⅞ × 27⅞".* *Private collection*

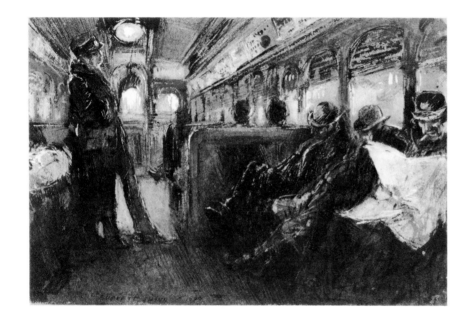

262. *Everett Shinn.* Sixth Avenue Elevated After Midnight. *1899. Pastel, 8 × 12⅜". Collection Arthur G. Altschul, New York*

263. *William Glackens.* Bus, Fifth Avenue. *1910. Pastel, 7⅜ × 10⅜". Mead Art Museum, Amherst College, Amherst, Mass.*

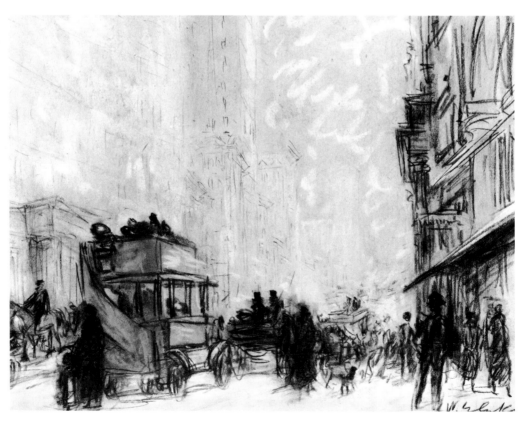

periodically plagued its economic and banking systems. The effect on the hordes of people now gathered in cities, divorced from the food-giving soil, was disastrous. It was neither the first nor the last intimation that democracy and technology together might not be able to provide all the answers to society's ills. The attendant distress was of course not confined to cities, but it was most apparent there, where the unemployed waited in long lines looking for jobs (plate 261).

As in all other large cities of the world, but perhaps more noticeably than elsewhere, the pace of life in New York seemed to quicken with each passing year. Morning, noon, and night, as taller buildings multiplied in and about the business district, more and more people poured onto the already congested streets. To take such crowds off the surface lanes, elevated railways (plate 262) and subway lines were introduced. Although most of these were hurriedly constructed, the relief they provided when finished was short-lived. Every effort to ease traffic congestion succeeded only well enough to invite bigger crowds onto the scene. Real congestion awaited only the advent and proliferation of the automobile—a development which, though not immediately recognized, would soon render all existing city streets practically obsolete. In 1910 William Glackens pictured Fifth Avenue, highlighting one of the open double-decker buses that were a delight to the city until the last of them was retired in 1946 (plate 263).

Without the telephone, the great concentration of people in tall buildings would have been impossible. This contraption, wrote Arnold Bennett, when he visited the country early in the century, was America's proudest and most practical achievement. "What startles and frightens the backward European in the United States," Bennett went on to say, "is the efficiency and fearful universality of the telephone." Indeed, America had become the most talkative nation in the world—a point suggested a few years later by the artist Charles Sheeler's self-portrait (plate 264).

About the turn of the century, while the Ashcan School was turning

264. Charles Sheeler. Self-Portrait. 1923.
Watercolor, conté crayon, and pencil, 19¾ × 25¾"
The Museum of Modern Art, New York. Gift of Abby Aldrich Rockefeller

out realistic depictions of the workaday aspects of contemporary urban life, other artists were looking to decidedly different models for inspiration. To a fair number of sensitive observers of the time, it seemed that the idealization of its womankind was a peculiarly American phenomenon. The form that this idealization took was not to see women as sensual objects, but rather to elevate them—or reduce them, depending on the point of view— to somewhat bloodless, sexless, and purified versions of the species. "The American girl is placed upon a pedestal," wrote one critic, "and each offers worship according to his abilities, the artist among the rest." Of those artists paying tribute to this ideal young lady, Charles Dana Gibson was the most popular, if hardly the best. His "Gibson Girl" became the ubiquitous symbol of this improbable creature (plate 265).

At the beginning of the century, American taste was being led in new directions, with important guidance from two prominent figures—Louis Comfort Tiffany and Edward William Bok. Taste, Tiffany observed, "is a matter of education and we shall never have good art in our homes until the people learn to distinguish the beautiful from the ugly." In 1900 he established the Tiffany Studios, where, with the help of hundreds of female "craftsmen," he produced an endless variety of ornamental, yet useful, objects. One testimonial to his multifaceted talents stated that he, more than any other artist of the age, had affected and improved the public taste of America. The hyperbole latent in that judgment can be explained by the fact that Tiffany himself commissioned the book in which it appeared. His name is closely associated with the Art Nouveau movement so popular at the time. In his lamps (plate 266), Tiffany exploited the relatively bright glare of the recently invented electric light bulb to call attention to the colorful designs of his famous lampshades. (As a footnote, now for the first time in history the source of light could be pointed down as well as up.)

Beginning in 1889, and for thirty years thereafter, Edward Bok, an immigrant from Holland, was the editor of the prestigious *Ladies' Home Journal*. From that position, he zealously set about improving the lives of the readers of his magazine. Appalled by what he considered the "wretched" state of American domestic architecture, he made many efforts to change things for the better. In 1901, for example, he commissioned the gifted American designer Will Bradley to prepare designs for a model house (plate 267). He then published these designs in the *Journal*. Bradley's drawings expressed a questing spirit that looked for a fresh, "modern," and relatively simple departure from the clichés of the past. In Bok's Pulitzer Prize-winning autobiography, he summed up his own reforming achievements: "Bok had begun with the exterior of the small American house and made an impression on it . . . he had changed the lines of furniture, and he had put better art on the walls. . . . He had conceived a full-rounded scheme and he had carried it out."

In the several decades preceding World War I, two developments tended to reduce the role of the artist as a reporter of the world around him. First was the increasing reliance on photography and photoengraving technique to serve this function. Second was an important trend on the part of artists to use natural forms primarily as points of departure for inventions in pattern and color, leaving only a minimal visual hint of some nominal "subject" in their finished works. In this manner, John Marin, the patriarch of modernist art in America, transmuted the Brooklyn Bridge (plate 268), the towers of Manhattan, and the rugged coast of Maine—anything he pictured, in fact—into an explosive and lyrical geometry of forms and colors

265. Charles Dana Gibson. The Gibson Girl. 1899. Pen and ink. Illustration for Charles Scribner's Sons

266. Louis Comfort Tiffany. Suggestion for Lamp for Miss H. W. Perkins. n.d. Pencil and watercolor on board, 6⅞ × 5⅛". The Metropolitan Museum of Art, New York. Purchase Walter Hoving and Julia T. Weld, Gifts, and Dodge Fund, 1967

267. *Will H. Bradley.* Design for a Living Room. *Watercolor, 10 × 12⅞".* From Ladies' Home Journal,
1901. The Metropolitan Museum of Art, New York. Gift of Fern Bradley Dufner, 1952

that he had really created in his mind's eye. Charles Sheeler, too, in his
depiction of a barn (plate 269) reduced the subject to an abstract, albeit still
recognizable, design. The point in illustrating these two arbitrary examples
is to bring to mind that such radical departures from traditional ways of
representing the surrounding world, like it or not—and many do not—have
inevitably affected our way of looking at things, a point to bear in mind in
viewing some of the illustrations that follow.

A centuries-old dream to connect the Atlantic and Pacific oceans by
artificial waterway approached reality in 1904, when the United States
purchased the New Panama Canal Company from French speculators who
had gone bankrupt in a vain attempt to cut a canal through the mountains
and jungles of Panama. Ten years later the canal was opened to commercial
traffic. It was a remarkable tribute to the organizing skill of American
engineers—and to the sanitary work that made this pestiferous zone a livable
place.

Hardly less impressive was the rebuilding of San Francisco, which had
suffered one of the greatest disasters of modern times when, on April 18,
1906, a devastating fire and earthquake all but destroyed the city. In 1915,
to celebrate both its own rapid renascence and the opening of the canal,

268. John Marin. Brooklyn
Bridge. 1910. Watercolor, 18½
× 15½". The Metropolitan
Museum of Art, New York. The
Alfred Stieglitz Collection, 1949

269. Charles Sheeler. Barn
Abstraction. 1917. Conté
crayon, 14⅛ × 19½"
Philadelphia Museum of Art,
Louise and Walter Arensberg
Collection

270. *Bernard R. Maybeck.* Palace of Fine Arts, Panama-Pacific International Exposition, San Francisco. *1915. Charcoal, 20 × 70″. Collection Hans Gerson, San Francisco*

San Francisco held the Panama-Pacific International Exposition. Many Americans made their first transcontinental trip to wonder at the "dream city of cobweb palaces" that had been raised in celebration on the shore of the Bay. One of the most memorable of the exposition buildings was the Palace of Fine Arts, built from the design of Bernard Maybeck (plate 270).

When, in the summer of 1914, war broke out in Europe, few Americans expected or wanted this country to take part in the conflict. Europe was still far away—crossing the ocean by the fastest ships took well over a week—and, at the time, it was all but inconceivable that airplanes could cross the Atlantic. Europe's troubles were of its own making; let it settle them as best it could. America must get on with its own business. "Every man who truly loves America," President Wilson admonished his countrymen, "will act and speak in the true spirit of neutrality."

Public sentiment in favor of one side or the other was unevenly divided. Many Americans were relatively recent immigrants from nations on both sides of the battling armies. But less than three years later, the United States was in the war up to the hilt. Once again, as in the Civil War, the nation had to train a huge army of what were mostly civilians to do battle. When conscripts were called up for military service, very few of those who had strong attachments to their homelands placed that interest above their support for the United States—which the German government, in particular, had real cause to lament when American troops went into action.

In the late spring and early summer of 1918, American divisions were rushed into battle to bolster the Allied forces at Château-Thierry and Belleau Wood. Here, along the Marne, barely fifty miles from Paris, the German offensive was checked and thrown back. Paris was saved, and, with that victory, the course of the war changed. "Day and night for nearly a month," wrote an artist covering the action at Belleau Wood, "men fought in its corpse-choked thickets, killing with bayonet and bomb and machine-gun. It was gassed and shelled and shot into the semblance of nothing earthly. . . . Finally, it was taken." The German Chief of Staff conceded that the check his armies received there and at Château-Thierry was of vital consequence to his subsequent conduct of the war.

Heroic and successful as such military actions were, America's more important contribution to the war was to provide the Allies with sufficient matériel and other supplies, thus enabling them to hold out and, in the end, to conquer. Industrial resources at home had been mobilized on a gigantic, almost incredible, scale. The nation's entire economy had been redirected—

geared and planned to answer the demands of the war effort. It was impressive evidence of what such a planned economy could accomplish. As Wilson eloquently pointed out, the United States had gone to war to prove the efficacy of cooperation by men of goodwill and common purpose. It had emerged from the war the most powerful industrial nation on earth.

Few, either at home or abroad, shared the president's lofty idealism at war's end. "Mr. Wilson bores me with his Fourteen Points," complained Georges Clemenceau, "the Tiger" of French politics. "Why, God Almighty has only ten!" In fact, the treaty of peace that Wilson had helped to negotiate at Versailles in 1919 with the three other members of the "Big Four"—David Lloyd George of Great Britain, Georges Clemenceau of France, and Vittorio Orlando of Italy—was not ratified by Congress until almost three years later.

In this country, there was a strong tendency to write off the war as a necessary, perhaps, but momentary foreign entanglement not to be repeated. Doughboys, returning from the "great crusade" that had put an end to war and had made the world "safe for democracy," looked at the Statue of Liberty and vowed never again to pass it outward bound (plate 271). The war was "over, over there" as one popular song put it, and the victory parades staged across the nation were a living testimony to that fact (plate 272). Now America could return to its earlier tranquil isolationism free from the nettlesome disputes and perplexities of the Old World.

271. *Rollin Kirby. Oh, Lady! Lady! 1918. Pencil, 15 × 20″. From* The World, *December 2, 1918. Museum of the City of New York*

272. *Dodge MacKnight. Flags, Tremont Street, Boston. 1918. Watercolor, 16½ × 23⅛″. Museum of Fine Arts, Boston*

Between Wars

273. Charles Burchfield. Old Tavern at Hammondsville, Ohio. 1926–28. Watercolor, 25¾ × 33″. Addison Gallery of American Art, Phillips Academy, Andover, Mass.

Boom and Bust

CONFIDENT OF ITS STRENGTH, convinced of its immunity from foreign incursions, and long turned inward by historical circumstances, America's immediate postwar aim was to return to its traditional isolationism and to what then Senator Warren G. Harding blithely referred to as "normalcy." However, come war, come peace, American society has never been static. The comfortable pattern of life in prewar years was outmoded even before the troops returned from Europe. True, at war's end almost half the population of the United States lived on the land, as most Americans traditionally had, and there was still a widespread conception of a small-town America—an America whose probity and character were derived from its small communities, in spite of the ever-rising cities and their growing industrial plants. Even to this day, the figure of Uncle Sam resembles his prototype, Brother Jonathan, a country fellow with a good deal of horse sense and a cracker-barrel philosophy. (Efforts to urbanize him by shaving off his rustic beard have quietly been ignored.)

Yet, as Charles Burchfield's drawing of a decaying little midwestern community so poignantly intimates (plate 273), the still-lingering image of a bucolic America was richer in nostalgia than in actual fact. In the words of one popular wartime song: "How 'Ya Gonna Keep 'Em Down on the Farm (After They've Seen Paree)?" A symbol of these radically changing times was the ubiquitous automobile, an early model of which is tucked into the corner of Burchfield's drawing. When one could buy a car for two hundred dollars, as was possible in 1924, there was hardly any reason not to. (During one twelve-month period in 1920–21, Ford Motor Company sold a million and a quarter of its cars.) For rural folk, going to town was no longer an occasional expedition but a newly discovered social necessity. The very phrase "going to town" came to mean making the most of things and having a good time. Actually, it was the town that was going to the countryside, by automobile—as well as by movie and radio. More than ever, urban values were spreading a standard of culture across the land.

274. Ben Shahn. WCTU Parade. c. 1934. Gouache, 16 × 31½". Museum of the City of New York

275. Joseph Webster Golinkin. Texas Guinan's Portable Nightclub. 1928. Pencil. Museum of the City of New York. Courtesy of Captain Joseph Webster Golinkin

The road back to normalcy, in fact, led almost everywhere except to a restored prewar past. In spite of Wilson's idealistic vision, the postwar world had stopped far short of bringing about a millennium. Men who had experienced the gruesome realities of modern warfare and, hardly less important, the boredom and seeming futility of the regimentation that attended it, came home disillusioned and cynical.

At home, the spirit of regimentation and self-denial generated by the war effort had made it possible, in January 1919, to write the Eighteenth Amendment into the Constitution. Its passage had been secured through the lobbying efforts of a number of temperance movements, whose members, when the amendment was repealed, once again took up their crusade with steadfast determination (plate 274). Although almost two thirds of the American people had already lived under prohibitory laws by local option, legislation on a federal level was quite another matter. A sizable segment of the population greeted with dismay the specter of a "dry" nation. Others, in principle, resented this restriction of their personal liberty. Large numbers of otherwise respectable citizens broke the law without a second thought. The speakeasy became something of an institution, a symbol of one aspect of American life that replaced the old-fashioned corner saloon. Texas Guinan, who ran a number of New York nightclubs where wine and liquor could be had (plate 275), became one of the brightest lights on Broadway.

The undeniable thirst of so many Americans called forth gangs of highly organized outlaws—bootleggers, highjackers, professional gunmen, and other racketeers—whose business often resulted in sanguinary warfare among rival gangs. For more than a decade, the nation was treated to a spectacle of lawlessness and corruption without precedent in its history. The gangster

276. Ben Shahn. Prohibition Alley. 1934. Gouache. Museum of the City of New York

277. Harold Rambusch. Auditorium of the Roxy Theater. 1926. Watercolor, 16 × 19″. Rambusch Company, New York

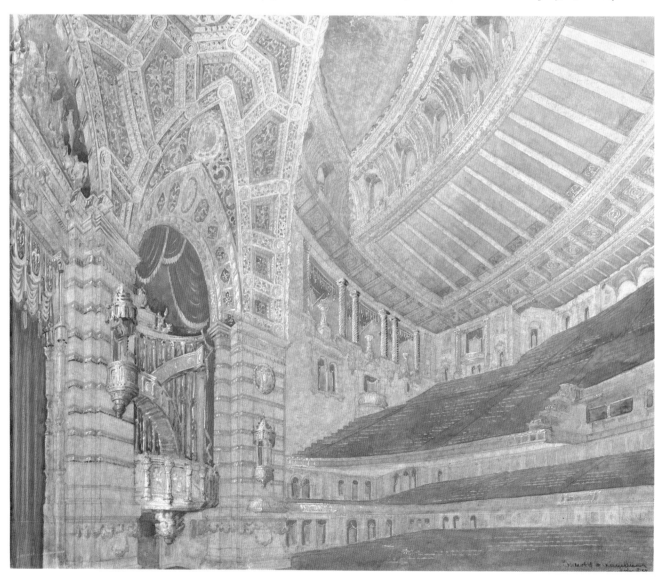

Al ("Scarface") Capone, leader of a large syndicate and instigator of many bloodbaths, became a prominent national figure. The pervasiveness of his influence is clearly suggested in Ben Shahn's *Prohibition Alley* (plate 276), in which his image looms large, dominating the entire scene. Prohibition became the hottest issue of the 1920s, outranking in importance almost all other national problems.

During this decade, a persistent suspicion was plaguing the imagination of many "real Americans" that the more recent arrivals were to blame for many of the nation's ills, real or imaginary. (Will Rogers, the very popular part-Indian "cowboy philosopher with a cool brain and a warm heart," countered such smug assumptions with gentle wit, pointing out that his forefathers had not come over on the *Mayflower*, but had met the boat.) Responding to that fear, policies of rigid restriction on immigration were adopted by Congress in 1921, 1924, and 1929 (plate 278). With that legislation, an era of deep significance in human history came to an end.

The nativist sentiments that had led to such enactments found a more grotesque expression in the revival of the Ku Klux Klan. The Klan was hostile to any and every group that did not conform to its ideal of "native, white, Protestant supremacy"—in other words, blacks, Catholics, Jews, immigrants from certain countries, or similar categories of "un-American" folk. This kind of reactionary spirit found its most sensational outlet in the trial and subsequent execution of Nicola Sacco and Bartolomeo Vanzetti, two philosophic anarchists of foreign birth (plate 279). The conviction (in July 1921) and electrocution (in August 1927) of these two men, on what seemed to many to be dubious evidence, shocked a broad segment of the public both at home and abroad. Had America, it was asked, a nation dedicated to political experiment and itself a radical element in the society of nations, become the world's most conservative power, fearful of outside influence and hostile to any suggestion of change?

While these grave matters were casting shadows across the nation, the Jazz Age came to full flower. "Jazz has come to stay," announced the eminent conductor Leopold Stokowski, "because it is an expression of the times in which we are living, of the breathless, energetic, superactive times." The euphoric spirit of those times was captured in the novels of F. Scott Fitzgerald and piquantly caricatured in the drawings of John Held, Jr. The "flaming youth" of the 1920s was pictured as bibulous, overtly carefree, and unrestrained by the social conventions that had guided earlier generations to maturity. The youthful pursuit of happiness was attended by the syncopations of jazz orchestras, visions of sexual liberation, and the inducements provided by bootleg liquor.

By the 1920s the labor-saving machines of industry were providing Americans with more leisure time than had ever been known elsewhere in history. What they would do with all that time was a problem quickly solved by all manner of recreational facilities. Watching the movies became the addiction of countless millions. One learned pundit wryly observed that if the American public were for some reason deprived of its movies the nation would witness a gruesome revolution within a week. Large and elaborate theaters, such as New York's Roxy (plate 277), were billed as "cathedrals of the motion picture," and played to full houses. Leading luminaries of the stage gained even greater fame in the movies (plate 280)—and the industry grew to be very large and wealthy.

The nation's pleasure and its business were becoming interdependent. Billions of dollars were involved in the business of supplying those who

278. *Rollin Kirby.* I Sympathize Deeply with You, Madame, but I Cannot Associate with You. *1923. Pencil. Private collection*

279. *Ben Shahn.* Sacco and Vanzetti. *1952. Ink, 5¾ × 8⅝". Fogg Art Museum, Harvard University, Cambridge, Mass.*

280. *John Singer Sargent.* John Barrymore. *1923. Charcoal, 24 × 18". The Fine Arts Gallery of San Diego*

281. *Rollin Kirby.* What Dr. Butler Objects To. *1930. Pencil, 17½ × 12¼". Museum of the City of New York*

would have some form of recreation, regardless of price, with the facilities and paraphernalia to do so. If, at that time, Americans had returned to the concepts of their Puritan forefathers and had shunned amusement as an evil, the country's entire economy would have been very seriously dislocated. Even college sports were becoming commercialized. In 1927, for example, during the relatively short autumn football season, thirty million spectators paid about fifty million dollars to watch the sport—much to the enrichment of collegiate coffers and much to the chagrin of disapproving observers (plate 281). Professional football was only then beginning to attract such crowds.

Boxing bouts for the heavyweight championship attracted such vast numbers of paying customers that those watching the fight from the more distant seats of an amphitheater were often unable to tell who had won at the end of the match. One of the most savage and controversial of such encounters took place in 1923. Almost incredibly, the challenger, Luis Firpo ("the Wild Bull of the Pampas"), knocked the champion, Jack Dempsey, out of the ring. But, helped by news reporters, Dempsey climbed back in and proceeded to whip the Argentine. Appropriately, the high drama of the bout was drawn by George Wesley Bellows (plate 282), who had given up a career as a professional athlete when he decided to become a professional artist.

In the eyes of one reporter, the sporting scene had the character of a Roman circus. The public could afford both its bread and its circuses in those halcyon days of the early 1920s. At the time, America appeared to have arrived at an "upland of plenty." In 1929 one prominent and confident authority observed that anyone could be, and everyone should be, rich. "You can't lick this Prosperity thing," Will Rogers explained. "Even the fellow that hasn't any is all excited over the idea." To prosper was almost

282. *George Wesley Bellows. Dempsey Through the Ropes. 1923. Crayon, 21½ × 19⅝". The Metropolitan Museum of Art, New York. Rogers Fund, 1925*

283. Earl Horter. The Chrysler
Building Under Construction.
*c. 1930. Ink and watercolor, 20¼
× 14¾". Whitney Museum of
American Art, New York*

obligatory. It was in that year and in that highly optimistic spirit that
construction on New York City's Chrysler Building was begun (plate 283).
Reaching a height of 1048 feet, this extremely handsome structure had been
planned as—and, in 1930, became—the tallest building in the world. Its reign
was brief, however, for early in the following year it was surpassed by the
Empire State Building at 1250 feet. The latter skyscraper, constructed al-
most entirely of standardized machine-made parts, was built in remarkably
short time. At peak speed, fourteen-and-a-half stories were raised in only
ten working days.

It was in the decade of the 1930s that a substantial portion of Rocke-
feller Center was built. Fairly called "the most successful effort at high-
density urban design in the nation," it remains one of New York's most
impressive architectural monuments—a magnet for sightseers drawn from all
parts of the globe. One of the renderings of the prospective complex (plate
284), made in 1931, shows various roof gardens that would, in fact, become

284. John Wenrich. Rockefeller
Center. *1931. Pastel, 22 × 18".
Rockefeller Center, Inc., New
York*

such an agreeable feature of the Center's buildings; also visible are several pedestrian bridges, planned by the architect Raymond Hood, which in the end were deemed impractical and never built.

Among his many other endeavors, Hood visualized a plan for Manhattan in which underpasses and overpasses would ease the heavy flow of traffic in the center of the city (plate 285). It was in many ways unfortunate that his plan did not materialize, for when the tall towers of Manhattan disgorged their working populations onto the same old city streets, congestion in downtown New York became worse than ever. The increasing numbers who sped to and from their jobs by subway were subjected to travel

285. Raymond M. Hood. A Busy Manhattan Corner: Aerial View of a Visionary Plan. 1929. Watercolor. The New-York Historical Society

conditions that would have made cattle complain (plate 286), conditions that grew progressively worse.

In the autumn of 1929, at about the time that the Chrysler and Empire State buildings were heading into the skies, the stock market collapsed with a thunderous crash. The almost mystic sanctity of American prosperity had somehow been violated and it left the country "outraged and baffled." The nation was unfamiliar with the degree of suffering that soon occurred. It seemed like some ghastly prank of nature, rather than the result of any overindulgence or inadequate planning. Wilson's prophecy that America might one day have to pay a heavy debt for its wasteful opportunism and its frenetic scramble for quick wealth had come all too true.

Although it was but one aspect of the Great Depression, it became frightfully apparent that in the West, the settlers had unsettled the soil almost as effectively as they had settled the land. In 1934 great dust storms swept over the western plains. Tearing up the overworked and misused soil and spreading it out in dark clouds over large areas of the countryside, these storms uprooted hordes of hopeless farmers and their families, who took to their overburdened jalopies to find a haven "elsewhere" (plate 287). "They scuttled like bugs to the westward," wrote John Steinbeck in *The Grapes of Wrath,* "and as the dark caught them, they clustered like bugs near to shelter and water." It seemed like a reversal of the country's history, with civilization retreating before the advancing wilderness of wind and sand.

The events of the 1930s gave a strong jolt to the nation's government, shaking it into new and important patterns. More than a century earlier, Jefferson, that great individualist, had remarked that the intervention of government in the affairs of the people, rather than destroying individualism, might sometimes be a means of preserving it. With the election of Franklin Delano Roosevelt (plate 288) and the inception of the New Deal, that supposition was given a crucial test.

In some important ways, the programs of the New Deal were a natural outgrowth of those initiated in Theodore Roosevelt's Square Deal and

286. Rollin Kirby. Not Experts—Just Sardines. 1927. Pencil, 15 × 18⅞". From The World. *Museum of the City of New York*

287. Philip Reisman. Migrants: The Grapes of Wrath. *1940. Ink. Private collection*

Woodrow Wilson's New Freedom, but the scale on which they were carried out was something new. It is not surprising, therefore, that historians have referred to the changes effected during Roosevelt's term of office as "the third American revolution." William Allen White, the nationally famous editor of the *Emporia* (Kansas) *Gazette,* observed at the time a new desire on the part of the American people to use government as an agency for promoting human welfare. Not all the programs favored by Roosevelt's administration were, in the end, successful. The most notable of these was the National Industrial Recovery Act, which Roosevelt himself described as "the most important and far-reaching ever enacted by the American Congress." The act envisioned a trusting relationship between private enterprise and government regulators, and it was to be carried out on a massive scale that would touch the lives of virtually all Americans.

The program was launched in 1933 with all the fervor of a wartime campaign. "If we are to go forward," Roosevelt expounded, "we must move as a trained and loyal army willing to sacrifice for the good of a common discipline." Although many were willing to do so, a sizable number were not. Strong resistance was mounted and the act was ultimately deemed unconstitutional. The Blue Eagle which had become a popular symbol of the National Recovery Administration (the bureau in charge of implementing the act's reforms) disappeared from the scene. Those most bitterly opposed to the New Deal felt that the damage had already been done, however, and that American life would never again be what it had been. The necessary evil of government had become so necessary that it had ceased to be an evil, or so it seemed to many. Two eminent historians have claimed that, in saving the system of private enterprise by ridding it of its grosser abuses and forcing it to accommodate itself to larger public interests, Roosevelt may rightly be remembered as the greatest American conservative since Alexander Hamilton.

The nativism that characterized the postwar years in America, with the intolerance that often attended it, sometimes in very sinister ways, persisted into the 1930s. In one popular book on art published in 1934, the author damned the work of virtually all the artists with alien backgrounds and foreign-sounding names as un-American and unworthy of serious consideration. His list included a number of the most significant artists of the day, men who were refugees from Europe's turmoil and whose work pumped fresh blood into the mainstream of American art. That nativism received more benign expression in the regionalism encouraged by the Federal Art

288. *Loris Selmi.* Franklin Delano Roosevelt. 1933. *Charcoal, 21⅜ × 16⅝". Franklin D. Roosevelt Library, National Archives and Records Service, Hyde Park, N.Y.*

289. *Grant Wood.* Study for Breaking the Prairie. *c. 1935. Pencil, chalk, and graphite, 22¾ × 80¼". Whitney Museum of American Art, New York*

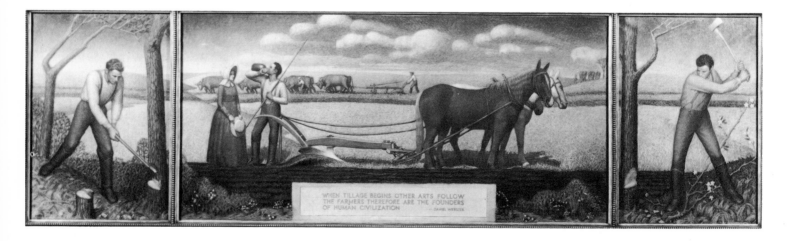

Project, a government agency designed to help artists ride out the Depression. In his nostalgic study for a mural intended for the State College of Agriculture and Mechanical Arts in Ames, Iowa (plate 289), Grant Wood, a native Iowan, celebrates the role of the pioneering midwestern farmer, industriously working the land in what the artist considered to be the grass roots of the nation.

In the same year that Wood produced that drawing, Paul Cadmus, another artist who worked on FAP murals, drew his impression of racial prejudice in its most savage and bigoted manifestation (plate 290). Lynching

290. Paul Cadmus. To the Lynching! 1935. Pencil and watercolor, 20½ × 15¾". Whitney Museum of American Art, New York

had a long and frightful history in America, and although such extralegal executions had been diminishing for decades, in the 1930s they were still staining the nation's honor with shame and disgrace. Most of the victims were southern blacks, the lynchers maniacal white "America Firsters."

In spite of all the upheavals of the Depression years, the democratic system once more proved its viability. As Winston Churchill advised the House of Commons, democracy was the worst form of government except for all those other forms that have been tried from time to time. Political conventions, that often seemed more like a circus than a serious means of deciding the public will, continued in their customary fashion (plate 291). In the election campaign of 1940, many dissident voices were raised against the radical innovations of the New Deal and the formidable leadership of Franklin D. Roosevelt. Nevertheless, "that man," as his resentful critics referred to him, was chosen as the Democratic nominee and went on to win an unprecedented third term in the White House.

Meanwhile, at the nadir of the Depression, New York City had its own faith in government restored with the election of Fiorello Henry LaGuardia (plate 292) as mayor. The "Little Flower" as he was affectionately called, was the son of an Italian immigrant. With absolute honesty and indefatigable attention to the public welfare, he made superb appointments, cracked down on crime and police corruption, obtained a new city

291. Thomas Hart Benton. Political Convention. n.d. Pen and ink, wash, and watercolor, 12 × 14″. Private collection

*292. Peggy Bacon. Fiorello Henry
LaGuardia. 1934. Lithograph, 14 × 10″
The Butler Institute of American Art,
Youngstown, Ohio. Gift of Louis Held*

charter, reformed the civil service, and for twelve years gave the city—so
repeatedly called "ungovernable"—the most efficient administration man
could remember. To cynics, it was a revelation of what could be done by
men of goodwill, honest purpose, and unyielding determination.

It was during his time in office that a gigantic world's fair was opened
in New York. The exposition, dedicated to the "World of Tomorrow," was
dominated by the Theme Center—comprised of the 610-foot-high Trylon,
the 200-foot-wide Perisphere, and the 950-foot-long Helicline—a ramp em-
bracing the other two (plate 293). The fair had been planned to present a
vision of "a happier way of American living through a recognition of the
interdependence of men, and the building of a better world of tomorrow
with the tools of today." President Roosevelt opened the fair with a talk
delivered in the Court of Peace, a talk which marked the first time a pres-
ident of the United States had faced television cameras. It was a signal,
according to the *New York Times* that "a new industry had been launched
into the World of Tomorrow."

It was tragically ironic that while the fair was still open the world of

the immediate tomorrow took on a very different cast with the outbreak of
World War II. Once again the United States would reluctantly be drawn
into the conflict, assuming its former role as, to use Roosevelt's words, "the
arsenal of democracy."

*293. Lucille Corcos. 1939
World's Fair. c. 1939. Tempera
on masonite, 17½ × 13½".
Collection Beverly and Ray
Sacks, Cedarhurst, N.Y.*

War and Peace

294. *Hugh Ferriss. General View, United Nations Headquarters.*
c. 1948. Charcoal, 21½ × 31″. Courtesy Jean F. Leich

Deepening Global Responsibility

NEXORABLY, the United States was led toward war by forces beyond its control. This time, however, it would be war not only in Europe but around the globe. After that "day of infamy," December 7, 1941, when in a sneak attack the Japanese destroyed the American fleet at Pearl Harbor, there remained no tolerable alternative to taking up arms in order to oppose the hostile forces that had been loosed in East and West alike.

It took almost four years after that attack—four years of slaughter and horror on both fronts—before the matter was finally settled. In the Pacific arena, the turning point of the war came in 1943, with the long-drawn-out and frightfully costly American victory at Guadalcanal. From that point on, the only direction the Japanese moved was "backward." Eyewitness descriptions of that jungle warfare are hard to imagine. As one participant inscribed on the grave marker of a buried marine comrade after the fighting was over:

> And when he goes to Heaven
> To St. Peter he'll tell
> "Another Marine reporting, sir,
> I've served my time in hell."

In the western theater, Hitler's last desperate gamble was the counteroffensive of 1944–45, known as the Battle of the Bulge. One element in the Americans' strategy to halt and turn back the German advance was to occupy the densely wooded Hürtgen Forest, located astride the Siegfried Line just inside the German border. This was ultimately accomplished but at enormous cost. More than twenty-four thousand American soldiers were killed, missing, captured, or wounded before the area was won. An additional nine thousand were disabled by illnesses resulting from long exposure to insufferable weather conditions. The appalling tragedy was compounded by the fact that, in retrospect, it seems the battle need never have been fought. It was a ghastly tactical mistake.

Many years ago Henry Adams foresaw the probable outcome of the scientific developments occurring in his own day. He observed that man had unleashed forces moving in an unbroken sequence that was even then rapidly accelerating—implacable forces that he believed could not be held in check and that would lead to "cosmic violence." At some not very distant day, he mused, the human race might very well commit suicide by blowing up the world. Such a spectacle had a monstrous rehearsal in 1945, when American aviators dropped atomic bombs on Japan, thus ending the war.

With the hope of finding a more reasonable means of settling international differences, in the early summer of 1945 the United Nations Charter was signed, and subsequently ratified, by the requisite number of nations. The headquarters of this new organization (plate 294) was to be located in the eastern United States. This country had emerged from the global conflict as the richest and most powerful nation on earth. Now faced with the unprecedented responsibilities that came with world leadership—leadership of the free world, that is—it settled down to a cold war with the totalitarian forces mustering behind the "iron curtain".

During the early 1950s concern over a perceived Communist threat to our democracy was fanned into a short-lived blaze of hysteria by representatives of our own government. In a shameful display of demagoguery, Senator Joseph R. McCarthy (plate 295) held his infamous and widely publicized hearings, in which he irresponsibly accused a sizable number of worthy

citizens of subversion, espionage, and other grave improprieties. Although there was often little or no evidence to support his charges, careers of highly respectable men were ruined in the course of those proceedings. It was a somber few years for the champions of democracy. However, the nation soon recoiled in shock from the experience. The term "McCarthyism" became an epithet commonly used in contempt of the kind of notorious political tactics that the senator used.

Twice in the generation following World War II, the United States has taken up arms in far corners of the earth—in Korea and Indochina—where the nation's vaunted invincibility has been put to the test. Or, as might more truly be said, where it became painfully clear that any attempt to demonstrate such invincibility implied unthinkable consequences—consequences that were foreshadowed at Hiroshima and Nagasaki.

As Ralph Waldo Emerson, "the Sage of Concord," suggested more than a century earlier in his essay "Compensation," if the force is there so is the limitation. His words have taken on fresh meaning for the present generation. It has become increasingly apparent that the extremes of power are hedged by troubles and perils that cannot safely be ignored—in peace as in war.

"The farmer imagines power and places are fine things," Emerson continued. "But the President has paid dear for his White House. It has commonly cost him all his peace, and the best of his manly attributes." Emerson was writing at a time of intense political factionalism, but he was thinking in terms of universal principles which he considered timeless. His words came hauntingly to mind in 1974 when the president of the United States, embroiled in scandal (plate 296) and faced with possible impeachment, quit his high place in the White House forever.

Henry Adams had believed it likely that America, more than any other nation, would shape the uncertain future of the twentieth century. And thus it appears to be happening. The United States is not only an industrial

295. David Levine. Joseph R. McCarthy. 1965. Pen and ink. From the New York Review of Books, *1965. Private collection*

296. Howard Brodie. Watergate Hearings. 1974. Pencil. Wide World Photos, Inc., New York

297. *Paul Stevenson Oles*. Rendering of the Vietnam Memorial. *1981. Colored pencils, 9 × 12″. Vietnam Veterans' Memorial Fund, Washington, D.C.*

giant, a technological prodigy of immense potential; it is also a meeting ground for ideas and ideals that have no counterpart elsewhere in the world. As such—as a truly democratic society—it has had, and will continue to have, its share of problems. In the decades after World War II, violent protests have been staged against our extravagant and, to many, dubious military programs, and over questions dealing with civil rights. At times they have threatened to rip the fabric of American society. One indication of how volatile such feelings can become occurred recently, as a bitter debate was waged over a fitting memorial to the 57,709 Americans who died or were declared missing in the Vietnam War. The winning design, selected from 1,421 entries in a national competition, was submitted by a young Chinese-American woman. Her proposal consists of two black granite walls—inscribed with the names of the dead—that meet in a **V** and recede into the ground (plate 297). While most of the criticisms of the highly imaginative proposal (one veteran referred to it as "a black gash of shame") have been based on aesthetic grounds, they nevertheless reveal the ambivalent attitude that many Americans still have in regard to that tragic conflict.

During these recent decades, the power of central government has extended its reach over the lives of individual Americans to a degree unimaginable in former times. For many citizens, the growing dependence upon a remote and impersonal bureaucracy, federal or state, has robbed them of the sense of shared purpose that was so essential to the survival and development of American communities earlier in our history; that is, indeed,

still close to the concept of any livable democratic society—of any free society.

One can see in the youth movement of the 1960s and the early 1970s (plate 298), and in the black militancy of the same years a quest for some more immediate community of interests than can be found in the complex political framework of the time. In this same connection the long-professed faith in the American melting pot has been questioned by a wide variety of ethnic groups, who revert to their separate group identities (plate 299) as a means of protecting themselves from other, competing groups and from what they perceive to be the general indifference of the government.

In recent years, also, Americans have not only reached for the moon, but have actually walked and driven on it, while the world at large watched those eerie adventures on television screens. Although it has been less than three decades since our Gemini program (plates 300, 301), the exploration of outer space has become almost commonplace, not always rating headlines in the daily press.

Such audacious ventures would, of course, be impossible without the electronic devices that have become the ubiquitous tools of the current age (plate 304). The "computer revolution" is confronting us with incalculable hoards of data which, it seems to laymen, we are not altogether sure how to use properly. Yet, as the economist and social critic Thorstein Veblen once observed, invention is the mother of necessity. The innovations made possible by advancing technology have produced things and introduced practices for which there had been no previous demand and which did not exist before World War II—things and practices to which the daily routine of American life has already become inseparably geared.

To supply all the energy required by the needs and wants of modern

298. *David Levine*. Two Brooklyn Museum Art Students. *1970. Ink, 13¾ × 11″. The Brooklyn Museum, N.Y.*

299. *Francis Brennan*. Study in Black and White. *1976. Carbon pencil, 10⅞ × 12⅜″. Collection the artist*

300. Paul Calle. Gemini IV Launch from Cape Kennedy. 1965. Pencil, 30 × 22″. National Aeronautics and Space Administration, Washington, D.C.

301. *Paul Calle.* Astronaut Edward H. White, Gemini IV Pilot, Suiting Up. *1965. Pencil, 30 × 22″. National Aeronautics and Space Administration, Washington, D.C.*

302. *Howard Koslow.* Wind Machine at Princeton University. *1972. Acrylic on gessoed masonite, 22 × 16½″. From Popular Science, November 1972. Popular Science magazine, New York*

303. *Francis Brennan.* "The Earth Lies Polluted Under Its Inhabitants. . . ." *1976. Ink and carbon pencil, 15 × 10″. Collection the artist*

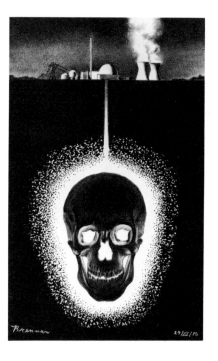

life has put strains on the country's diminishing natural resources, strains to which Woodrow Wilson had called serious attention early in the century, and which by the 1960s and 1970s were becoming an immediate and very crucial problem. The policies of oil-rich Near Eastern nations, together with the political instability of that part of the world, aggravated the problem to an even more serious degree.

Solar and geothermal energy promise some relief from the heavy reliance on such conventional sources as fossil fuels—oil, natural gas, and coal. One authority on such matters testified before a congressional committee that wind power might "become a significant factor" in solving the overall problem. Among many other experiments in this direction, an "advanced technology wind-driven generator"—in short, an updated windmill—was developed at Princeton University (plate 302). With its sailwing blades, whose leading edges are shaped and built like those of airplane wings, this model is as efficient as the best wind turbine ever conceived. Experimental developments such as these, if used to supplement other sources, may help to alleviate the energy crisis by generating pollution-free electricity. "Pollution" has become one of the dirtiest words in the American language, as we struggle with the toxic by-products of our industries. In the words of the prophet Isaiah, "the earth lies polluted under its inhabitants" (plate 303).

In spite of the unforeseen problems and tribulations of our recent history and the growing cynicism that these developments have on occasion evoked, America at large seems to cling to its traditional faith that technological advances in a democratic context will contribute to the public weal. Some indications of this may be read in the skylines of our larger cities. The skyscraper is the quintessential American creation. The jagged outline of the cities' towering buildings is one dominant symbol of our New World civilization and a clearly perceived reminder of our technological competence.

In recent years some significant changes have appeared in these outlines, changes that reflect new attitudes both on the part of the business community toward its immediate environment and on the part of the public toward the business community. A new generation of skyscrapers has been growing up and a significant number of these constructions have departed from the monotonous uniformity of the flat-topped, boxlike, glass-encased

304. James Wyeth. Firing Room. 1969. Watercolor, 18 × 25". National Aeronautics and Space Administration, Washington, D.C.

towers that, for some time, have been the standard expression in skyscraper design. Instead, the best of these more recent buildings have a refreshing degree of individuality, often suggesting the forms of abstract sculpture. Also, in their allover designs they include areas which accommodate the needs and interests of the city and community at large. In either case, by pleasing the eye of the beholder or by providing facilities for public use, they show a considerable social awareness that is all for the good.

With its numerous small setbacks, cut-ins, and nips and tucks proceeding up its entire height, the recently built Trump Tower (plate 306) provides a fresh and lively accent to New York City's midtown. It is also a welcome example of what skyscrapers may add to the visual qualities of the metropolis. Far across the continent in Oregon, Michael Graves's Portland Public Services Building (plate 305) provides an entirely different departure from the glass-box formulas of yesteryear. The character of its design has no

305. Michael Graves. Portland Public Services Building, Fifth Avenue Facade. 1980. Pencil and prismacolor, 11 × 7½". Max Protetch Gallery (courtesy Michael Graves), New York

306. Richard C. Baehr. The Trump
Tower. *1980. Watercolor, 9½ × 4¼"*
The Trump Organization, New York

precedent in the history of tall buildings. Without compromising its func-
tional integrity, the building expresses a quality of eclectic romanticism that
through imaginative compositions seeks to link the lessons of the past with
the promises of the future.

Visions of the Future

307. Mark Foersch, Unimation, Inc. A Computer-controlled Assembly Line. 1982.
Magic marker and felt-tip pen, 8 × 10⅝". Harry N. Abrams, Inc., New York

Toward a New Tomorrow

THOMAS JEFFERSON once remarked that he preferred the dreams of the future to the history of the past. Even his fertile imagination might stagger, however, in contemplating the prospects that informed men envision as we approach the twenty-first century. In the Middle Ages learned scholars speculated on how many angels could dance on the head of a pin. Today, serious scientists wonder when a computer—the size of a pinhead—may be developed, in which could be stored every word from every book published over the course of one hundred years.

To laymen, such informed projections of what the future world may bring often appear too fantastic for credence, as, for example, Jules Verne's account of a trip to the moon seemed to the readers of his day. Yet, there is every reason to believe that the "far-out" predictions of today will be as real to our great-grandchildren as the moon landing has been to our generation, who watched it on television barely a century after Verne wrote his account.

Jefferson would surely be interested, to say the least, in a not unrealistic speculation, put forth by the distinguished scientist Gerard K. O'Neill, that within a century more Americans may be living in space colonies than are presently living in the United States; living, it might be added, more abundantly and in more attractive, controlled environments than many of their earth-bound compatriots. Sources of energy to power those far-distant communities would not depend upon earthly resources but would probably come from materials mined on the moon, on asteroids, or from the inexhaustible outpourings of the sun into space.

Much of what will happen to change the ways and means of daily life will not result from miraculous breakthroughs in fundamental science, but will almost inevitably stem from what is currently known and being put into practice at one stage or another of our growing development. On this basis, predictions become more dependable.

Our factories are already being increasingly "manned" by tireless, uncomplaining, and remarkably efficient robots (plate 307). It is not unlikely then that in the not too distant future, these robots will be at the disposal of the average American citizen. They may, in fact, even look like the average American citizen. In a household, some such "being" could be sent to the kitchen to perform, in addition to less agreeable chores, the selection of the evening's wine for dinner. In the task of recognizing the individual bottles, "he" would be guided by holograms—three-dimensional projections—to which he has been programmed. He would also ungrudgingly clean up the kitchen when dinner is over, greatly enhancing his usefulness as a household helper.

Foretastes of the future are indeed all about us, if only in incipient stages. One projected experiment, in future high-rise housing, envisions a vertical community of dwellings on multiple levels, with a village-like setting on each floor (plate 308). As planned, every level will be made up of a flexible platform on which real-estate plots can be purchased. Private houses, the various styles of which will be determined in accordance with the owners' preference, can be installed with appropriate landscaping, much as they are in suburban areas, except here they would be compacted into a single framework. The individual houses, gardens, and streets will be serviced by a central elevator and a specially designed mechanical core. A ground floor and one intermediate level will contain shops, markets, offices, and entertainment facilities.

We can also see in the large glass-roofed, landscaped central courtyards

308. *SITE Projects.* High-rise of Homes.
1981. Pen and ink and wash, 22 × 30".
SITE Projects, New York

of some public buildings embryonic beginnings of whole towns—towns in which inclement weather could be shut out and replaced by controlled climatic conditions with closely simulated sunshine. Floater cars, speeding underground through vacuum tunnels, might very well connect these towns with one another. Traveling at what will probably be at least ten times the speed of our current automobiles, these cars will require only small quantities of electric power instead of fossil fuels.

Clearly, we face a future of unavoidable change and unprecedented challenge. However, as earlier chapters in this book have indicated, change and challenge are not new to American experience. We are what the past has made us. The society of no other country has been so profoundly modified, so richly benefited, or so pitilessly tested, by the advances of technology as America has. Seen in historical perspective, the technological developments of recent years, for example, appear to be remarkable not so much because they have involved new principles, but because the rate of their progress has been so immeasurably stepped up. If we choose to use our past with understanding and confidence, it will serve us well in the future.

Bibliography

Adams, Henry. *The Education of Henry Adams.* Boston: Houghton Mifflin Co., 1918.

Adams, William Howard, ed. *The Eye of Thomas Jefferson.* Washington, D.C.: National Gallery of Art, 1976.

Agar, Herbert. *The Price of Union.* Boston: Houghton Mifflin Co., 1950.

Alberts, Robert C. *Benjamin West.* Boston: Houghton Mifflin Co., 1978.

Albion, Robert Greenhalgh, and J. B. Pope. *The Rise of New York Port.* New York: Charles Scribner's Sons, 1939.

"American Drawings, Watercolors, and Prints." *The Metropolitan Museum of Art Bulletin,* Vol. 37, No. 4 (spring 1980).

Andrist, Ralph K., ed. *The American Heritage History of the Confident Years.* New York: American Heritage Publishing Co., 1973.

———, ed. *The American Heritage History of the Making of the Nation, 1783–1860.* New York: American Heritage Publishing Co., 1969.

———, ed. *The American Heritage History of the 20's and 30's.* New York: American Heritage Publishing Co., 1970.

Audubon, John James. *The Original Water-Color Paintings by John James Audubon.* New York: American Heritage Publishing Co., 1966.

Baillie-Grohman, William A. *Sport in Art: An Iconography of Sport During Four Hundred Years.* London: Ballantyne and Co., Ltd., 1913.

Baldwin, Leland D. *The Keelboat Age on Western Waters.* Pittsburgh: University of Pittsburgh Press, 1941.

Bartram, William. *The Travels of William Bartram.* Edited by Mark Van Doren. New York: Dover Publications, 1928.

Bishop, J. Leander. *A History of American Manufactures from 1608 to 1860.* Philadelphia: E. Young and Co., 1868.

Bliven, Bruce, Jr. *Battle for Manhattan.* New York: Henry Holt and Co., 1955.

Blow, Michael, ed. *The American Heritage History of the Thirteen Colonies.* New York: American Heritage Publishing Co., 1967.

Bowes, Frederick P. *The Culture of Early Charleston.* Chapel Hill: University of North Carolina Press, 1942.

Bridenbaugh, Carl. *Cities in the Wilderness: The First Century of Urban Life in America, 1625–1742.* New York: Alfred A. Knopf, Inc., 1938.

Brown, Ralph H. *Mirror for Americans.* New York: American Geographical Society, 1943.

Bruff, J. Goldsborough. *Gold Rush: The Journals, Drawings, and Other Papers of J. Goldsborough Bruff . . . April 2, 1849–July 20, 1851.* Edited by Georgia Willis Read and Ruth Gaines. New York: Columbia University Press, 1949.

Bryce, James. *The American Commonwealth,* 2 vols. New York: Macmillan Co., 1910.

Burlingame, Roger. *Backgrounds of Power.* New York: Charles Scribner's Sons, 1949.

Cable, Mary. "Buildings for Sale." *American Heritage,* Vol. 30, No. 5 (1979).

———. "Main Street of America." *American Heritage,* Vol. 20, No. 2 (February 1969).

Carman, Harry J., ed. *American Husbandry.* New York: Columbia University Press, 1939.

Chevalier, Michel. *Society, Manners, and Politics in the United States: Letters on North America.* Boston, 1839.

Clark, Victor S. *History of Manufactures in the United States.* New York: McGraw-Hill Book Co., 1929.

Cumming, W. P., S. E. Hillier, D. B. Quinn, and G. Williams. *The Exploration of North America 1630–1776.* New York: G. P. Putnam's Sons, 1974.

———, R. A. Skelton, and D. B. Quinn. *The Discovery of North America.* New York: American Heritage Press, 1972.

Cummings, Paul. *American Drawing: The 20th Century.* New York: Viking Press, 1976.

Dana, Richard Henry. *Two Years Before the Mast.* Boston, 1840.

Davidson, Marshall B. *The American Heritage History of Antiques.* New York: American Heritage Publishing Co., 1969.

———. *The American Heritage History of the Artists' America.* New York: American Heritage Publishing Co., 1973.

———. *The American Heritage History of Notable American Houses.* New York: American Heritage Publishing Co., 1971.

———. *The American Heritage History of the Writers' America.* New York: American Heritage Publishing Co., 1973.

———. "Carl Bodmer's Unspoiled West." *American Heritage,* Vol. 14, No. 3 (April 1963).

———. *Life in America,* 2 vols. Boston: Houghton Mifflin Co., 1951.

———. *New York: A Pictorial History.* New York: Charles Scribner's Sons, 1977.

DeVoto, Bernard. *Across the Wide Missouri.* Boston: Houghton Mifflin Co., 1947.

Dickens, Charles. *American Notes.* London, 1842.

Dondore, Dorothy Anne. *The Prairie and the Making of Middle America.* Cedar Rapids, Iowa: The Torch Press, 1926.

Dulles, Foster Rhea. *America Learns to Play: A History of Popular Recreation, 1607–1940.* New York: D. Appleton-Century Co., 1940.

Dunbar, Seymour. *A History of Travel in America.* Indianapolis: Bobbs-Merrill Co., 1915.

Edwards, Everett E. *American Agriculture: The First 300 Years.* Washington, D.C.: U.S. Department of Agriculture, 1941 (Yearbook Separate No. 1783).

Ellis, David M., J. A. Frost, H. C. Syrett, and H. J. Carman. *A Short History of New York State.* Ithaca, N.Y.: Cornell University Press, 1957.

Emerson, Ralph Waldo. *The Essays of Ralph Waldo Emerson.* New York: Modern Library, Random House, Inc., 1944.

Filson, John. *The Discovery, Settlement and Present State of Kentucke.* Wilmington, Del., 1784.

Fish, Carl Russell. *The Rise of the Common Man, 1830–1850.* New York: Macmillan Co., 1927 (*A History of American Life,* Vol. 1).

Flanagan, John T., ed. *America Is West.* Minneapolis: University of Minnesota Press, 1945.

Flexner, James Thomas. *George Washington in the American Revolution.* Boston: Little, Brown and Co., 1968.

———. *Steamboats Come True.* New York: Viking Press, 1944.

———. *The Traitor and the Spy.* New York: Harcourt, Brace and Co., 1953.

Forbes, Esther. *Paul Revere and the World He Lived In.* Boston: Houghton Mifflin Co., 1942.

Fox, Dixon Ryan. *Yankees and Yorkers.* New York: New York University Press, 1940.

Gabriel, Ralph Henry. *The Course of American Democratic Thought,* 2nd ed. New York: Ronald Press Co., 1956.

Garland, Hamlin. *A Son of the Middle Border.* New York: Macmillan Co., 1925.

Garraty, John A. *The American Nation: A History of the United States.* New York: Harper and Row, Publishers, 1968.

Glover, Katherine. *America Begins Again: The Conquest of Waste in Our Natural Resources.* New York: Whittlesey House, McGraw-Hill Book Co., 1939.

Goetzmann, William H. *Army Exploration of the American West, 1803–1863.* New Haven, Conn.: Yale University Press, 1959.

Greenbie, Marjorie Barstow. *American Saga: The History and Literature of the American Dream of a Better Life.* New York: Whittlesey House, McGraw-Hill Book Co., 1939.

Greene, Evarts Borstell. *The Revolutionary Generation.* New York: Macmillan Co., 1943 (*A History of American Life,* Vol. 4).

Hacker, Louis Morton. *The Shaping of the American Tradition.* New York: Columbia University Press, 1947.

Hamilton, Dr. Alexander. *Gentleman's Progress: The Itinerary of Dr. Alex-*

ander Hamilton, 1744. Edited by Carl Bridenbaugh. Chapel Hill: University of North Carolina Press, 1948.

Hamlin, Talbot. *Benjamin Henry Latrobe.* New York: Oxford University Press, 1955.

Hansen, Marcus Lee. *The Atlantic Migration, 1607–1860.* Cambridge, Mass.: Harvard University Press, 1940.

———. *The Immigrant in American History.* Cambridge, Mass.: Harvard University Press, 1940.

Hart, Albert Bushnell, ed. *American History Told by Contemporaries.* New York: Macmillan Co., 1897–1929.

Hendricks, Gordon. *The Life and Work of Winslow Homer.* New York: Harry N. Abrams, Inc., 1979.

———. *The Life and Works of Thomas Eakins.* New York: Grossman Publishers, 1974.

Hennepin, Louis. *A New Discovery of a Vast Country in America.* London, 1698.

Holliman, Jennie. *American Sports (1785–1835).* Durham, N.C.: Seeman Press, 1931.

Hone, Philip. *Diary.* Edited by Allan Nevins. New York: Dodd, Mead and Co., 1927.

Honour, Hugh. *The New Golden Land: European Images of America from the Discoveries to the Present Time.* New York: Pantheon Books, 1976.

Huber, Leonard V. *Louisiana: A Pictorial History.* New York: Charles Scribner's Sons, 1975.

Hulbert, Archer B. *The Paths of Inland Commerce.* New Haven, Conn.: Yale University Press, 1920 (*The Chronicles of America,* Vol. 21).

Hunter, Louis C. and Beatrice J. *Steamboats on the Western Rivers.* Cambridge, Mass.: Harvard University Press, 1949.

Ives, Joseph C. *Report Upon the Colorado River.* Washington, D.C., 1861 (House of Representatives Executive Document No. 90, 36th Congress, 1st Session).

Janson, Charles William. *The Stranger in America, Containing Observations Made . . . on the . . . People of the United States (1793–1806).* London: J. Cundee, 1807.

Jensen, Oliver, ed. *New York, N.Y.* New York: American Heritage Publishing Co., 1968.

———, ed. *The Nineties.* New York: American Heritage Publishing Co., 1967.

Josephy, Alvin M., Jr., ed. *The American Heritage Book of Indians.* New York: American Heritage Publishing Co., 1961.

———, ed. *The American Heritage Book of Natural Wonders.* New York: American Heritage Publishing Co., 1963.

———, ed. *The American Heritage History of the Great West.* New York: American Heritage Publishing Co., 1965.

Kalm, Peter. *The America of 1750: Peter Kalm's Travels in North America.* Edited by Adolph B. Benson. New York: Wilson-Erickson, Inc., 1937.

M. and M. Karolik Collections of American Water Colors and Drawings, 1800–1875, 2 vols. Boston: Museum of Fine Arts, 1962.

Ketchum, Richard M., ed. *The American Heritage Book of the Pioneer Spirit.* New York: American Heritage Publishing Co., 1959.

———, ed. *The American Heritage Book of the Revolution.* New York: American Heritage Publishing Co., 1958.

———, ed. *The American Heritage Picture History of the Civil War.* New York: American Heritage Publishing Co., 1960.

———, *The Battle for Bunker Hill.* Garden City, N.Y.: Doubleday and Co., 1962.

———, *Will Rogers: His Life and Times.* New York: American Heritage Publishing Co., 1973.

Kimball, Fiske. *Domestic Architecture of the American Colonies and of the Early Republic.* New York: Charles Scribner's Sons, 1922.

King, Edward. *The Great South: A Record of Journeys. . . .* Hartford, Conn., 1875.

Knight, Sarah Kemble. *The Private Journal of a Journey from Boston to New York in the Year 1704.* Albany, N.Y.: F. H. Little, 1865.

Kouwenhoven, John A. *Made in America.* Garden City, N.Y.: Doubleday and Co., 1948.

Kraus, Michael. *Intercolonial Aspects of American Culture on the Eve of the Revolution.* New York: Octagon Books, 1928.

Krout, John Allen, and D. R. Fox. *The Completion of American Independence, 1790–1830.* New York: Macmillan Co., 1944 (*A History of American Life,* Vol. 5).

Kurz, Rudolph Friedrich. *Journal.* Translated by Myrtis Jarrell; edited by J. N. B. Hewitt. Washington, D.C.: Smithsonian Institution, 1937 (Bureau of American Ethnology Bulletin 115).

La Rochefoucauld-Liancourt, François, Duc de. *Travels Through the United States.* London, 1799.

Lewis, Meriwether, and William Clark. *The Journals of Lewis and Clark.* Edited by Bernard DeVoto. Boston: Houghton Mifflin Co., 1953.

Marcy, Randolph B. *Thirty Years of Army Life on the Border.* New York: Harper and Brothers, 1866.

Marryat, Frederick A. *A Diary in America, with Remarks on Its Institutions.* New York: W. H. Colyer, 1839.

Martineau, Harriet. *Society in America.* New York: Saunders and Otley, 1837.

Matthews, William, and D. Wecter. *Our Soldiers Speak, 1775–1918.* Boston: Little, Brown and Co., 1943.

Mayer, Frank Blackwell. *With Pen and Pencil on the Frontier in 1851: The Diary and Sketches of Frank Blackwell Mayer.* Edited by Bertha L. Heilbron. St. Paul: The Minnesota Historical Society, 1932.

McCullough, David. *The Great Bridge.* New York: Simon and Schuster, 1972.

McMaster, John Bach. *A History of the People of the United States.* New York: D. Appleton and Co., 1883–1913.

McWilliams, Carey. *Ill Fares the Land: Migrants and Migratory Labor in the United States.* Boston: Little, Brown and Co., 1942.

Miller, Alfred Jacob. *The West of Alfred Jacob Miller.* Norman: University of Oklahoma Press, 1951.

Monaghan, Frank, and M. Lowenthal. *This Was New York.* Garden City, N.Y.: Doubleday and Co., 1943.

Morison, Samuel Eliot. *Builders of the Bay Colony.* Boston: Houghton Mifflin Co., 1930.

———. *The Maritime History of Massachusetts.* London: William Heinemann, Ltd., 1923.

———, and H. S. Commager. *The Growth of the American Republic,* 2 vols. New York: Oxford University Press, 1942.

Muirhead, James Fullerton. *The Land of Contrasts: A Briton's View of His American Kin.* Boston: Lamson, Wolffe and Co., 1898.

Nevins, Allan, ed. *America Through British Eyes.* New York: Oxford University Press, 1948.

———. *The Emergence of Modern America.* New York: Macmillan Co., 1927 (*A History of American Life,* Vol. 8).

Ogg, Frederic Austin. *The Old Northwest.* New Haven, Conn.: Yale University Press, 1920 (*The Chronicles of America,* Vol. 19).

Olmsted, Frederick Law. *The Cotton Kingdom: A Traveler's Observations. . . .* New York: Mason Brothers, 1861.

O'Neill, Gerard K. *2081: A Hopeful View of the Human Future.* New York: Simon and Schuster, 1981.

"One of the Mississippi Bubbles." *Newberry Library Bulletin,* No. 5 (September 1946).

Panofsky, Erwin. "On Movies." *Bulletin of the Department of Art and Archeology of Princeton University* (June 1936).

Parkman, Francis, Jr. *The Battle for North America.* Edited by John Tebbel. Garden City, N.Y.: Doubleday and Co., 1948.

———. *The California and Oregon Trail.* New York: G. P. Putnam, 1849.

———. *The Oregon Trail.* New York: Modern Library, Random House, Inc., 1949.

Parrington, Vernon Louis. *Main Currents in American Thought.* New York: Harcourt, Brace and Co., 1927–30.

Parton, James. *Life and Times of Benjamin Franklin.* New York: Mason Brothers, 1864.

Paul, Rodman W. *California Gold: The Beginning of Mining in the Far West.* Cambridge, Mass.: Harvard University Press, 1947.

Petersen, Charles E. "Steamboating on Western Waters." *Dictionary of American History.* New York: Charles Scribner's Sons, 1946.

Phillips, Ulrich Bonnell. *Life and Labor in the Old South.* Boston: Little, Brown and Co., 1929.

Powell, John Wesley. *First Through the Grand Canyon.* Edited by Horace Kephart. New York: Outing Publishing Co., 1915.

Prown, Jules D. *John Singleton Copley,* 2 vols. Cambridge, Mass.: Harvard University Press, 1966.

Ralph, Julian. *Our Great West.* Freeport, N.Y.: Books for Libraries Press, 1970 (reprint of 1893 ed.).

Richardson, Albert D. *Beyond the Mississippi.* Hartford, Conn.: American Publishing Co., 1867.

Richardson, E. P. *Painting in America.* New York: Thomas Y. Crowell Co., 1956.

———. "Peter Martensson Lindström, Swedish Artist-Explorer, and the Delaware Indians." *American Art Journal,* Vol. 12, No. 1 (winter 1980).

Robert, Joseph Clarke. *The Tobacco Kingdom*. Durham, N.C.: Duke University Press, 1938.

Robertson, Archibald. *Archibald Robertson . . . His Diaries and Sketches in America, 1762-1780*. Edited by Harry Miller Lydenberg. New York: New York Public Library, 1930.

Rollins, Philip Ashton. *The Cowboy*. New York: Charles Scribner's Sons, 1922.

Roosevelt, Theodore. *Theodore Roosevelt: An Autobiography*. New York: Charles Scribner's Sons, 1924.

Rugoff, Milton, ed. *The Britannica Encyclopedia of American Art*. Chicago: Encyclopaedia Britannica Educational Corp., 1973.

Schafer, Joseph. *The Social History of American Agriculture*. New York: Macmillan Co., 1936.

Schlesinger, Arthur M. *New Viewpoints in American History*. New York: Macmillan Co., 1922.

——. *Paths to the Present*. New York: Macmillan Co., 1949.

——. *The Rise of the City*. New York: Macmillan Co., 1933 (*A History of American Life*, Vol. 10).

Sears, Stephen W., ed. *The American Heritage Century Collection of Civil War Art*. New York: American Heritage Publishing Co., 1974.

Sert, José Luis. *Can Our Cities Survive?* Cambridge, Mass.: Harvard University Press, 1942.

Shelley, Donald A. "George Harvey and His Atmospheric Landscapes of North America." *New-York Historical Society Quarterly*, Vol. 32, No. 2 (April 1948).

Slosson, Edwin E. *The American Spirit in Education*. New Haven, Conn.: Yale University Press, 1921 (*The Chronicles of America*, Vol. 33).

Slosson, Preston William. *The Great Crusade and After*. New York: Macmillan Co., 1930 (*A History of American Life*, Vol. 12).

Spiller, R. E., E. W. Thorp, T. H. Johnson, H. S. Canby, and Associates, eds. *Literary History of the United States*. New York: Macmillan Co., 1955.

Stebbins, Theodore E., Jr. *American Master Drawings and Watercolors*. New York: Harper and Row, 1976.

Stegner, Wallace B. *Beyond the Hundredth Meridian*. Boston: Houghton Mifflin Co., 1954.

Steinbeck, John. *The Grapes of Wrath*. New York: Viking Press, 1939.

Stokes, I. N. Phelps. *The Iconography of Manhattan Island*. New York: Robert H. Dodd Co., 1915-28.

——, and D. C. Haskell. *American Historical Prints*. New York: New York Public Library, 1932.

Sullivan, Mark. *Our Times: The United States, 1900-1925*. Charles Scribner's Sons, 1926-35.

Svinin, Pavel Petrovich. *Picturesque United States . . . A Memoir on Paul Svinin*. Translated and edited by Avrahm Yarmolinsky. New York: W. E. Rudge, 1930.

Taft, Robert. *Artists and Illustrators of the Old West, 1850-1900*. New York: Charles Scribner's Sons, 1953.

Tarbell, Ida M. *The Nationalizing of Business*. New York: Macmillan Co., 1936 (*A History of American Life*, Vol. 9).

Thorndike, Joseph J., Jr., ed. *The American Heritage History of Seafaring America*. New York: American Heritage Publishing Co., 1974.

——, ed. *Three Centuries of Notable American Architects*. New York: American Heritage Publishing Co., 1981.

Tocqueville, Alexis de. *Democracy in America*. Edited by Phillips Bradley. New York: Alfred A. Knopf, Inc., 1945.

Trachtenberg, Marvin. *The Statue of Liberty*. New York: Viking Press, 1976.

Trollope, Anthony. *North America*. New York: Harper and Brothers, 1862.

Trollope, Frances M. *Domestic Manners of the Americans*. London, 1832.

Tryon, Warren S., ed. *A Mirror for Americans*, 3 vols. Chicago: University of Chicago Press, 1952.

Twain, Mark (Samuel Langhorne Clemens). *Life on the Mississippi*. Boston: James R. Osgood and Co., 1883.

Tyler, Alice Felt. *Freedom's Ferment: Phases of American Social History to 1860*. Minneapolis: University of Minnesota Press, 1944.

Tyler, Lyons G., ed. *Narratives of Early Virginia, 1606-25*. New York: Barnes and Noble Books, 1966 (reprint of 1907 ed.).

Utley, Robert M., and W. E. Washburn, eds. *The American Heritage History of the Indian Wars*. New York: American Heritage Publishing Co., 1977.

Veblen, Thorstein. *The Instinct of Workmanship, and the State of the Industrial Arts*. New York: Macmillan Co., 1914.

Webb, Walter Prescott. *The Great Plains*. New York: Grosset and Dunlap, 1931.

Wecter, Dixon. *The Age of the Great Depression*. New York: Macmillan Co., 1948.

Wells, H. G. *The Future in America*. New York: Harper and Brothers, 1906.

Wertenbaker, Thomas Jefferson. *The Old South*. New York: Charles Scribner's Sons, 1942.

Whitman, Walt. *Complete Writings*. Edited by R. M. Bucke, T. B. Harned, and H. L. Traubel. New York: Camden Edition, G. P. Putnam, 1902.

Wied-Neuwied, Maximilian, Prince of. *Travels in the Interior of North America*, 2 vols. Edited by R. G. Thwaites. Cleveland: A. H. Clark Co., 1906 (*Early Western Travels*, Vols. 22-24).

Willison, George F. *Saints and Strangers*. New York: Reynal and Hitchcock, 1945.

Wilson, Woodrow. *Selected Addresses and Public Papers*. Edited by Albert Bushnell Hart. New York, 1918.

Wright, Louis B. *The First Gentlemen of Virginia*. San Marino, Calif.: Huntington Library, 1940.

Index

Photograph Credits

The author and publisher wish to thank the museums, galleries, libraries, and private collectors for permitting the reproduction of works of art in their possession and for supplying the necessary photographs. Photographs from other sources (listed by plate number) are gratefully acknowledged below.

American Antiquarian Society, Worcester, Mass.: 132, 133; Armen Photographers, Pine Brook, N.J.: 79; Avery Library, Columbia University, New York: 294; Oliver Baker Associates, Inc., New York: 258; Ted Bickford, New York: 305; David I. Bushnell, Jr., Cambridge, Mass.: 11; Geoffrey Clements, New York: 289; Geoffrey Clements, New York (courtesy Whitney Museum of American Art, New York): 229; Louis H. Dreyer, New York: 285; James R. Dunlop, Washington, D.C.: 211; Frick Art Reference Library, New York: 31, 118; D. Graf, West Berlin: 12; Hans E. Lorenz, Williamsburg, Va.: 61; Lou Malkin, Vinard Studios, Pittsburgh: 125; Larry McBrearty, Tarrytown, N.Y.: 39; Museum of Fine Arts, Boston: 254; Piaget, St. Louis: 170, 178; William A. Porter, San Francisco: 270; Mike Posey, New Orleans: 92; Walter Rosenblum, New York: 259; Royal Collection, Copenhagen: 214; Louis Schwartz, Charleston, S.C.: 47; Scranton Photo Studio, Scranton, Pa.: 207; Mark Sexton, Salem, Mass.: 37; Joseph Szaszfai, New Haven, Conn.: 257; Taylor and Dull, New York: 260; Marvin Trachtenberg, New York: 242; Ken Veeder, Hollywood, Calif.: 244; Nemo Warr, Detroit: 29.